JAPANESE TATTOOS

HISTORY • CULTURE • DESIGN

Brian Ashcraft with Hori Benny

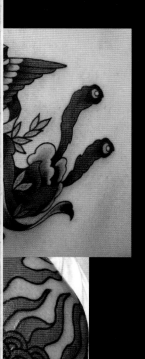

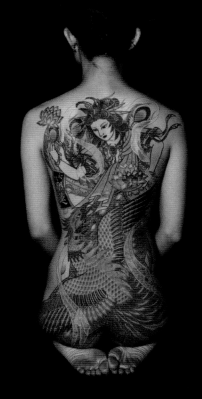

TUTTLE Publishing

Tokyo | Rutland, Vermont | Singapore

CONTENTS

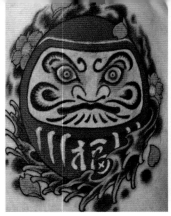

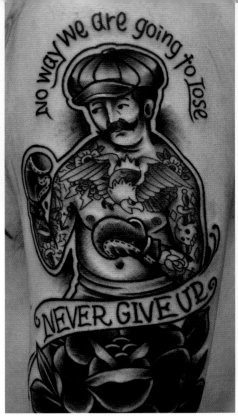

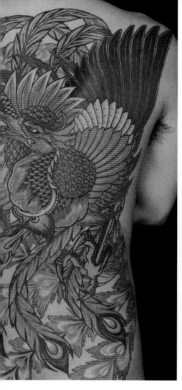

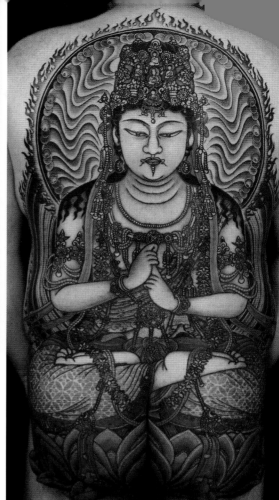

INTRODUCTION

EXPLORING JAPAN'S TATTOOING TRADITION
THE WORLD OF JAPANESE IREZUMI

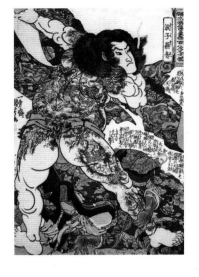

It was early spring. The weather was still too cold for the cherry blossoms to cover Japan in hues of pink and white. My coauthor Hori Benny, an American-born Osaka-based tattooist, and I took an early morning bullet train to Horiyoshi III's Yokohama studio. Our interview with the world-famous tattooer was supposed to be only an hour, but we ended up spending the day with him, the first of several visits.

During our talks, Horiyoshi III, who was busy working on a succession of clients, generously shared his insights. One of them in particular stuck with me as I wrote this book: "In a funny way, everything in Japan is connected to *irezumi*," he said, using the Japanese word that refers to tattoos. The statement couldn't have have been truer. In irezumi you'll find expressions of the seasons, the folklore, the religions, and many other aspects of Japanese culture.

WHAT DOES "IREZUMI" MEAN?

Irezumi isn't simply the Japanese word for "tattoos." Throughout the country's history, different words have referred to tattoos, and the word irezumi itself has been written with different characters, each having a separate meaning or nuance, whether that was the irezumi (入れ墨) that was a branding mark, meted out as punishment to criminals, or the irezumi (刺青) that was done of free will. Other words have been used, such as *irebokuro* (入れ黒子), which dates from the 1700s. Additional old terms include *mon mon* (紋々), where "mon" refers to a crest; or *monshin* (紋身), which literally means a crest on one's body. These are not used today. The word *horimono* (彫り物), however, still is; it can refer to tattoos or any other engraved thing. More recently, the term *wabori* (和彫り), which means "Japanese engraving," was coined in the 20th century to refer specifically to Japanese tattoos.

AN ANCIENT TRADITION

Tattoos go back as far as Japan's recorded history. Japanese accounts as early as the fifth century mention punitive irezumi, but tattoos had other purposes before that. For example, a third-century Chinese account mentions that Japanese people tattooed themselves to mark social class and protect themselves from harmful sea creatures. If true, this would support the theory that the patterns on the faces of the prehistoric Japanese terracotta burial figures known as *haniwa* are not painted, but tattooed.

There are other tattoo traditions in Japan with a long, rich history, such as that of the Ainu people in Hokkaido. Their facial and hand tattoos are from a different tradition than those found on Japan's main island in cities like Osaka and Tokyo, and they fall outside the purview of this book.

BECOMING A HORISHI

In Japan, *horishi* (tattooers) study and train for years to master their craft. In the past, that meant a lengthy apprenticeship in which the apprentice, or *deshi*, would clean up the studio and practice drawing and tattooing himself (or, more recently, herself). This would continue until the day the master, or *shisho*, finally deemed the pupil good enough to work on actual clients.

Some tattooers stick close to the master's style or continue to work from iconic designs, while others might

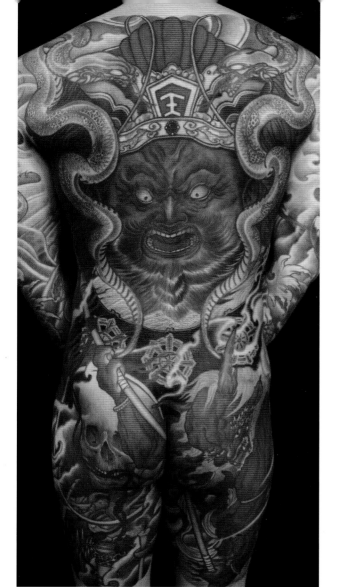

Opposite, top *Suikoden* hero Roshi Ensei as depicted by influential Japanese woodblock artist Utagawa Kuniyoshi. **Left, above** A bodysuit featuring Emma-o, the Buddhist god of hell. Emma-o metes out sentences and rules the underworld. His hat reads 王 (*ou*), meaning "king," and the wheels represent the Buddhist Wheel of Law. **Left, below** In this sculpture, a Japanese tattooer is using the *tebori* hand-poked method to tattoo a woman's back with a dragon.

try to add their own interpretation or go off in another direction altogether. Once a tattooer debuts, "Hori" (彫), which refers to engraving or carving, is added before their name. Calling oneself "Hori" explicitly states a mastery of craft and artisan stature. It's the irezumi equivalent of "Dr." or "Prof."

This system has created close-knit tattoo families called *ichimon*. Even after graduating and setting up shops of their own, former apprentices continue to have close relationships with their master and are expected to take care of their teacher should something happen. Not all of Japan's best tattooists have gone through an apprenticeship. What they all share is a serious study of tattoo motifs and design, whether with a mentor or not.

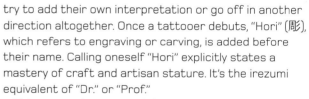

A LIFESTYLE CHOICE

People in Japan get irezumi for a variety of reasons. Some get them to protect their bodies, or for religious reasons. Others get tattoos because they look good.

Whatever the reason, irezumi is a lifestyle choice—and in Japan, a brave one at that. Even today, when tattooed people in Japan go out in public, unless it's a specific special occasion, such as a religious festival; or a safe environment, such as a bohemian district of a big city, most cover up their ink. This is because of the wide-spread belief that only Japan's gangsters, the yakuza, have irezumi, so if you are tattooed you are dangerous. Covering up one's ink is not only a courtesy to avoid unsettling others, but is also to protect from discrimination, whether applying for a job or renting an apartment.

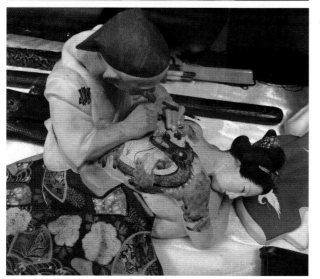

My local bartender in suburban Osaka has had his biceps inked with Polynesian-style "tribal" designs. When I asked him why he hadn't gone with Japanese irezumi motifs, such as flowers or Buddhist gods, he replied, "Because I don't want to be confused with a gangster." There are also notions in Japan that tattoos are dirty, because unclean needles spread a whole array of diseases, as well as a Confucian belief that it is disrespectful to modify the body bestowed on you by your parents.

There is, however, a long, proud tradition of firemen, blue-collar workers, and artisans getting tattooed for religious convictions, to protect their bodies from hazardous work, and simply because irezumi look damn cool.

UNDERGROUND TATTOO CULTURE

Although largely hidden, irezumi culture remains strong. If you look closely, you'll catch glimpses. A glimpse of red under a sleeve. Some black at the edge of a pair of shorts. Flashes of yellow or blue. Irezumi are designed to be covered and worn under clothes. But because tattoos aren't out in the open in Japan as they are in the West, when you finally do see them, they have enormous impact and power. This is what makes irezumi unique; this is their appeal. Generally speaking, irezumi are personal and private, unlike Western-style tattoos, which often seem to be for show.

In Japan, foreigners with tattoos are less likely to be judged harshly than the locals who have them. The common assumption is that Western-style tattoos are for fashion, while Japanese ones are for unsavory types. This is why inked celebrities like Johnny Depp or athletes like Brazilian soccer star Neymar Jr. can appear on television or in print ads with their tattoos on display. Meanwhile, many tattooed Japanese celebrities tend to cover their irezumi for fear of alienating fans or being misrepresented. Most people in Japan don't see tattoos during daily life. The chances of you seeing someone's irezumi at a PTA meeting, at a convenience store or McDonald's, or even on the subway are very, very low.

For all of that is made of irezumi's connection to Japanese organized crime, it's important to remember that, during the periods in which tattooers were persecuted and could be arrested for practicing their craft, it was the yakuza who kept tattooers employed. Regardless what you think of yakuza or their activities, if you like Japanese tattoos, the fact that yakuza have kept the tradition alive should be respected.

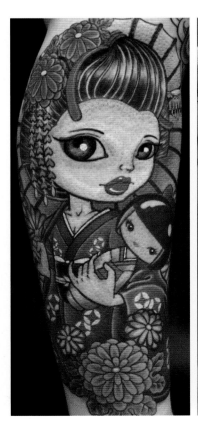

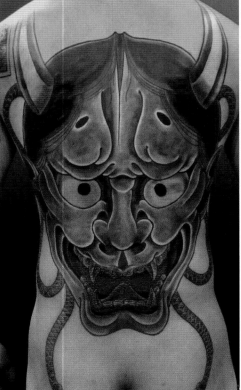

Far left The wooden doll (called a *kokeshi*) makes a striking comparison between the courtesan and the doll itself. Kokeshi can be tokens of friendship, but are sometimes compared to phalluses, underscoring the lush, sexualized themes in this tattoo. **Left** Hannya masks (see page 112) are iconic and powerful. The back is the body's biggest canvas for irezumi—and what better way to make a statement than with a giant Hannya?

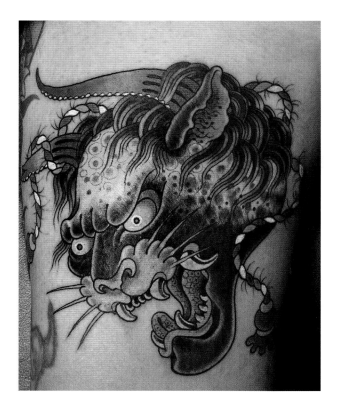

TATTOO PROHIBITION

Today, tattooing isn't banned in Japan, but the practice exists in a legal gray zone. In 2001, the Ministry of Health, Labor and Welfare classified tattooing as a medical procedure, with the rationale that only a licensed health care professional can penetrate the skin with a needle and insert pigment. The government, however, does not issue tattoo licenses, and the industry continues to be unregulated. In some parts of the country, there are large, open tattoo shops right on the street with clearly marked signs. In other regions, tattooers work out of unmarked studios and rented apartments.

From the late 19th century to the end of World War II, tattooing was illegal in Japan. During the U.S. Occupation (1945–1952), the tattoo ban was finally lifted after an American officer under General Douglas MacArthur met with Horiyoshi II of Tokyo. (Note: this Horiyoshi family is different from the Yokohama Horiyoshi line.)

The U.S. military might have been more accepting of the craft due to its tradition of service members getting inked.

Irezumi prohibition had been part of an effort to modernize and align Japan with Western morals. During the 19th century, officials issued various edicts against tattooing (one 1811 edict pointed out that, horrors of horrors, irezumi were fashionable among the country's youth). These went largely ignored, but in 1872, the Tokyo government announced the Ishiki Kai ordinance, which was soon followed by a similar national decree. The Ishiki Kai ordinance banned major and minor social transgressions, including peeing in front of stores, being naked in public, mixed communal bathing, selling pornography, and tattooing. Those who violated serious infractions, such as tattooing, were fined. Those who couldn't pay the fine were whipped. People who already had ink could avoid police trouble by paying for a permit.

The ban, however, applied only to Japanese people. The government never anticipated that some foreign visitors, including those from the upper echelons of society, would become enamored of tattoos. There was an obvious gap in how foreigners saw irezumi and how the Japanese ruling class saw them. Lord Charles Beresford, an admiral and a member of British Parliament, got tattooed in Japan, and later recalled how the country's upper crust was astonished because they thought it was only for the "common people."

Above A traditional American black panther design infused with Hannya mask elements. **Far right** Irezumi have provided plenty of fodder for Japanese pulp writers. **Right** Not all the 20th-century pulp stories were set in the modern day. This one shows a traditional horishi at work.

No Tattoos Allowed
Check Your Ink At The Door

At hot springs, public baths, swimming pools, and gyms across Japan, you'll see signs that state the same thing: folks with tattoos cannot enter.

It wasn't always so. In the years after World War II, when many middle- and lower-class families in towns and cities still used the local bathhouses because they didn't have tubs at home, establishments couldn't be picky about clientele. Everyone needed to bathe.

As the Japanese economy grew in the 1960s and 70s, and as urban homes became more luxurious, regular public bathing became less common. This also meant that tattoos were seen more rarely. Bathhouses and hot springs became more strict about who they would and would not let in.

These days, not all establishments have tattoo bans. There are hot springs and bathhouses that allow inked bathers (though they might ask you to cover your tattoo with a towel or even a special sticker). Some that technically don't allow them might turn a blind eye, especially for international visitors. Don't expect that, though: In 2013, for example, one Hokkaido hot springs denied entry to a New Zealand woman with traditional Maori facial tattoos. The incident made international news.

Left This warning sign was posted at a pachinko parlor entrance. Note that it uses the irezumi kanji (入れ墨) that refers to punishment tattoos.

Inked Royals
Blood Blue, Black Ink

During the late 19th century, tattoos became a fad among European royalty. For bluebloods, permanent ink was the ultimate souvenir of an exotic voyage.

The British king Edward VII helped to kick off this trend after getting a Crusaders' cross tattooed on his forearm in Jerusalem. As a boy, Edward wore naval-inspired playsuits and popularized sailor clothes among the Europeans, which later spread to Japan. That Edward was quite the trendsetter!

His sons, Prince Albert Victor and the future King George V, both got dragon tattoos while visiting Japan in 1881. The last Russian Tsar, the future Nicholas II, also got a dragon tattooed on his arm while visiting Japan in 1891. During that trip, there was an attempt on his life. He survived, but didn't make it through the Bolshevik Revolution.

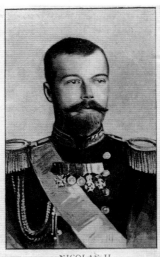

NICOLAS II
EMPEREUR DE RUSSIE

Above Regal tattoo enthusiasts like Nicholas II were irezumi's earliest ambassadors.

THE RISE OF ONE-POINT TATTOOS

One-point designs are popular today in Japan, especially among people who want some ink but don't want to make the commitment that bodysuits or large back pieces require. In Japan, one-point designs traditionally have been a way to distinguish Western-style tattoos from the irezumi house style. Many tattooers in Japan are equally fluent in both, and can do big pieces surrounded by *gakubori* (see page 136) and isolated one-point tattoos. This flexibility ensures steady work, but it's hardly a new phenomenon.

During the 19th century, Japanese tattooers began modifying their designs to appeal to foreign customers. Most tattoo tourists got isolated one-point tattoos depicting things like samurai or geisha. In comparison, the full bodysuits, with their intricate designs and elaborate backgrounds, must have looked like artistic marvels to foreigners. No wonder they influenced a generation of talented Western tattooers like Sutherland MacDonald and George Burchett.

Few visiting Japan, however, completely covered themselves in ink. The reason was convenience: Most simply didn't have the time and wanted something that could be done quickly. There were exceptions, though. Over the course of several months in 1872, Charles Longfellow, son of the American poet Henry Wadsworth Longfellow, got several years' worth of irezumi, including an image of Kannon (page 89) on his chest and a koi fish (page 73) ascending a waterfall on his back. Because so much work was jammed

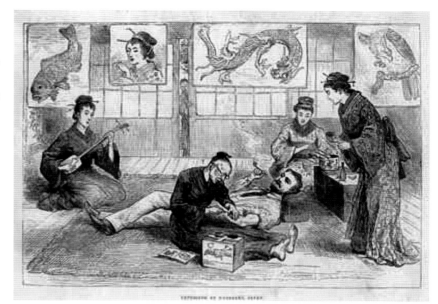

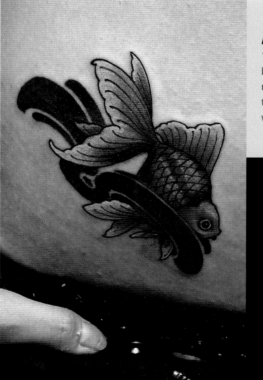

Above In the West, the popular 19th-century notion of tattooing was based more on stereotypes than in reality. **Left** Japanese motifs such as this swimming goldfish also make wonderful stand-alone designs.

Right In traditional American tattooing, skulls and roses are often paired. Here, waves and peonies replace the roses, underscoring the life-and-death theme and giving the tattoo a decidedly Japanese feel.

into a short period of time, Longfellow didn't have the time to recoup between sessions, so he got morphine injections to make it through.

During 20th century, one-point tattoos were the dominant style in the West, while large interwoven designs were the most common in Japan. But by the early 1980s, something funny was happening: a new generation of Japanese born after World War II who were into American and British culture wanted foreign-looking one-point tattoos. Around that time, American tattooer Don Ed Hardy inked Western-style designs on the members of the Black Cats, a popular Japanese rockabilly band. Just like that, a clear division between the words "tattoo" and "irezumi" was drawn. Tattoos were fun and fashionable. Irezumi were scary. This separate terminology has relaxed considerably. Some Japanese tattooers now use the words interchangeably. Others, however, still do not.

WHY JAPANESE TATTOOS CHANGED

Modern life influences the way tattoos are executed on physical and subconscious levels. There are no truly traditional Japanese tattoos because people don't live in a traditional world. Western fashion, the internet, Japanese TV shows, and Hollywood movies all create a vastly different visual landscape. All of this impacts tattoos, reflecting contemporary visual culture. This is most evident in anime-infused geek ink.

Even if the designs hark back to an earlier era, modern tattooers can put a contemporary spin on their work with eye-popping hues. Colors like bright oranges, strong navy blues and vibrant purples are not originally part of irezumi's color set. It wasn't until the decades after the Second World War that a greater variety of hues like purple and orange started being used in Japanese tattooing in a

big way. A whole host of new designs followed, along with a new way of thinking. Irezumi underwent one of its most significant changes ever.

ABOUT THIS BOOK

Irezumi are still an underground phenomenon in Japan; indeed, that's part of their appeal. Because of this, irezumi are enveloped in mythos and misinformation. My coauthor Hori Benny and I have seen plenty of non-Japanese with either faux or downright awful "Japanese-style" tattoos. Over the course of researching, interviewing, and writing this book, we consulted numerous friends, colleagues, experts, and total strangers with the goal of introducing and decoding the most prevalent motifs so that English speakers can have a better understanding of their meaning and hopefully get Japanese tattoos that can be worn with pride—as they should be.

The Birth of the Tattooing Machine
The Electrical Revolution

Samuel O'Reilly patented the first tattoo machine in 1891. The New York City tattooist based his device on Thomas Edison's motor-powered electric pen. Twenty days later, in London, Thomas Riley filed a patent for a single-coil tattoo machine, which had been created from, of all things, a modified doorbell.

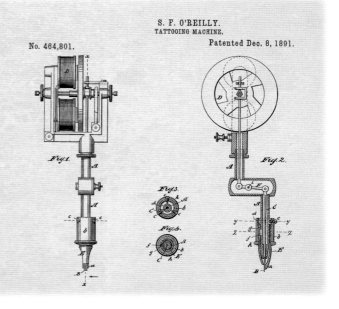

TATTOOIST PROFILE

HORIYOSHI III

JAPAN'S MOST FAMOUS TATTOOIST

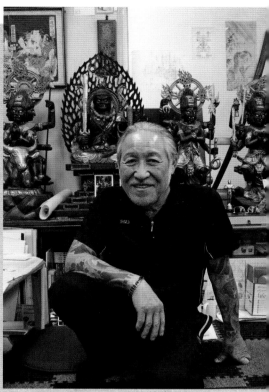

Above Master tattooer Horiyoshi III in his Yokohama studio.

"Are you ready?" Horiyoshi III calls to the customer in the waiting area. The unassuming client looks to be in his late 20s and seems like a typical button-down white-collar worker. He enters, greets the tattoo master with a bow, and undresses, revealing an irezumi bodysuit. He lies down on his stomach. On his back is a depiction of Buddhist hell—Horiyoshi III's handiwork.

With international exhibitions of his paintings, numerous publications on his tattoos and his designs, and even a clothing line named after him, Horiyoshi III is perhaps Japan's most famous tattooist. He is also a dedicated scholar of the form. The studio, a second-story walk-up in Yokohama, is lined with books. "I have another couple thousand or so at home," he says. "This is because I'm serious about learning."

Horiyoshi III wasn't always a keen student. "Growing up," he admits, "I was a hoodlum." Born Yoshihito Nakano in 1946, he began working as a welder in a Yokohama shipyard after finishing junior high school. "Lots of shipbuilders had tattoos," he recalls as he pulls on a pair of latex gloves. Nakano saw his first tattoo at age 11 at a public bathhouse. "It was a culture shock, but I thought it looked

pretty cool." At 16, he began tattooing himself. This was a time when information about tattoos was still scarce and techniques were only passed down from master to apprentice. "It was all guesswork," he says. "I tattooed my leg using needles fastened to disposable chopsticks."

At age 25, Nakano finally secured an apprenticeship with Yoshitsugu Muramatsu (aka Horiyoshi I), a well-known tattooist in Yokohama. Nakano showed up at Muramatsu's studio unannounced after his letters had gone unanswered. "Of course, I was nervous," he says. "There wasn't a sign outside the studio like there are on my shops today." It wasn't a place you could just pop in for a chat. "It was completely underground," he says, recalling how the studio had the "strong scent of the outlaw." Unlike today, the majority of the clients were yakuza. Horiyoshi I, who had already named his own son Horiyoshi II, gave Nakano the "Horiyoshi" name as well. In 1979, after a lengthy apprenticeship, Horiyoshi III was born.

The tattoo machine fires up, its buzzing echoing through the studio. Horiyoshi III puts Vaseline on the customer's back. "I used to think I'd rather quit tattooing than use a machine," he says, as he begins shading in the Buddhist hell. Horiyoshi III also practices *tebori*, often called the "hand-poked method" in English. For centuries, tattooing in Japan was synonymous with tebori, while the stereotype was that the tattoo machine was for foreigners. For Horiyoshi III, that would change in 1985, when he attended a tattoo convention in Rome and saw first-hand how efficient, versatile, and easy to use the machine was. He attended with his friend American tattooist Ed Hardy, who not only used the machine, but was also better versed in irezumi than Horiyoshi III. Japanese tattooing wasn't simply a method of inserting ink, but rather,

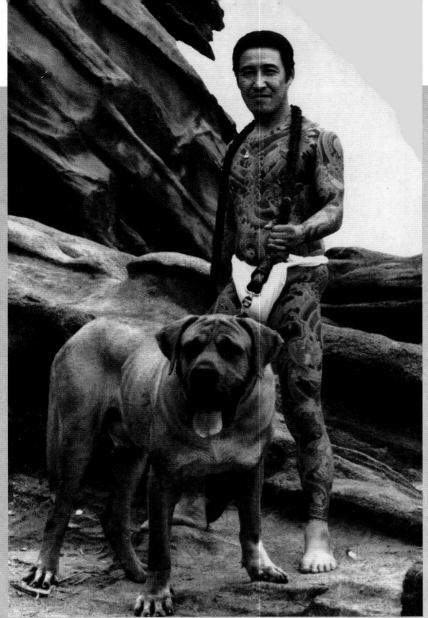

This is a magazine article.

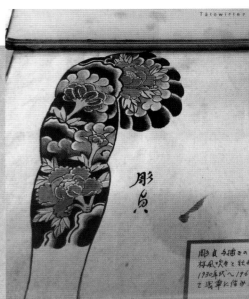

彫員

彫貞 う描さの
祥鳳吹きと牡丹
1930年式へ196
で浅草に住み

an entire history and catalogue of iconography.

After the Rome convention, realizing there were those outside Japan who knew more about his country than he did, Horiyoshi III arrived back in Japan with a new-found thirst for Japanese art, history, and culture. It wasn't simply a matter of pride. It was the beginning of a lifelong pursuit of knowledge. "Mankind has made it this far by studying," he says. "The tattoo machine, for example, was the result of someone studying."

Horiyoshi III began spending his days in libraries and bookstores. "I had this small camera that I'd use to snap photos if there was a book with only one page I wanted," he recalls. "The shopkeepers would get pissed at me." He did buy countless books, and filled his home and studio with them. "When you have lots of knowledge, you get wisdom," he says. "When you have lots of wisdom, you get an endless flow of original ideas." The impact is clearly evident in his art.

"Personally, I don't like the word 'art,'" Horiyoshi III says. Admirers of his work, however, would be quick to call it just that. "You shouldn't call what you do art—but I won't stop others from using the term," he adds. It's not simply that the work should speak for itself, but also that Horiyoshi III respects the tradition of the *shokunin*—the craftsman. "I would call myself a shokunin, not an artist," he explains.

"In the art world, you are allowed to fudge things," he continues, adding that artists can call "anything" art—even dog poop. "You cannot do that in the world of the shokunin." Irezumi is a language, with its own grammar and rules. "If you don't know the meaning of the symbols and the stories, you can't tattoo as well. Tattooing becomes superficial. Meaningless."

Or—just as bad—it can lead to mistakes. "Even if you see a tattoo that looks beautiful, if there's something that's not quite right, well, that's a mistake," he says. "It's like a Bentley with the steering wheel in the back seat," he adds, chuckling.

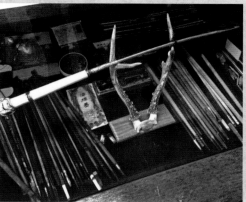

Far left A young badass Horiyoshi III poses with a *tosa*, a Japanese fighting dog that's banned in many countries. **Middle left** The Yokohama Tattoo Museum houses numerous important artifacts, such as these Hori Sada spring-themed sleeve designs. On the right arm, there are peonies; cherry blossoms are depicted on the other. **Left** Horiyoshi III's invention, a modern tebori tool that can be sterilized, rests atop the antlers. Below are traditional tattooing tools.

Horiyoshi III pauses. "This is just my opinion, but there isn't traditional tattooing in Japan anymore," he says. "In the old days, the needles and inks that tattooists used were closely guarded secrets. There was none of this—" he gestures toward the fluorescent lights overhead and the carpeting on the floor. "Tattoos were done on tatami mats by sunlight or candlelight, using old tools."

"Even if I were doing this tattoo by tebori, it wouldn't be traditional," he adds. The heater keeping the room warm on this chilly day would need to be shut off. Inks and colors that might fade easily or cause harm would have to be used, and there wouldn't be latex gloves and sterilization. That, explains Horiyoshi III, is how tattoos were traditionally done in Japan.

Pointing to the back covered with ink before him, he says, "Rather, I'd call this tattoo 'traditionalist.' That's the word I would use. Calling it 'traditional' is disrespectful to the tattooist of the past who worked under the threat of being arrested."

Horiyoshi III's work honors the past. Yet it moves the form forward and transforms it, too, whether through his use of different techniques or his creation of brand-new designs that exist in, as he would say, a traditionalist style. All of this is the result of decades of learning—from books, from people, and from life. "I'm still studying," Horiyoshi III says. "And I've been doing this for over forty years."

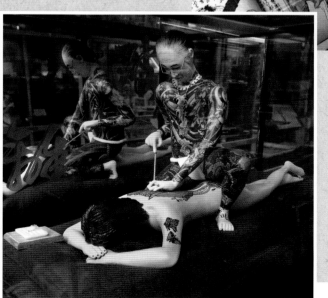

Above The second floor of the Yokohama Tattoo Museum is filled with rare prints, old texts, and countless historical artifacts. **Left** A statue of Horiyoshi III tattooing a phoenix on a woman's back. In his right hand, he holds the tattooing tool; his left holds a paintbrush in place, which he can use to dab ink on the tool.

KANJI TATTOOS
WORDS AND PHRASES, PUNISHMENT AND PLEDGES

Japanese script has found its way into tattoos in various forms over the centuries. It's easy to see the appeal: Japanese writing is beautiful, with flowing characters and pictograms. It's also easy to see why so many tattooists outside the country often make mistakes when working with Japanese script: the language is complex, and incorporates several different writing systems.

In recent years, bad kanji tattoos have become a cliché. Just look online: There's the man who thought he got the word "courage" tattooed on his back, but found out the characters 大過 (*taika*) actually meant "big mistake." There's the woman who ended up with 醜 (*shuu*), thinking it meant "friendship," only to find out it means "ugly," or the individual sporting a tragic バカ外人 (*baka gaijin*, meaning "stupid foreigner") tattoo. Then there are the folks who end up with ink that either doesn't make sense, or worse, is complete gibberish. This is enough to put anyone off the idea of getting a kanji tattoo! It shouldn't, though, as long as you make an

informed decision. In Japan, *irezumi* aren't done on a whim; there is traditionally more thought given. Japan has a long history of script tattoos—some of it good, some of it bad, and all of it fascinating.

Old Chinese and Japanese manuscripts, a mix of fact and folklore, do mention tattooing. One Chinese account dating from the late third century states that in Japan, decorative markings denoted rank or social status, and that Japanese shell divers had tattoos to protect themselves from harmful sea creatures. But by the fifth century, tattooing had an entirely different meaning: punishment and shame. Punitive tattoos were likely imported to Japan via China and were used to ostracize. In ancient China, which influenced early

Japanese culture, tattoos were used to mark criminals and slaves, so it's certainly possible that this is how disciplinary tattoos came to Japan. The *Nihon Shoki* (*Chronicles of Japan*), which dates from 720 AD and is the country's second-oldest history text, recounts how in 400 AD Emperor Richu had a rebel tattooed on the face for attempting to plot a coup, showing just how damning tattoos were. The same text recounts a story of an old codger with a tattooed face who commits theft, with the obvious implication that tattoos marked crooks. Yet another story tells how in 467 AD Emperor Yuryaku had a man permanently inked on the face after his dog killed an imperial bird. Irezumi weren't exactly winning in the ancient history PR department.

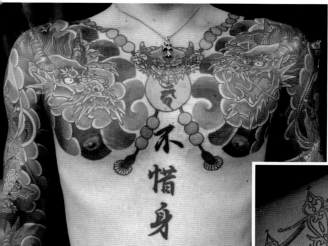

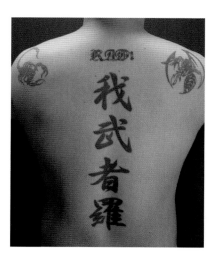

Left, above and below Common locations for kanji irezumi include the chest and the spine. The tattoo 不惜身命 (*fushakushinmyou*) is sometimes translated as "not sparing one's life for a worthy cause," but actually, it's a religious expression that refers to self-sacrificing dedication to Buddha or Buddhist law. The tattoo 我武者羅 (*gamushara*) means "daredevil," "hothead," or even "lunatic." Yikes! **Below** This motif depicts Kusanagi-no-Tsurugi, the legendary Japanese sword used to slay the Japanese dragon Yamata no Orochi. Traditionally, this dragon is said to have eight heads, but here it has one. A bonji character alluding to the Buddhist deity Fudo Myoo (see page 98) is emblazoned on the blade.

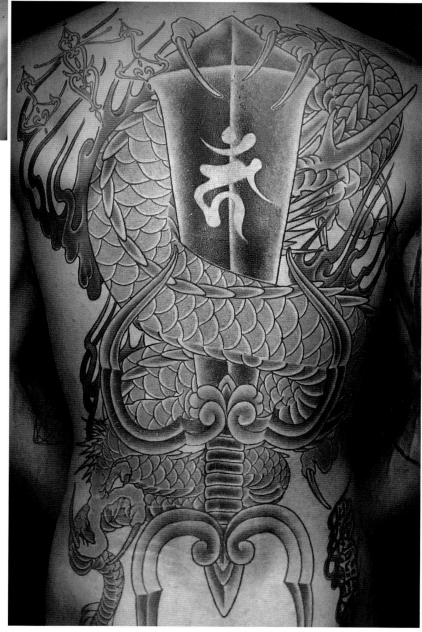

During the seventh century, irezumi began to fade as punishment, and save for one surviving mention of punitive tattoos in a 13th-century legal code, it wasn't until the 17th century that penal tattoos were back with a vengeance. In the early 1600s, the Tokugawa shogunate took over Japan, creating a highly stratified society and secluding the vast majority of the country from the outside world. By the later part of that century, irezumi penalties

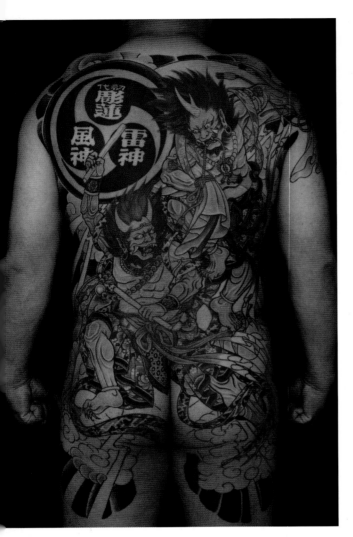

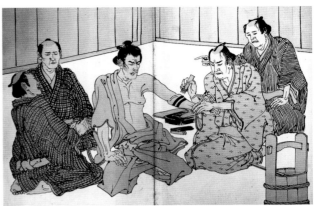

Above The act of applying punishment tattoos is called *irezumi-kei* (入墨刑), with *kei* referring to penalty, sentence, or punishment. **Left** This shows the Japanese deities Fujin (the god of wind) with Raijin (the god of lightning and thunder). Their names are written in kanji (風神 and 雷 神) in the large round *mitsudomoe*, a popular symbol in Shintoism and throughout Japan. The triple *tomoe* mark has many meanings; in one interpretation, it represents mankind, the material world, and the celestial world. The comma-shaped tomoe is also said to represent curved ritualistic stones from ancient Japan (for more, see page 101). **Opposite, top** Punishment could be permanent. Here, a punitive tattoo is inked on as a lasting reminder. **Opposite, bottom right** The kanji here (南無大師遍照金剛, Namu Daishi Henjyou Kongou) is from esoteric Japanese Buddhism, and refers to praying to Koubou Daishi, who founded the mystic Shingon sect. The lotus (more on page 40) also has strong Buddhist associations. **Opposite, bottom left** *Tora* (虎) means "tiger." Due to the animal's position in the zodiac calendar and its symbolic associations, tora is a powerful kanji character that is popular in calligraphy.

returned, along with the slicing off of noses and ears—the latter a gruesome punishment that was no longer inflicted by 1720. Punitive tattoos, however, stuck around.

Irezumi became associated with crimes like fraud, extortion, or selling knockoff goods, as well as theft. Essentially these became a way to mark con men and to keep tabs on the lowest members of society. If anything, tattoos were perhaps another way the Tokugawa shogunate could solidify the country's feudal system and keep people in their place.

The idea was that tattoos could make offenders and undesirables stand out in society with a permanent scarlet letter that bled right into the skin and couldn't easily be taken off. The characters selected were like

giant billboards that screamed, "Stay away!" And the irezumi could not have been more obvious: The kanji for evil (悪, *aku*) was tattooed on criminals' heads in Edo (present-day Tokyo), while in one region of western Japan (present-day Wakayama Prefecture) the character was tattooed on the bicep. In Kyushu, there was a three-strikes system: The first was a tattooed horizontal stroke, the next was a curved stroke, and the final infraction saw the addition of another curved stroke and a dash, creating 犬 (*inu*, the kanji for "dog") in the middle of the forehead. In other parts of Japan, a large "X" would be tattooed above the offender's brow.

Not all the disciplinary tattoos were kanji inked smack dab on the foreheads of the poor offenders. There was also a complex system of lines and bars tattooed on

people's arms. As with the punitive forehead tattoos, the style of the abstract bars and stripes varied from region to region. This was because, although Japan was finally unified under the Tokugawa regime, feudal lords still ruled different parts of the country and carried out the law in slightly different ways. For example, in Kyoto, two lines might be tattooed on the bicep, while in Tokyo, two stripes around the forearm would be tattooed for the first offense. A third line would be added for the second offense. In the region of Japan known today as Yamaguchi Prefecture, the punitive tattoo was shaped like a diamond. In another region, it was a circle. Whatever the form, the message was clear: People with irezumi were bad news. The stigma of this punishment still remains. Even today, many tattooists in Japan will not tattoo the faces or foreheads of customers who live in Japan, because these markings cannot be easily hidden.

Imagine walking around 17th-cen-

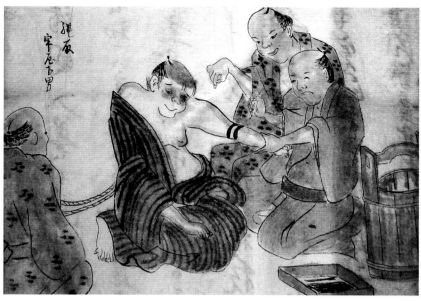

tury Japan with "dog" tattooed on your noggin. Similarly, imagine walking around modern-day Japan with "big mistake" or "ugly" written on your body. This is why horrible kanji tattoos inadvertently feel like modern-day punitive tattoos, where the crime is ignorance and carelessness. Those who want script tattoos need to be savvy.

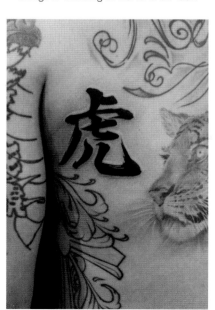

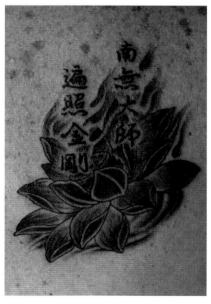

PLEDGE TATTOOS

Not all tattoos had negative connotations. They were also used to express ideas, feelings, and individualism that it sometimes felt like the ruling class was keen to stamp out. To maintain power, the Tokugawa government stratified society. It ensured that everyone knew their place by establishing dress codes—only certain classes were able to wear specific colors. Bound by Confucian ideals, priests and samurai were at the top of the heap, while the merchant class—despite its wealth—was below the farmers and artisans. Samurai protected the people, while field laborers and artisans produced food and goods. Merchants only made money, which Confucian society looked down upon. In the real world, however, cash-strapped samurai would increasingly need to borrow funds from the nouveau riche merchants.

Since Confucianism stressed the importance of filial piety, samurai were less likely to permanently mark

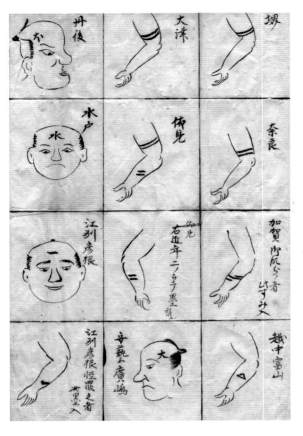

Left This sheet shows how various parts of Japan used different punitive tattoos. **Right** A lover's hand can be seen inscribing characters on a courtesan with a needle. **Opposite** For courtesans, their kimono, their musical ability, and their appearance were essential to their livelihoods. This hand-colored woodblock print, which dates from the 1660s, shows a courtesan playing for her lover.

Written Japanese
Hiragana, Katakana and Kanji

The written Japanese language uses four different writing systems. There are the two native syllabaries: the curvy *hiragana* and the angular *katakana*. Originally, hiragana was referred to as *onna-de*, meaning "woman's hand," as court ladies used the script to write poetry.

Today, the script is widely used by all Japanese, and the feminine connotations have subsided. Katakana was originally used by Buddhist monks, but these days it's largely reserved for phonetic renditions of foreign words and onomatopoeia. *Romaji*, which literally

a	i	ka	ki	sa	shi	ta	chi
あ	い	か	き	さ	し	た	ち
ア	イ	カ	キ	サ	シ	タ	チ

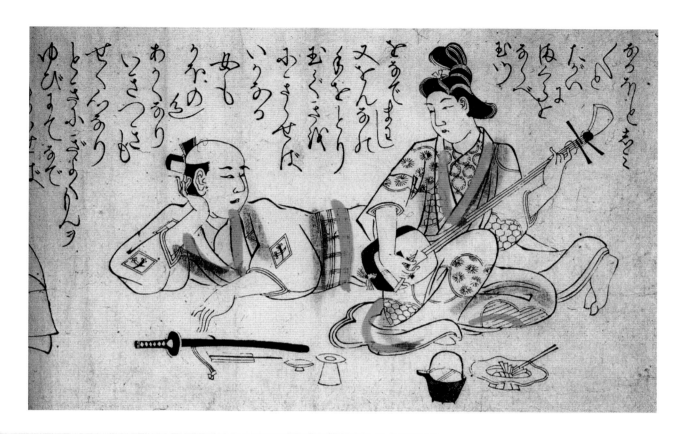

means "Roman letters," is typically used for company or product names and acronyms. Finally, there's *kanji*, the pictographic characters imported from China in the fifth century. Japanese uses kanji much like English uses Latin and Greek: as root words and linguistic building blocks.

In Japanese, each kanji character can have several different readings, and some kanji can sound the same, but have totally different meanings.

Opposite The curvy hiragana and angular katakana are Japan's indigenous writing systems. Small children first learn hiragana before learning katakana. After mastering both, they begin studying basic kanji characters, such as "*ichi*" (一, one) and "*yama*" (山, mountain).

For example, the Japanese word 花 (*hana*) means "flower," while 鼻 (*hana*) means "nose." Then there are the kanji that look similar, such as the character 人, which means "person" and 入, which refers to entering. This is where errors often arise in tattoos, with the incorrect characters being used.

The kanji used in modern China and Japan look different—so please, do not mix them! Mainland China uses simplified, modernized versions of kanji, while traditional kanji continue to be used in Japan (and also in Hong Kong and Taiwan). Japan also has its own homegrown kanji, called *kokuji* (国字, or "native script") that aren't used in China.

themselves, as it was considered disrespectful to parents. Tattooing was seen as defacing the body created by one's mother and father. However, that doesn't mean samurai always refrained from irezumi, whether it was a pledge tattoo or perhaps even the samurai's clan marking. It's said tattoos were sometimes used to identify fallen warriors whose bodies might have been stripped on the battlefield by scavengers. These irezumi served as rudimentary dog tags.

While Confucianism might not have been hip to tattoos, it did not equal puritanism. There were plenty of places for adult men to blow off steam, including the licensed pleasure quarters, where high-class courtesans would entertain clients. With marriage more like a business

Mottoes and Mantras
Japanese Sayings to Live By

Try to find Japanese idiomatic expressions, mottoes, or mantras that sound cool, instead of trying to shoehorn in some shoddy computer software translation of an English idiom. Japan has its own sayings, and many of them make suitable tattoos.

悪因悪果

AKUIN AKKA "Cause evil, create evil." This essentially means "You reap what you sow." The phrase encompasses Buddhist ideals of karma.

知者不惑

CHISHAFUWAKU "A wise person doesn't waver." Quoted from the *Analects* of Confucius.

千代

CHIYO "A thousand years." This tattoo can be seen in a mid-19th-century woodblock print by the artist Munehiro Hasegawa. The kanji can also be written as 千世. Another option is 千代に八千代に (*chiyo ni yachiyo ni*) or, loosely, "For eternity."

出たとこ勝負

DETATOKO SHOUBU This means "leaving things to chance."

一期一会

ICHIGO ICHI-E Literally "one time, one meeting," this phrase has been translated as "once-in-a-lifetime encounter" or even "Treasure every meeting, because it won't happen again." Steeped in Zen Buddhist notions of transience, the centuries-old phrase even appeared in the Japanese title of *Forrest Gump*.

命

INOCHI "Life." There is a historical precedent for putting a lover's name in front of this kanji—for example, 上田様命 (*Ueda sama inochi*, or "My life for Mr./Ms. Ueda.") There are also reports of tattoos with the lover's name in front of the phrase "My whole heart for my whole life" (一心命 or "*isshin inochi*") during the Edo period.

確乎不抜

KAKKOFUBATSU Determined or steadfast. Quoted from an ancient Chinese text.

起死回生

KISHI KAISEI To come back from a hopeless situation. Be aware that this is actually the name of a move in mah-jongg as well as in *Pokémon*.

南無妙法蓮華経

NAMU-MYOUHOU-RENGE-KYOU "Hail Lotus Sutra," from one of Buddhism's most important teachings, the Lotus Sutra.

南無阿弥陀仏

NAMU-AMIDA-BUTSU "I sincerely believe in Amida Buddha." Chanting this prayer can lead to rebirth in the Pure Land.

七転び八起き

SHICHITENHAKKI or **NANAKOROBI YAOKI** Literally, "Fall down seven times, stand up eight times." In short, don't give up. Be aware that when tattooed, the endings "*bi*" (び) and "*ki*" (き) are often omitted, leaving just these four characters: 七転八起.

七生報国

SHICHISHOU HOKOKU Loosely, "Seven lives of patriotism," indicating an undying devotion to one's country. The phrase continues to have strong nationalistic connotations, but originally appeared in the 14th-century Japanese text *Taiheiki* in reference to the Buddhist concept of being reborn several times, and is associated with reverence for the emperor. In 1970, when writer Yukio Mishima tried to stage a military coup and restore the imperial throne to power, he wore a bandana bearing this motto. Mishima was unsuccessful and committed ritual *seppuku*.

その日を摘め

SONO HI WO TSUME Literally, "to pick up or hold the day," equivalent to *carpe diem*. The phrase いまを生きる (*ima wo ikiru*), also translated as "carpe diem," is the Japanese title of the film *Dead Poets Society*. Unless you are a huge fan of that movie, perhaps this phrase is best avoided. Japanese people would probably be more inclined to get the original Latin text instead of its Japanese translation.

雲散霧消

UNSAN MUSHOU "Scattering clouds, disappearing mist," or "to vanish without a trace." Also translated, however, as "going up in smoke."

我事において後悔せず

WAGAKOTO NI OITE KOUKAISEZU "No regrets," or literally, "As for personal matters, have no regrets." This was written in 1645 by swordsman Miyamoto Musashi, a week before he died, in his collection of maxims titled *Dokkoudou* (The Path of Self-Reliance). Other doozies in the same work include 身を浅く思い、世を深く思う (*mi wo asaku omoi, yo wo fukaku omou*, "Consider yourself lightly, think of the world deeply"); 善悪に他を妬む心なし (*zen aku ni ta wo netamu kokoro nashi*, "Don't be jealous of others' good or evil"); and 身を捨てても名利は捨てず (*mi wo sutetemo meiri wa sutetezu*, "Even if you abandon your body, do not cast aside your honor").

Right, above The character *myou* (妙) has a variety of meanings and connotations, including, "unusual," "mysterious," or "odd," and even "excellent," superb," or "skilled." **Right, below** The phrase 愛のこくはく (*ai no kokuhaku*) literally means "confession of love."

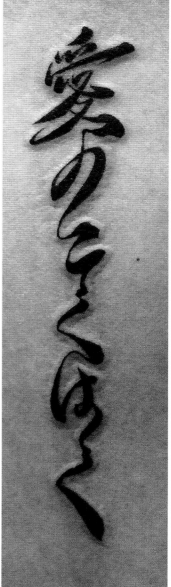

How to Get a Good Kanji Tattoo
Five Important Tips

Above Kanji calligraphy can be written in a variety of styles. This scroll was exhibited at a museum in Kagoshima, Japan.

Kanji are beautiful and can make meaningful tattoos. The key is to make sure not to end up with the equivalent of modern-day punitive ink. Here's how to avoid that:

1. Check the Kanji

The internet is littered with characters that "look" like kanji, but are actually utter gibberish. Or, if they are kanji, they might be backwards. Or upside down. Or missing a stroke. Remember that 大 means "large" and 犬 means "dog." That's one dash away from disaster. Sometimes, bad kanji tattoos also split up single characters into two separate ones, rendering them utterly meaningless; or flip them, turning the characters backwards. If you are trying to get an English word into Japanese, then it will be written in the phonetic katakana and not kanji. For example, "Brian" is ブライアン ("Buraian") and "Ben" is ベン (literally, "Ben").

2. Check the Tattooist

Outside of Japan, many tattooers will not know how to read and write kanji. Each kanji character has a set stroke order, which typically goes from top to bottom, moving left to right. Things like how the kanji are balanced visually are key. The characters are not written willy-nilly! Japanese calligraphy, or *shodo* (書道) requires years to master the written language's emotive and beautiful

strokes. That being said, some kanji characters are difficult for native speakers to write, and even some Japanese tattooists are not confident enough in their own calligraphy to work freehand, preferring to work from templates, or fonts. A talented tattooist, whether he or she understands Japanese or not, will be able to render even the most complex character if working from correct reference material. While, in the least smarmy way possible, it's not a bad idea to ask the tattooist if he or she can write Japanese, perhaps the best thing is to look at work that the tattooist has done or bring in accurate reference material for your tattoo.

3. Remember, a Kanji Tattoo Is Not Just a "Design"

Keep in mind that people who know Japanese might see your tattoo. While a tattoo of a samurai with "samurai" (侍) written in Japanese characters might sound cool, be aware that it is akin to getting a skull inked with "skull" written below it in English. Something like *bushido* (武士道, "way of the samurai") might be a better choice. When selecting a phrase, try to think of how you would feel if saw someone with an English tattoo that read "Water" or "Fire." Simple words or adjectives might look odd to Japanese, who tend to get either mottoes, names, or prayers inked on

their bodies (see examples on page 15).

4. *Don't Use Machine Translations*

While translation software continues to be important, and may be handy for giving you a vague idea of what you are reading on a Japanese website, it isn't perfect. Idiomatic expressions and nuance get lost in translation, and you'll end up like the guy who wanted a tattoo of "freedom" in Japanese, but ended up with 無料 (*muryou*, or "free of charge"). And yes, he paid for that tattoo.

5. *Do Your Research*

You are getting a Japanese script tattoo, so how about hitting up your local library? Or bookstore? Or looking online? Or checking with someone who knows Japanese? Sure, while acting on impulse is fun—and is certainly part of the Western tradition—foreign-language tattoos should have a tad more preparation, understanding, and context. For example, it might seem cool to get a tattoo that says "ronin" (浪人, a masterless samurai), but realize that today, the word also refers to students who didn't pass their university examinations.

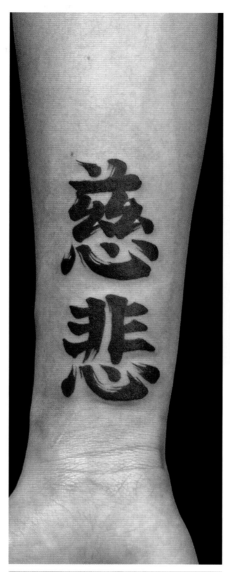

Left, above *Jihi* (慈悲) is translated as "mercy," "compassion," or "benevolence." Both kanji contain *kokoro* (心, "heart"), underscoring the word's intrinsic meaning while also making for a balanced set of characters. **Left, below** *Chouetsu* (超越) is "transcendence." **Below** *Itaidoushin* (異体同心) is often translated as "same mind, different body."

partnership than a romantic arrangement, the late 1500s saw the pleasure quarters rise in Kyoto and Osaka (and later, in Tokyo's Yoshiwara district), creating a venue for proclamations of love and pledges of devotion. Sex wasn't always the main object; if the clients wanted that, they could always frequent the unlicensed prostitutes for a far cheaper experience. High-class courtesans had the right to refuse johns they weren't into, so clients would primp to look their best, buying new kimonos and carrying new swords just to impress the ladies. Once the client became a regular patron, he forfeited his right to see other courtesans. Violating this understanding could result in a beating by the brothel's muscle.

Against this backdrop, a declaration of fidelity was important for both the client and the courtesan—for the

Ancient Bonji Characters
Esoteric Buddhist Calligraphic Writing

Originally from North India, *bonji* are ancient calligraphic characters that are used to write Buddhist mantras in Sanskrit; they were influential in the development of hiragana and katakana in Japan. Bonji characters have mystic powers and continue to appear in esoteric Buddhism, most notably Japan's Shingon ("True Word") sect. In tattooing, bonji irezumi for the zodiac animal of the year in which one was born are common.

Right Bonji can be found throughout Mount Koya, a sacred site located outside Osaka. Since the ninth century, the area has been the center of esoteric Japanese Buddhism. **Below** Birth-year bonji are common irezumi motifs.

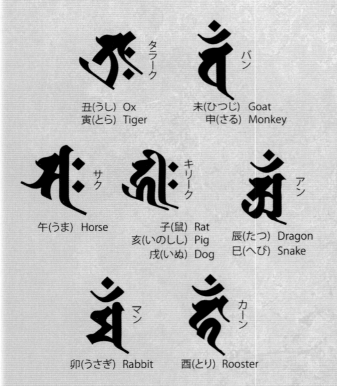

タラーク
丑(うし) Ox
寅(とら) Tiger

バン
未(ひつじ) Goat
申(さる) Monkey

サク
午(うま) Horse

キリーク
子(鼠) Rat
亥(いのしし) Pig
戌(いぬ) Dog

アン
辰(たつ) Dragon
巳(へび) Snake

マン
卯(うさぎ) Rabbit

カーン
酉(とり) Rooster

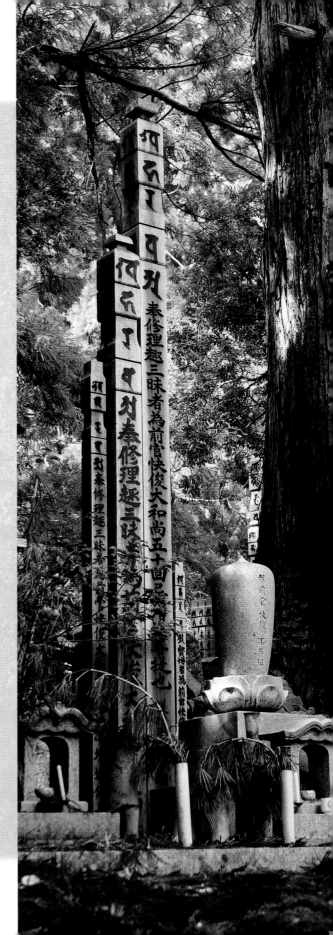

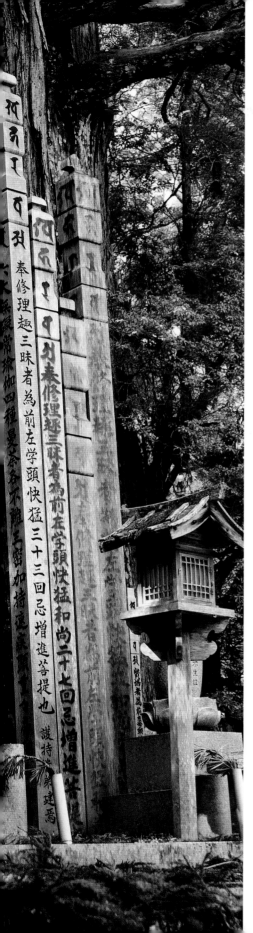

client, it could mean bragging rights; for the courtesan, it could be a way to string a customer along. A love pledge sealed in blood, or even a lock of the woman's hair or her clipped fingernail were most common, but among the lower-class courtesans, there were stories of working girls cutting off a finger for a lover or a client. Today, finger-cutting to make up for mistakes is part of yakuza lore, and there is even a Japanese children's equivalent of the pledge "Cross my heart, hope to die" that involves chopping off fingers! However, the ultimate declaration of permanent love was a tattoo. It was a way for clients to leave their mark—literally.

The decorative tattoos that increasingly began to appear by the late 1600s weren't yet the elaborate pictorial designs of flowers and fauna Japan has become famous for, but vows and pledges. Moreover, the early pleasure-quarter tattoos weren't done by artists, but rather by the courtesans themselves or their prized clients. These early tattoos were abstract, and would later evolve into written words and phrases.

First appearing in the pleasure quarters of Osaka and Kyoto, *irebokuro* (入れ黒子, literally, "inserted moles") were dots tattooed above the thumb on top of the hand. When that tattooed hand clasped another tattooed hand, the matching dots would interlock, creating a romantic way to hold hands—a secret proof of devotion in an age when marriages were not always for love, and passion was found elsewhere. And there was one courtesan who got an array of dots on her elbow—the same number as her lover's age. (No word on whether or not she updated the tattoo on an annual basis, though!)

Below Kanji tattoo designs can also be made to look like the carved stamps people use as official seals. **Middle** This piece is based on an ancient style of kanji that isn't used as writing in modern Japan. **Bottom** Out of all the bonji, this character appears twice on the Chinese zodiac calendar and represents three birth years: The Year of the Rat, the Year of the Pig, and the Year of the Dog.

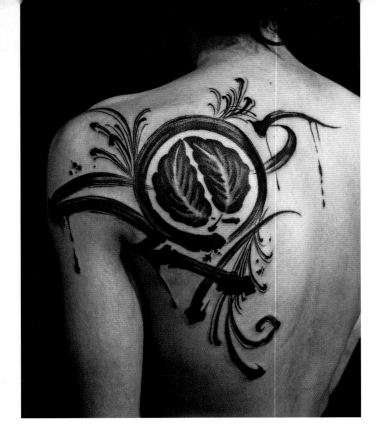

Left Many Japanese families have their own coat of arms. Here, a family crest represented by a pair of oak leaves is embellished with expressive brush strokes.

Then there was one courtesan who figured out that perhaps letting a customer write his name on your shoulder was bad for business, and supposedly had her customers' names inked between her fingers instead. There were also courtesans who tattooed moles or beauty marks on their faces, as well as replacing their eyebrows with ink in an early form of permanent makeup. In Osaka and Kyoto, irebokuro were wide-spread enough among the courtesan subculture that the term itself was used to refer to all tattoos.

Other examples of vow tattoos (起請彫り, *kishoubori*) include clients writing their names on the courte-san's shoulder or thigh with a brush, and then piercing the skin and rubbing in ink to create a permanent mark. The kanji for *inochi* (命, "life") would also be added after a lover's name to say "My life for so-and-so." This was another bold proclamation of affection, with the length of the last

stroke representing the strength of the pledge.

The highest-ranking courtesans were unlikely to get tattoos. Like samurai, many adhered to the Confucian ideals common at the time—namely that an individual receives their body from their parents and, out of filial piety, it should not be desecrated with permanent markings. These pledge tattoos were not part of daily life for the majority of men and women at the time, but were part of the country's burgeoning underground subculture.

With the increase of passion-driven tattoos, there were bound to be mistakes; moxibustion techniques using dried leaves were developed to burn and blister out unwanted tattoos, leaving a scar to mark a love gone sour. Some pleasure-quarter patrons would apparently try to get courtesans to remove the names of other lovers and have theirs inserted instead.

These melodramatic love tattoos

were, in a small, permanent way, more than hot-blooded expressions: they were acts of rebellion against a domineering and stratified society that was bent on exercising control, even if it failed to always do so. Tattoos were personal and private, offering freedom and expression. They were a perfect way to raise a middle finger at the country's Confucian morals.

Not all script tattoos were pacts between lovers. There were also religious pledges and personal mottoes. Just like today, early irezumi enthusiasts—artisans, actors, gamblers, or the roving weapon-wielding chivalrous men known as *otokodate*—wanted those words to live by with them at all times, whether they were proclamations to God or a simple turn of phrase.

The motivations haven't changed. Today, while bad kanji tattoos are mocked online as marks of shame, good ones are anything but, showing the grace and gravitas of the script itself. Yet as the 1700s gave way to the 1800s, Japanese tattoos would make a remarkable transformation: going from "scarlet letters" to designs of beauty that evoked fear and awe. This corresponds to the rapid success of Japanese woodblock prints from the seventeenth to nineteenth centuries—a golden epoch in mass-market art. Art was flourishing not only on paper, but also on the skin. Embarrassing punitive tattoos would be covered up and embellished with decorative designs and symbols, and Japan's pictorial tattoo tradition would flower.

The Tebori Tradition

Often called "hand-poked" in English, tebori (手彫り) is Japan's traditional method of tattooing.

Today, some tattooers in Japan, including some of the country's most famous, prefer the tattoo machine to tebori—as do many Japanese irezumi enthusiasts—simply for the amount of time it saves. But others, like Hori Magoshi of Osaka (now known as Hori Shige V), carry on the tebori tradition.

Tebori uses a tool called a *nomi* that is made from a slender piece of bamboo; needles, called *hari* in Japanese, are affixed with tightly wound silk string at the tip. The tool sometimes has a grip at the end for the tattooer to hold while inserting the ink. Horiyoshi III developed a steel nomi with needle tips that can be easily removed and sterilized. Hori Magoshi, however, makes his tools with bamboo, needles, silk string, and glue. He must sharpen the tattoo needles for each client, and spends between 20 and 30 minutes making each tool.

"For shading, I usually make tebori tools with 27 needles, and for coloring, I make tools with 18 needles," says Hori Magoshi, adding that number of needles can change depending on the tattoo. Besides crafting his own tools, he also mixes his own ink from pigment.

"This way of working makes my prep time much longer," he says, "but I feel like it brings me closer to irezumi." Even if the color and shading is done by tebori, Hori Magoshi still does the *sujibori* (outlining) with a tattoo machine, saying, "It's much smoother and takes far less time."

TYPES OF TEBORI

Tebori is the general catchall word for tattooing done by hand. Within tebori, there are different styles based on the way the tools are held or the way ink is inserted.

HANEBORI A tebori technique often used for shading, in which the needles are inserted in the skin and then slightly flicked upward while the tool is pulled back. This widens the puncture wound, allowing more ink to enter the skin and, as a side effect, causes more bleeding.

IMOTSUKI A style of tebori that inserts ink in a rhythmic up-and-down motion similar to that of a tattoo machine.

SHAMISENBORI A nearly extinct style of tattooing that uses needles affixed to the flat end of a handle resembling a shamisen pick. The tool is held like a pencil and the ink is inserted in an upward-moving motion. For more details, see page 143.

TSUKIBORI "Tsuki" means "jab" or "stab"; this technique uses such a motion to insert ink into the skin, typically with a long tebori tool. Unlike hanebori, there is no upward-flicking moment. This is simply puncturing the skin with a tebori tool.

Top Hori Magoshi prepares his tools for a client. **Above left** Ink is inserted into the skin one poke at a time. **Above right** The tools of the trade.

TATTOOIST PROFILE YUTARO SAKAI

A JAPANESE TATTOO WARRIOR WITH SAMURAI SPIRIT

"I was worried about getting a dishonorable discharge," says Yutaro Sakai. With only three more months left in the Japanese Self-Defense Force (Japan's military), Sakai got a Virgin Mary tattooed on his chest. He raises his hand, which is now covered in permanent ink, and clenches it. "It was the size of my fist."

Yutaro has since left his native Japan, making a name for himself in California, where he is known for his takes on classic Japanese motifs. It's late now; San Francisco is covered in night, and the big studio is empty save for the 42-year-old Yutaro, who sits in a black swivel chair next to his stainless-steel desk.

On the palm of Yutaro's right hand, there are four characters: 刺青戦士 (*irezumi senshi*, or "tattoo warrior"). Showing the tattoo, he says, "Grime did this for me." Grime owns Skull

and Sword and is perhaps one of the best-known contemporary American tattooers. On Yutaro's left hand, next to a teardrop, there are two more inked characters: 侍魂 (*samurai tamashii*, "samurai spirit"). Yutaro adds, "I'm always fighting for myself to get better and trying to push tattooing forward." The samurai spirit is what powers that fight.

Growing up in Chiba, outside of Tokyo, Yutaro didn't come across irezumi as a kid. "When I was a teenager, I'd hang out at motorcycle

shops in Japan, and lots of the bikers had American-style tattoos," he says. "I thought those were really cool, and I was very much into Western culture and foreign things."

Unlike service members in military forces in countries such as the U.S., those in Japan are not allowed to get tattoos. In order not to get caught, Yutaro had to cover up his fist-sized Virgin Mary with a bandage. Things got trickier when he got two more tattoos. "I wasn't the kind of kid who was always drawing at school, but the moment I got that first tattoo, I thought, 'I could do this as a job—I want to do this,'" Yutaro says.

After an honorable discharge, he made the leap to the U.S. He found himself at a sushi restaurant in Oregon, washing dishes for ridiculously low pay. Hoping to tattoo, he quit his job, spent his savings on a Harley, and rode down to California, sleeping outside along the way. He knew a tattooer in Japan who had

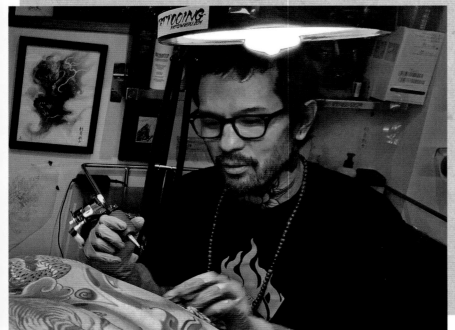

Left Starting in 2016, Yutaro is slated to begin tattooing at Seven Doors Tattoo in London.
Opposite, bottom Noh theater masks are paired with cherry blossoms and maple leaves, which represent the transition of seasons.

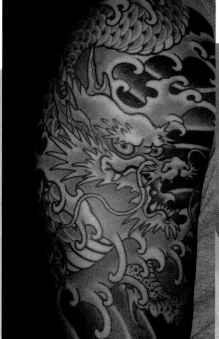

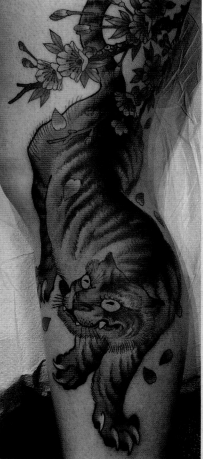

Above and right A dragon among waves and a tiger among spring flowers. Yutaro's work shows a deep understanding of Japanese themes.

apprenticed in Venice Beach. Covered with dust and totally ripe after not bathing for days, Yutaro walked into that shop and said in broken English, "Please teach me tattoo."

That was more than two decades ago, and he has lived in the U.S.—mostly California—ever since. The relaxed rhythm at which Yutaro speaks, his accent, and his general mood all make him seem like a native. "I say I'm half-Californian and half-Japanese," he quips.

While Yutaro is now known for large classic designs, like Hannya masks (see page 112), koi (see page 73), and tigers (see page 68), back when he was just starting out, he cut his teeth on kanji tattoos. He recalls, "Tattooing kanji characters was a great way to get experience, because the characters generally don't have a background, and since they're black, they don't require color work." This helped him get used to tattooing on

human skin, a totally different medium than merely drawing on paper. "But some difficult kanji that aren't often used are even hard for

Japanese to read and write," he explains with a smile.

Understanding a language involves more than merely knowing the correct stroke order or having the right brush flow. Yutaro pauses, running his fingers through his beard. "English is much more direct that Japanese, because 'yes' means 'yes' and 'no' means 'no.' But in Japanese, 'yes' can mean 'no.'" There's a difference between simply tracing characters or letters and having a deeper understanding of what they actually mean. "Whether you are doing kanji or even English language calligraphy, it's important to know how the characters or letters work."

Just as Yutaro got into tattoos via American biker culture, Westerners often get interested in tattoos via kanji and other Japanese motifs. "I think the reason is that the grass is always greener," Yutaro says. "This is just my opinion, but for me, the human brain gets stimulated when it encounters things it doesn't usually come across on a regular basis." It's something Yutaro knows firsthand.

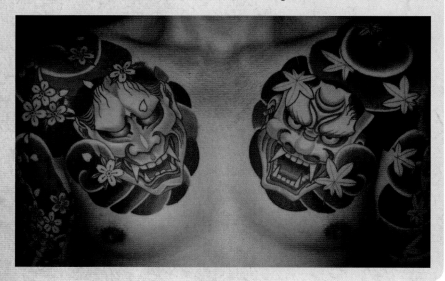

HIDADDY
HIP-HOP RAPPER AND MC

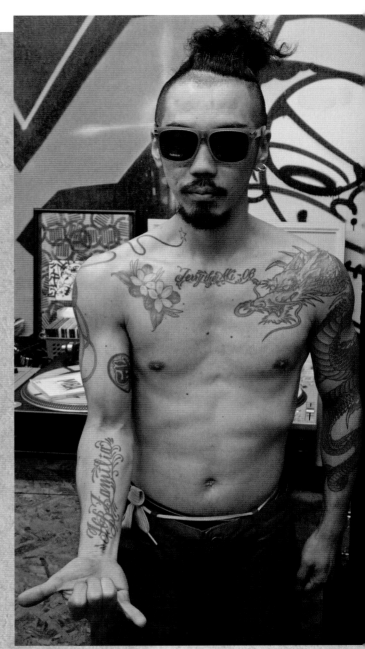

Running down Hidaddy's spine is a line of beautiful, flowing kanji script. It reads 韻踏合組合, or Infumiaikumiai (loosely, the Rhyme Stepping Association), the name of the hip-hop group he belongs to. Since kanji can be read from top to bottom, tattoos running down the spine are popular, with the column of bones symbolizing one's true essence. "I got it on my back because I want to keep carrying the group until the day I die," Hidaddy says. Infumiaikumiai debuted in 2000 and released its seventh album in 2014. When not cutting a new track with the group, Hidaddy competes in freestyle rap battles, runs his own clothing line, and releases solo albums.

Hidaddy's tattoos show how rap music has been absorbed by Japanese culture. On the bottom of his foot, he has another kanji tattoo that reads 韻 (in, or "rhyme" in Japanese). Due to constantly peeling skin, the bottom of the foot is hardly an ideal place for a tattoo. But this is a linguistic pun, because to rock out rhymes in Japanese is literally to step on them. "I got this because I'm always stepping on rhymes on stage," he says. "Part of the tattoo has started to vanish, but man, the whole thing's not going to disappear!"

Over his shoulder blades, the word "Rhyme" is inked in English, with the letter y cradled by a skull. It's a collaborative piece: well-known Japanese graffiti artist Casper designed the text, while Osaka-based tattooist Hori Wataru designed the skull and did the tattooing. "The design means that my weapon of choice isn't my fist, but words and rhyme."

There's a crest on Hidaddy's legs with the kanji for one, two, three (一, 二, 三), which can be read as "ichi, ni, san" or as "hi, fu, mi"—the name of his clothing line and boutique, Hifumi Shop. "Hifumi," points out Hidaddy, "rhymes with infumi, the Japanese word for rhyme."

On the inside of his arm, cursive writing in Spanish reads "HB Familia." This refers to Head Bangerz, a spinoff group Hidaddy is a member of. The other members of the group got the same tattoo together on the same day. "Even

when we are not all together, when I look at the tattoo, I know we are still connected." A mic with a coiled cord is on Hidaddy's left arm, a reminder of his profession. Hidaddy says, "I thought adding a crown like LL Cool J has on his mic tattoo would be a bit much!" A dragon coils around his right arm for protection and power. "I love *Dragon Ball*," he confides.

Hidaddy's other tattoos are also deeply personal, like the symbol 武, or *bu*, which refers to the martial arts as well as the military. This tattoo is actually the logo for Master Mutaito's Training Academy, which appears throughout the *Dragon Ball* anime and manga series. It's also a character Hidaddy used in both his sons' names. His twin daughters, whose names both contain the kanji for jasmine (莉), got their own tattoo references: two pictorial jasmine tattoos on his chest, close to his heart. "I'm such a doting dad," he says. Directly above the flowers, in English cursive, a tattoo reads, "Terry The Aki–06." Says Hidaddy, recalling the late Japanese hip-hop and reggae artist, "Terry passed away in 2007, and this is a way for me to remember him, may he rest in peace," he says. "Even now, I want lots of people to hear his music."

As a rapper and MC, Hidaddy uses words, rhyming them and bending them to tell a story, create a mood, and express himself and his feelings. This love of language can be seen all over his body.

Left Hidaddy recording a track for an upcoming release in his private studio. **Far left** Hidaddy shows off his ink in front of the turntables at his clothing shop.

NATURE TATTOOS

FLEETING CLOUDS, BLOOMING FLOWERS, BREAKING WAVES, THE RISING AND SETTING SUN

Motifs inspired by the natural world have been the subject of poems, paintings, and, yes, tattoos, for centuries. Nature's transience can be captured permanently with a brush on paper or a needle on skin. *Irezumi*, however, do more than mirror seasonal or natural images: they reflect the person's life or attitude while underscoring the central theme and concept of the tattoo. In irezumi, nature is often what ties everything together. That makes sense; the same is true in real life.

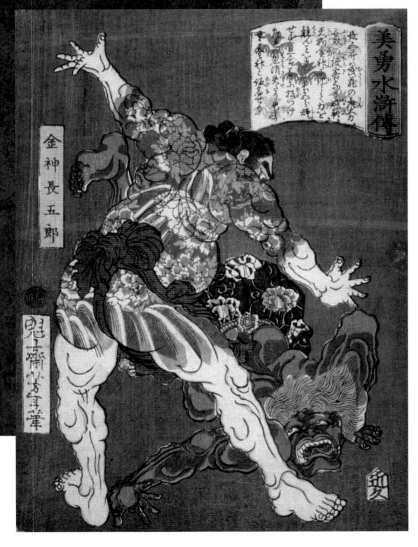

Right This early depiction shows a Japanese bodysuit solely composed of peonies and water.

THE COLORS OF IREZUMI

The first Japanese tattoos were dark. But by the early 18th century, the irezumi palette had expanded to what is considered its traditional color set: black and red, and all shades thereof.

The earliest dot and kanji tattoos were black. As irezumi became more elaborate, black continued to be the dominant color. In the hands of skilled tattooists, the color was incredibly versatile, and could be shaded to depict waves or clouds—and everything in between.

Red, with its solar connotations, remains one of Japan's most important—and oldest—colors. For example, *shu iro*, a shade of scarlet, was used to color clay figures from the Jomon period (14,000–300 BC). Red denotes the sun, as seen on the country's flag. That's why even today, Japanese children color in the sun with red, instead of orange.

Other colors came far later. By the Meiji era (1868–1912), blue-green (*shinbashi-iro*) was popular. Even after yellow and white were added to irezumi, they were used sparingly. White, for example, colored in dragons' eyes. There are stories of white lead being used to ink irezumi that would only be revealed when the skin was flushed after drinking or while in the bath. This practice, if it actually existed, hasn't survived in its original form.

Made with methods that ranged from boiling rags to mixing minerals like iron sulfate with rice paste, the irezumi colors of old were not as safe as modern synthetic inks—some of the colors, like the red made with green vitriol, could be toxic and cause fevers or rashes. Getting inked in red became a test of endurance and, for some, a display of machismo: The more red their irezumi had, the tougher they were. Modern tattooers who mix their own colors, however, use red pigments that are much easier on the body. As calligraphy ink wasn't ideal for irezumi, black pigment was instead made from lantern soot, a practice that continues today among tattooers in Japan who mix their own ink.

The colors now used in irezumi have a strong connection to nature, whether it's red symbolizing the sun, yellow with its earthy and religious connotations, or green and blue, colors that can be interchanged to represent water and creation. By combining or diluting these basic hues, different shades are achieved, bringing to life swirling clouds, crashing waves, or an array of seasonal flora.

NATURE MOTIFS

Though sometimes used as a central motif, flowers are typically paired with other design elements in irezumi, whether those are animals, mythical creatures, gods, or heroes from the past. There are important and logical rules about how nature should be depicted on the skin, with the most common and traditional being "Don't mix the seasons." Even today, this maxim is generally still followed in Japan, and it's a good rule of thumb. There are exceptions, but adhering to the rudimentary rules of irezumi grammar remains important.

The prevalence of flowers and

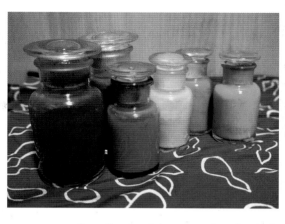

Above Glass jars of pigments waiting to be mixed.

leaves in irezumi should not be surprising. The same motifs appear on kimono, combs, tableware, and family crests—as they have for more than a thousand years. There's a lasting stereotype that Japan is one with nature—heck, even Vincent Van Gogh, who had never visited the country, enthused to his brother Theo how the Japanese "live in nature as if they themselves were flowers." It's a notion that the country seems more than happy to perpetuate, whether through art, poetry, or even its own currency, which sports floral motifs.

While the stereotype is just that—a stereotype—the importance of nature and the seasons in Japan is undeniable. Aside from the densely packed cities, this is a mountainous country that is largely covered in forests. Its indigenous religion, Shintoism, is centered around nature; its adopted religion, Buddhism, is filled with floral imagery. This is a country in which flowers and trees continue to carry the utmost importance, from the cherry blooms that herald the coming of spring to the pine branches that mark the New Year, and even to the chrysanthemum signifying the emperor himself.

CHERRY BLOSSOMS

In irezumi, the most popular seasons are spring and autumn. During these wonderfully bright and colorful in-between times, everything is in flux and either coming to life or beginning to wither. Capturing these fleeting, ephemeral moments makes them all the more powerful.

In Japan, nothing sums up the country's concept of beauty—or the country itself—better than the cherry blossom, or *sakura* in Japanese. Cherry trees bloom for short periods, peaking only for a few days, and then the blossoms fall to the ground or are washed away in a sudden spring rain. The entire country holds picnics called *ohana-mi* (お花見, literally "flower viewing"), a tradition that stems from an eighth-century aristocratic pastime. People eat, drink, and make merry with friends while soaking up the pink-and-white landscape. Other venerable spring rituals include picking and preparing flowers to be eaten so their power is transferred into the body. In a way, tattoos of spring flowers are an artistic

Left Horiyoshi III uses a rotary machine to ink a flurry of sakura around a dragon. **Below** Open cherry blossoms are contrasted with buds, creating a sense of time and movement.

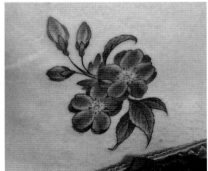

representation of this, infusing the body with the force of nature.

These days, as the TV news tracks the blooms' progress across the country, sakura are closely associated with new beginnings, whether that's the start of the new school year or even the commencement of corporate Japan's financial year, both of which begin in April. Comparisons between the sakura and feminine beauty are also common. Historically, however, cherry blossoms, with their brief bloom, have a decidedly masculine meaning, symbolizing the short life of a samurai warrior. This is perhaps why samurai clans rarely adopted the cherry blossom as their family crest or seal (known as a *mon* or *kamon* in Japanese), instead preferring flowers with longer-lasting blooms, such as the plum blossom or the chrysanthemum, or even vegetables like cucumber or eggplant.

The tough-guy associations continued through the 20th century. During World War II, for example, there was even a squad of kamikaze pilots dubbed *yamazakura*, or "mountain cherry blossoms." In the postwar years, the motif could be found in tattoos worn by members of the country's underworld, embracing the "live fast, die young" mentality.

What makes cherry blossoms so beautiful is precisely that they do not last forever. They fall and fade—as tattoos also do over time. They wither and die, just like the flesh. In Japan, this notion of impermanence is called *mujo* (無情). Besides being a key Buddhist concept, it's a central part of how Japanese traditionally view beauty and nature. The seasons change, you age, time passes, and life ends. Things, though, are born again and again. Like the seasons they

depict, irezumi are a powerful representation of mujo. Irezumi—all tattoos, for that matter—are only permanent as long as the body draws breath. They're far from a lasting form of expression compared to painting, sculpture, or music.

The awareness of these transitory phenomena in life is called *mono no aware* (もののあわれ) in Japanese, often translated as "the sadness of things." The cherry blossom isn't only beautiful when it's in full bloom, but also as its petals are swept up in the wind and scattered across the country, covering the earth that we tread with our feet.

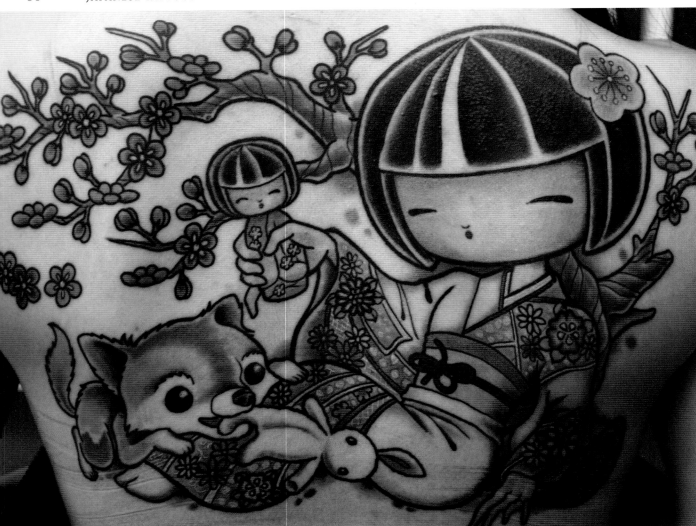

PLUM BLOSSOMS

Japan's favorite blossom wasn't always the sakura. In the eighth century, the *ume* plum blossom, which was imported from China, was all the rage. Immortalized in verse, it was the flower most lauded by poets of the day. Plum-blossom season in much of Japan is in February, when the weather is still cold, and the tree was praised for its fortitude and admired for its long bloom. People wore kimonos with plum-blossom motifs, and plum trees were planted in Nara, the capital, including at the

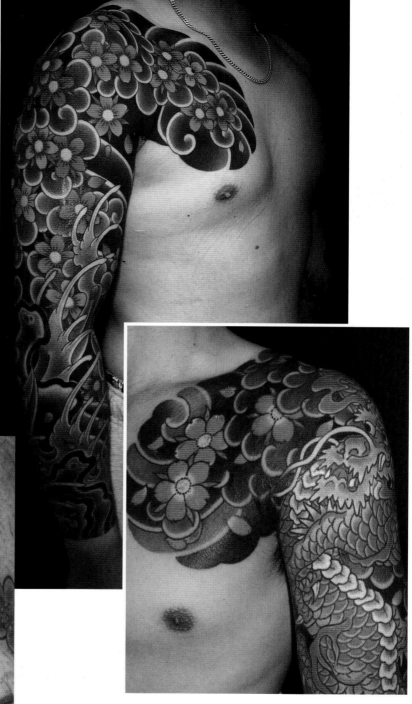

royal palace. But by the tenth century, with Japan increasingly defining its own national identity, the cherry blossom usurped the plum. Poets lauded the sakura, which grows wild in Japan, and even the royal palace replaced its blossoming plum tree with blossoming cherry. Still, the plum blossom has its devotees even today, and continues to evoke images of classical Japan.

In tattooing and in art, it can be difficult to tell the difference between a plum blossom and a cherry blossom. Typically, the plum blossom is shown with rounder petals, while cherry-blossom petals are split at the tips. Also, plum blossoms are often—but not always—somewhat redder than the pink sakura.

Opposite, above Typically only the blossoms of the plum are depicted in irezumi, but here, the branches and trunk are incorporated. **Opposite, below** Plum blossoms come in a variety of hues, including white, red, and pink. **Top** It's easy to confuse plum and cherry blossoms. Here, an entire sleeve is composed of sakura. **Above** A closer look shows the cherry blossom's five notched petals. **Left** Though they are similar to sakura in color, plum blossoms have round petals.

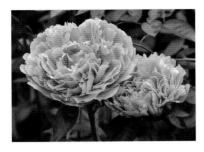

PEONIES

Each spring, the cherry blossoms return, brilliant and beautiful as ever. Given their associations with rebirth and life's fragility, it's no accident that Japanese Buddhists embraced cherry blossoms; temples often planted sakura on their grounds. The religion itself makes much use of flower imagery, including the peony, called *botan* in Japanese. The *hosoge*, an imaginary Buddhist flower, is even modeled after the peony. Its imagery is also found in designs at Shinto shrines.

In China, as in Japan, the peony is called the King of Flowers, with connotations of nobility, honor, and beauty. Legend states that more than a thousand years ago, a Chinese empress known by an unfortunate name that translates as "Horse-Faced Lady" prayed to an enormous statue of Kannon, the goddess of mercy, located in faraway Japan at a Buddhist temple in Nara called Hasedera. Horse Face's wish was granted, and she became a ravishing beauty. The now-stunning lady sent peony trees to the temple, cementing the peony's image as one good-looking trope. Today, Hasedera is famous for its peonies and sakura, and is known as the Temple of the Flowers.

Peonies were imported from China for their medicinal purposes as well

as for their aesthetic beauty, and the healing associations only made the royal flower all the more auspicious. In irezumi, peonies are paired with *shishi* (guardian lions, see page 70) not only because both hail from China, but also because there's a story that a shishi was cured of illness by eating a peony. The flower can be paired with tigers, too. Like the peony, that animal came to Japan from China, and also has medicinal properties.

Several varieties of peony are cultivated in Japan, including winter peonies that bloom in the cold, as well as the more common tree peonies, which bloom in spring and early summer. In irezumi, the peony can be a standalone motif, but it's also sometimes paired with the sakura, with both flowers complementing each other: Cherry blossoms, which represent spring in Japan, have a short bloom period, as

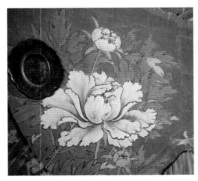

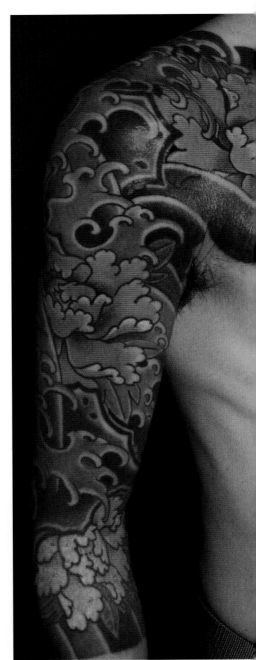

Top left Peonies are larger than many other flowers. **Above** The color of peonies varies widely both in real life and in irezumi. **Left, above** A Japanese sliding door decorated with a hand-painted peony. **Left, below** In tattoo designs, the peony's green leaves are just as important as the flower's petals for flow and balance.

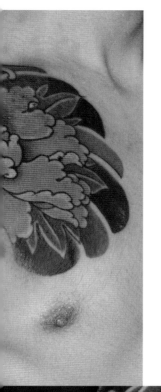

do peonies, which represent spring in China. Moreover, peonies and cherry blossoms are both used as imagery in the Pure Land branch of Buddhism, where botan is associated with paradise and sakura has the power to draw in believers' spirits. Pairing the blossoms together in a tattoo can give the work a religious nuance. Buddhism is rife with floral imagery, whether it's the Pure Land sutras that are full of blossoms or the lotus on which the Buddha sits. But keep in mind that both flowers are also strongly associated with gambling because of the floral-print card game *hanafuda* (see page 43).

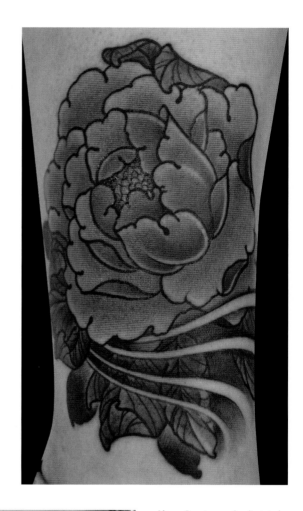

Above Peonies can be depicted in a variety of different ways. **Far left** Monotone backgrounds contrast sharply with the peony's vibrant colors. **Left** Here, the peony's petals are meticulously balanced in a minimalist style.

THE LOTUS FLOWER

This flower is a symbol of purity. Since it sprouts from muddy waters, the lotus shows that beauty can come from unexpected places. Rich with divine symbolism, it also represents enlighten- ment. In irezumi, the lotus flower is typically paired with Buddhist imagery, whether as a floral throne for a Buddha or as a divine trope. Buddhas and bodhisattvas are usually depicted sitting or standing on the lotus flower as well as holding it. The lotus also makes a fine stand-alone tattoo.

Far left A lotus blooms in the sunlight. **Below** Sometimes color choices don't reflect actual reality, as is evident in the lotus flowers and Mount Fuji represented here; this creates a dynamic contrast with the real world. **Below right** Beauty is fleeting, as seen in these falling lotus petals.

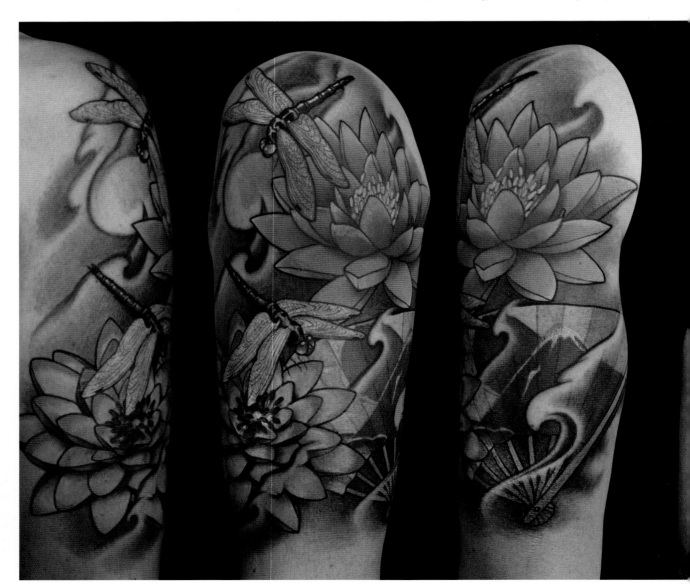

Above Lotus flowers depicted in three colors and in three stages give the illusion of time's passage.

Ikebana and Tattooing
Transient Art Forms

In English, *ikebana* is often referred to as the "Japanese art of floral arrangement," but this doesn't accurately convey what it really is. Long practiced by women and men alike, ikebana is written 生け花 in Japanese, literally "living" (生け, *ike*) "flower" (花, *hana*).

In both ikebana and tattooing, the artist works with life—the former with living flowers; the latter, living flesh. There are numerous schools of ikebana, each with slightly different approaches, but the vase is key. It's not just a container for holding the flowers, but part of the finished work itself; its shape reflects the season or the visual design of the arrangement. This is analogous to a client's body in tattooing.

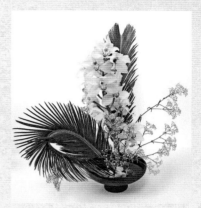

With its roots in Buddhism, a religion that gives great importance to flowers, ikebana, like tattooing, is a transient art. An arrangement does not need to be in full bloom to be considered beautiful. Some of the flowers in arrangements are purposely selected because they have yet to bud, while others are picked because they've already fully blossomed. With the passage of time, the arrangement's shape will change, much like tattoos change with time, until finally the flowers will wilt and die. Ikebana arrangements, like irezumi, are created with the implicit understanding that one day they will cease to exist, making our appreciation all the more pertinent.

Top Balance, color, and form are part of ikebana's beauty and simplicity. **Left** Like irezumi, ikebana continues to evolve. Here, Western flowers are incorporated in the presentation.

CHRYSANTHEMUMS

The chrysanthemum (*kiku* in Japanese), which also appears in the hanafuda card deck, begins blooming in September, when much of Japan is still unbearably hot. Originally imported from China more than a thousand years ago, the chrysanthemum, like the peony, was first used for medicinal purposes. Later, the yellow flower, with its radiant pedals, was compared to the sun and admired during fall chrysanthemum-viewing parties where participants drank wine made from the flowers. For a country whose imperial line is descended from the Shinto sun goddess Amaterasu, the chrysanthemum was a perfect fit. In the early 13th century, Emperor Go-Toba became enamored with the flower

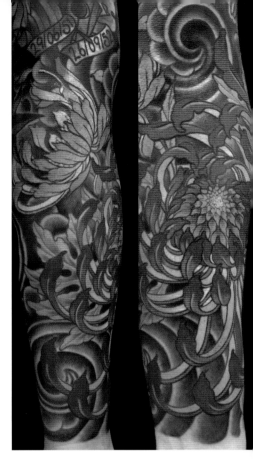

and had its motifs emblazoned on his kimono as well as his sword.

With its lengthy autumn bloom season, its perennial flowers, and its medicinal properties, the chrysanthemum symbolized long life, making it a perfect flower for an emperor intending a lengthy reign. In the 14th century, Emperor Go-Daigo used the chrysanthemum on his banners, cementing the flower's imperial status. The Japanese emperor, the oldest hereditary line in the world, today sits on the Chrysanthemum Throne, bears the Chrysanthemum Crest as the royal seal, and gives out the Supreme Order of the Chrysanthemum as the country's highest royal honor. All of these associations, from the longevous and mythological to the noble and nationalistic, have made the chrysanthemum a popular motif in Japanese tattoos. The flower is also used in funeral services in Japan, which is why it isn't typically given as a gift. It's also why some who live their lives on the edge get chrysanthemum irezumi, preparing themselves for death at a moment's notice.

Below The imperial chrysanthemum crest is called *kiku monshou* (菊紋章) in Japanese. **Bottom** The imperial crest appears on Shinto shrines throughout Japan.

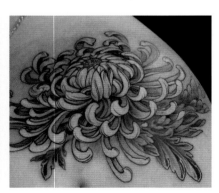

Above Just like people, flowers have faces. This chrysanthemum, located on the shoulder, faces up toward the sun. **Left** Simple color gradations are used to express depth and shape.

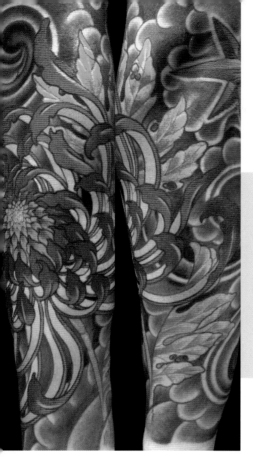

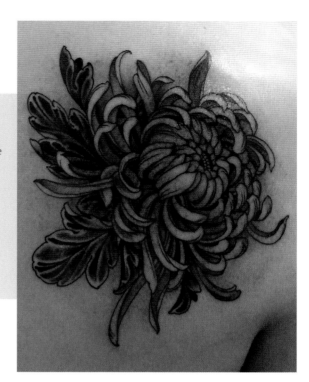

Right Even without color, the chrysanthemum's beauty is undiminished. **Left** The chrysanthemum's signature petals are especially accentuated here along the entire length of the arm.

Hanafuda Playing Cards
Here's the Deal

Hanafuda evolved after the Portuguese brought Western playing cards to Japan in the 16th century. Instead of being grouped in suits of hearts and spades or members of a royal court, the suits in hanafuda are flowers, like the peony and sakura, as well as the chrysanthemum, maple, and others. During the Edo period (1603–1868), hanafuda became increasingly popular, and like poker in the Wild West, it was a way rough-and-tumble men passed the time. Gambling added to the appeal of both the cherry blossoms and the peonies, flowers that already had a rich history with deep, evocative meanings.

According to some, the cards even inspired the slang for Japan's mafia: The word *yakuza* is said to refer to the worst hand in the game *oichokabu*, which is played with hanafuda cards. The hand "893" (or *yattsu*, *ku*, and *san*), became "yakuza," a term which was used to disparage betting men. Gamblers embraced the floral designs that appeared in hanafuda, often getting cherry blossoms and peonies tattooed on their bodies for luck, courage, and even simply good looks. Hanafuda cards themselves appear as motifs in irezumi, creating a playful pun: a visual depiction of a visual depiction of a flower.

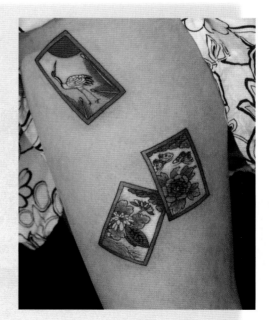

Above Hanafuda cards are evocatively fanned out across a thigh.

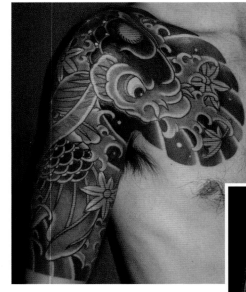

MAPLE LEAVES

Like the chrysanthemum, the maple has come to represent fall in Japan. This bright and colorful season, filled with harvest bounty, hasn't always had connotations of death and decay. Maple leaves, or *momiji*, were lauded by Japanese poets as early as the eighth century, and by the tenth century were second only to the cherry blossom in poetic importance. Before Japan slips into gray, white, and brown winter, autumn is also a last chance for a burst of color. Although maples turn both red and yellow, red maple leaves are the most common in tattooing.

Modern Japan still commemorates the fall season by watching the maple leaves turn—autumn's version of watching the cherry blossoms bloom, with the emphasis once again on the beauty of the passage of time and the transient nature of life itself. Following the long tradition of consuming seasonal plants, one city in Osaka Prefecture even batters and deep-fries maple leaves into delicious, crunchy tempura snacks. Tattooing goes one step further, inserting those brilliant red maple designs into the flesh.

Pictorially, maple leaves are incredibly flexible and can be depicted with a range of motifs, including various animals, fish, heroes, and deities. Fall leaves and flowers are also sometimes depicted with spring flowers in designs that completely break the "don't mix the seasons" rule. It's intentional and represents the entire year, making a harmonious pairing. Still, cross-seasonal collaborations are best avoided unless they are designed by a knowledgeable tattooist who can understand how they work thematically and thus do not clash. (Things get more complicated when animals and fish are inserted into the designs, which is covered in chapter 3.)

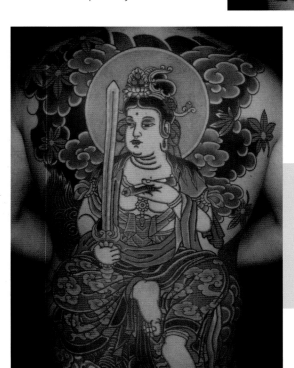

Variation in the maple-leaf colors shows nature's transience. **Left** A more placid expression of maple leaves adds to the tranquil nature of religious motifs.

Kimono Motifs
Wearing the Seasons

For centuries, kimono have let the Japanese wear the seasons on their sleeves—literally. As the temperature changes, so do the colors and patterns of kimono motifs.

During the Heian period (794–1185 AD), the upper classes wore elaborate multi-layered kimono, with colors and patterns swapped out month by month to correspond to whatever flower was in bloom or whichever leaves were changing color. In cherry-blossom season, for example, a white outer layer was accentuated by a pink inner layer, turning the wearer into a walking spring flower.

Some of the wealthy elite would mix in colors from upcoming months to show they were looking forward to a certain season; others could wear colors expressing longing for a past one. Meanwhile, the lower classes—the folks actually toiling away in the fields—worried less about whether their clothes matched poetic flowers and more about whether the harvest would be successful.

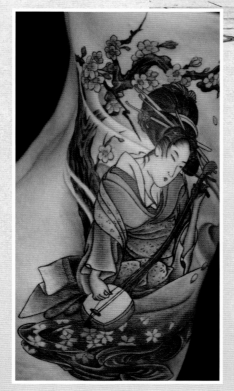

By the Edo period (1603–1868), even though the Tokugawa shoguns tried to control what people wore, rich and poor alike had access to seasonal kimono. People dressed not only in designs that alluded to spring, summer, fall, or winter, but also in styles that suited the seasons.

Like today, many people had four sets of clothing—one for each season—made from different materials and crafted in different styles to suit the weather.

The nature designs in irezumi are an extension of Japan's longstanding preoccupation with seasonal dress. They are another way people can express their appreciation and love for a span of time on the calendar. The key difference, of course, is that tattoos are a permanent way to reflect a particular season.

Above A woman wearing a spring-themed kimono carries a floral parasol. In Japan, the seasons aren't just worn—they are coordinated. **Left** A courtesan plucks a shamisen beneath falling blossoms. The flowers on her kimono echo those on the tree above her.

PINE TREES

The pine, a popular irezumi motif, is an evergreen, with fewer seasonal associations than other trees. It's often depicted representationally, with clusters of pine needles on a branch, or used as an abstract design element in irezumi backgrounds and borders. The evergreen needles symbolize long life, even immortality; the roots of pine trees were believed to be endless. Often planted at Buddhist temples, pine trees can also be found at Shinto shrines, because they are one of the natural elements that can serve as a *yorishiro*, an object that is capable of attracting Shinto spirits. Although pine needles and pine trees in tattoo designs are trans-seasonal, the tree does have strong winter connotations.

Right A rigid pine tree stands strong against the crashing waves. **Below left** Pine trees are often found in Japanese gardens. They are carefully trimmed and pruned to give them their unique shape. **Below right** Pine needles can be depicted in many ways. On this fan, for example, they are represented with simple lines.

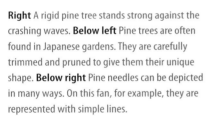

BAMBOO

Like pine, the bamboo can be depicted in any season, but is often used in winter imagery, as it's a symbol of the New Year in Japan. In January, bamboo and pine are grouped with the plum, starting the yearly cycle all over again. Originally from China, bamboo is strong, yet incredibly flexible and elegant. It grows faster than most other plants, sprouting a strong intertwined network of roots that hold the plant firmly in place and make a bamboo grove one of the safest places to be during an earthquake. Irezumi designs often pair bamboo with tigers (see more on page 68).

Right Known for its strength, bamboo lends power to the central tiger motif. **Below** Sunlight illuminates a dense bamboo grove.

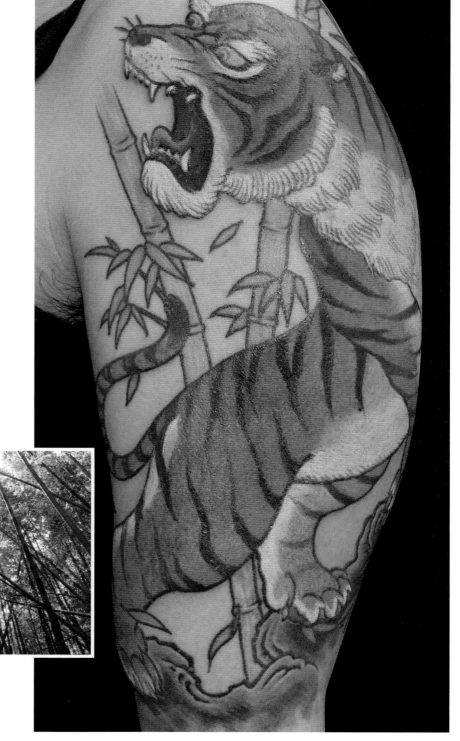

WIND AND WATER

Tattoo motifs of wind and water, like those of bamboo and pine, are trans-seasonal. They are often employed as unifying elements across the background of a tattoo. Connecting different tattoo elements with an overarching design is a defining element of Japanese tattoos; this is an important difference compared to Western tattoos, which traditionally are isolated images on the skin. Wind and water motifs make that connection.

Bokashi, or gradation, is an important irezumi technique tattooists use to depict elements like wind and water. The term "bokashi" is also used in traditional printmaking, which is no accident: Irezumi's blossoming in the 18th and 19th centuries corresponds with a boom in the popularity of woodblock prints. These prints often featured cloud, water, and wind motifs that had long been popular in Japan. Cloud and wind designs, for example, came to Japan by the mid-sixth century with the arrival of Buddhism from China. Water motifs also have a long history in Japanese art. For irezumi, color isn't necessary for depicting clouds, wind, or water, as all three are traditionally rendered in black, with gradation achieved by diluting the dark color. Tattooists can show their bokashi skills through these dark backgrounds, which then allow for greater contrast with the central motif.

Wind and water look very similar in irezumi; both are depicted with bar-like designs, traditionally in black. Depending on the main motif and the overall design, they can be placed on various parts of the body. What defines them as wind or water are the flourishes: Wind will have some swirls as well as puffy clouds worked in, while water has crashing waves, often with smaller wave fractals breaking from larger ones.

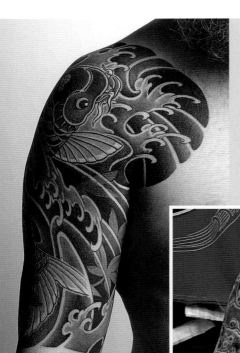

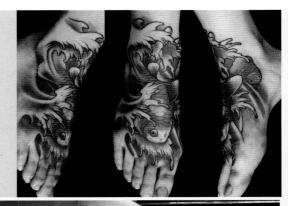

Left Soft color gradations and fractal lines give Japanese waves their distinct flow. **Right** Waves can be shown above and below the main subject to give a sense of depth. **Below** Curved bars and whirly puffs. Wind, like water, may be depicted in a wide variety of ways.

ROCKS AND EARTH

Not every irezumi is set in abstract clouds, waves, or flames. If the central motif is a human or a god, they may be depicted standing on solid ground. Rocks and earth provide a stage for large back-pieces, giving a real-world setting to the work.

Many of the rocks that appear in irezumi are based on *suiseki*, naturally occurring stones that are appreciated for their shape and beauty. The concept originally came to Japan from China, where these interestingly shaped stones are called "scholar's rocks."

Right Waves crash along rocks, while wind swirls through the sky. This is a dramatic composition that moves the viewer's eye throughout the work. **Below** While not necessarily seasonal, water suggests a springtime feeling throughout this design.

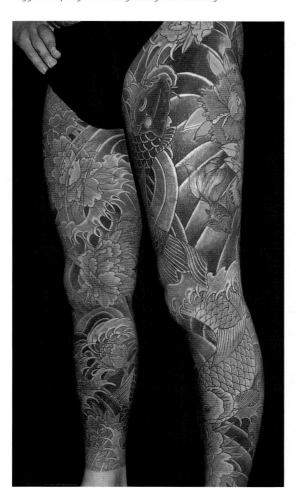

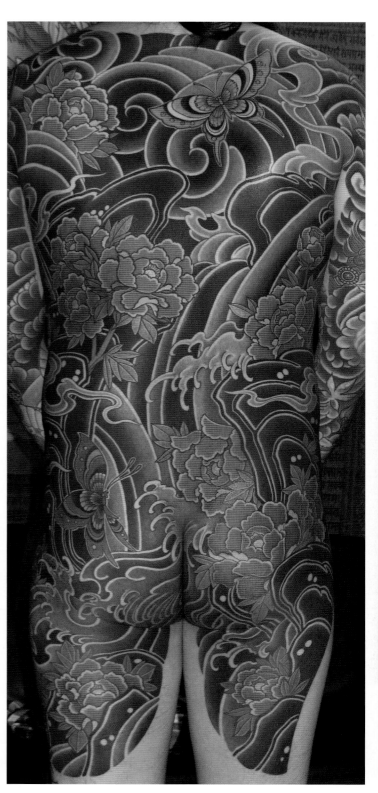

FIRE

In irezumi, fire often serves the same design function as wind and water. While fire is a natural element, it often carries mystical connotations in irezumi. In the Shingon Buddhist sect, fire represents purification, and priests burn cedar during fire rituals to cleanse negative energy. The Buddhist deity Fudo Myoo (see page 98) is typically evoked during these rituals. This explains why he's usually surrounded by flames in tattoo depictions. The flames not only make him appear even more ferocious, but also underscore notions of cleansing and purity. Stylistically, flames look similar to the fractal water designs found in irezumi, but they aren't depicted as crashing down like waves. Red was one of the first colors for irezumi, and thus was logically chosen to represent fire because of the strong contrast it made against darker tattoos.

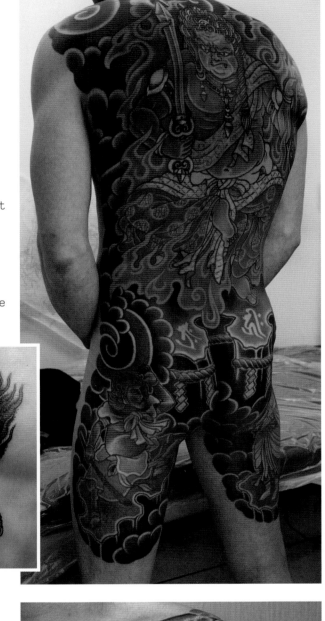

Far right Fire is both purifying and terrifying. Here, Fudo Myoo (see page 98) is engulfed in flames that are shaped like a mythical bird.
Right Flames surround this Buddhist sword, which is used to burn away sin and cut through ignorance.

THE SUN

In a country whose royal lineage is believed to descend from the sun goddess Amaterasu, sun imagery—be it the rising sun or the red circle—has appeared throughout Japan's history. It has also found its way into irezumi as a background motif, paired either with an animal or one of Japan's most recognizable symbols, Mount Fuji. Although the iconic mountain appears throughout Japanese prints and is an important part of national identity, it is not part of the standard irezumi canon, nor is it one of the most popular motifs. This should not dissuade clients from getting a tattoo of Mount Fuji; however, they should be aware of its place within the irezumi lexicon.

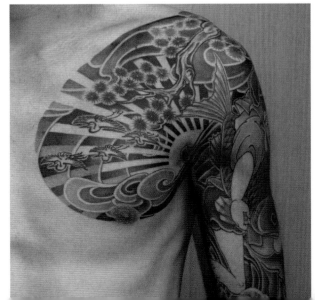

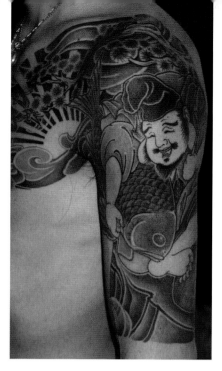

"Japan" is "Nihon" or "Nippon" in its native tongue, written as 日本, with the first character (日) meaning "sun." The flag, often called "the circle of the sun" (日の丸) in Japanese, did not become the country's official flag until 1870; however, samurai and feudal lords flew it in previous centuries—the oldest surviving flag dates from at least the 1500s. However, one ancient Japanese text puts the motif's first recorded appearance in 701 AD at Emperor Monmu's court. In late 13th-century depictions of the failed Mongol invasions of 1274 and 1281,

which nearly resulted in the conquest of Japan, samurai can be seen carrying sun banners and fans. The sun, as well as the chrysanthemum, signified more than royal mandate; it eventually came to define the entire country.

Opposite, bottom In this tattoo, the sunrays tie the central design together. **Left** In Japan, the rising sun design is not always used with military motifs. Here, the deity Ebisu (see page 97) snags a sea bream, Japan's most auspicious fish, under the early morning sun. This is why fishermen view the symbol as lucky.

The Rising Sun Flag Symbol
Auspicious or Outrageous?

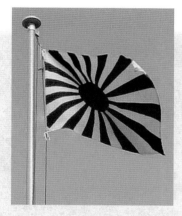

The Rising Sun Flag first became Japan's military flag in 1870. Prior to that, however, the design had appeared in the Edo period as an art motif. Today, the flag continues to be flown by the country's Self-Defense Forces, and the traditionally auspicious sunray motif pops up in a variety of designs in Japan, from the occasional food packaging to lucky fishing banners.

There is a history of the Rising Sun motif appearing in Japanese religious art, especially as a trope for the sun goddess Amaterasu. In one story, Amaterasu hid in a heavenly cave, plunging the world into darkness. She is depicted at the moment she finally emerged with rays of sunlight beaming from behind her head. The goddess is still

worshipped in Japan and, according to Shinto mythology, is said to be an ancestor of the emperor, explaining why images of the first legendary emperor Jimmu also feature the sunray design. Today, the imperial chrysanthemum, which appears on Japanese passports and as the symbol of Japanese royalty, echoes the sunray design. There are 16 crimson rays on the Rising Sun flag; likewise, the imperial chrysanthemum has 16 petals.

Those who get rising-sun tattoo designs do need to be aware that, because of the role of the Japanese military during its period of colonialism and World War II, the flag's motif is seen as offensive by some, especially in neighboring China and South Korea.

Flag or not, the rising sun itself remains incredibly important to the Japanese. Every January 1 many people pray and reflect as they watch the first sunrise of the year, which is called *hatsuhi no de* (初日の出). The event is broadcast on many news channels in Japan, which typically show the view from Mount Fuji, sunlight streaming everywhere. Thanks to the international dateline, Japan is one of the first countries in the world to view the sunrise. Those who see it look forward to the promise it offers for a new day and a new year.

TATTOOIST PROFILE GAKKIN

NOTES FROM THE TATTOO AVANT-GARDE

"It's easier to use fewer colors," says Gakkin. "Well, easier for me." Decked out in his trademark trilby hat, the 30-something-year-old Gakkin grins.

His Kyoto studio is on a side street near a leafy green canal. Inside, it's traditional Japanese chic. The walls feature photos of flower and animal tattoos Gakkin has done. On a shelf, there are about ten bottles of black ink next to two bottles of red; Gakkin gestures to the bottles, saying he recently got rid of all his yellow ink, too. A print of a lush, colorful landscape populated with every type of flower and bird imaginable hangs on the opposite site.

"I threw away all my colors so I can turn down doing colorful tattoos," Gakkin says. "It's not that I don't like color or color-work in tattoos. I do, and I don't think black is the best, but it works for me." Gakkin says he might change the way he thinks in the next five years. If Picasso had his blue period, Gakkin is in his black period.

It wasn't until Gakkin was a high-school exchange student in the U.S. and Canada that he saw tattoos up close. "Before that I had only seen them in movies," he recalls. "I don't remember the first design I saw, but it probably wasn't very good."

Back in Japan, Gakkin tried giving himself a tattoo. Not knowing exactly how tattoos were done, he used a razor blade to slash his chest and then rubbed in the ink. "It was big, really big," he says, gesturing. "I tattooed the words 'I am an antichrist, I am an anarchist,' you know, from the Sex Pistols song?" Gakkin's mom discovered her do-it-yourself tattooed son, covered in blood. "She was pretty cool about it, and even though she doesn't have any tattoos, she was like, 'That's not how you tattoo.'" So it was no surprise that after art school, Gakkin ended up as a tattooist. Thankfully, he's traded his straight razor for a tattoo machine.

"At home, I'm not one of those people who is always drawing," says Gakkin, who prefers to spend his free time with his family instead. "I like drawing on skin." His designs are done freehand on the flesh rather than on paper. "Working this way feels much more natural for me."

Using his dark palette, Gakkin is still able to tattoo anything he wants—from avant-garde shapes and mythical beasts to flowers. If anything, his bare-bones approach is reminiscent of the earliest Japanese tattoos, which solely used black ink. It was no accident that Gakkin didn't disregard red. In irezumi, and in Japan as well for that matter, the color is simply too important. It's used for the rising sun and for accents on traditional creatures such as the crane. Traditional tattooed flowers like peonies are bright red, and cherry blossoms are a diluted shade. "I don't like blue flowers," he says. Why? "I don't like blue. I like red." Gakkin also needs red for the drops of blood that are a feature of his more macabre work.

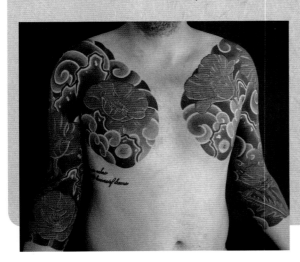

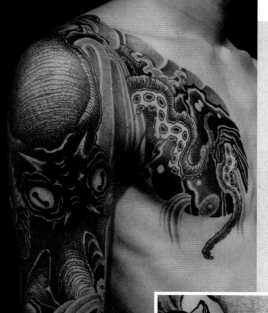

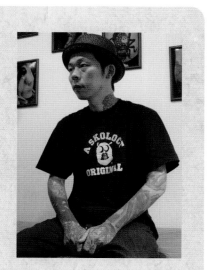

Opposite, top Off the beaten path, down a narrow Kyoto side street. **Opposite, bottom** Gakkin rarely uses red, but when he does, people notice. **Left** Not content to only use gradation, Gakkin also incorporates texture to create form. **Right** Gakkin at his Kyoto studio. **Below left** Negative space is a strong feature of Gakkin's work. The untattooed areas are as important as the tattooed ones. **Below right** Geometric shapes, another of Gakkin's hallmarks, contrast with the black feathers. **Bottom** Birds and flowers, traditional symbols of beauty in Japan, are often paired.

Black is the color Gakkin likes using best. No color is more versatile in Japanese tattooing. Black brings not only spiders and crows to life, but also nature motifs like water—which is traditionally done in black ink— and essentially anything else Gakkin wants to tattoo. While contrast gives Gakkin's limited colorwork more impact, he can still depict natural forms in dark hues, because the shapes of certain flowers such as cherry blossoms, or foliage like bamboo, are so iconic that they can be easily conveyed. Fifteenth-century ink painters didn't need a spectrum of colors, and Gakkin doesn't, either.

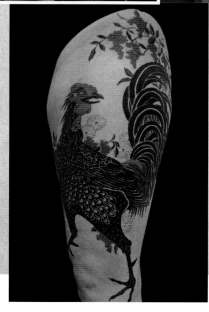

"I figured I could do what I needed by using various shades of black, along with negative space, and then add red for contrast," says Gakkin. "Black doesn't fade." The colors in tattoos fade, just as flowers and leaves do. Gakkin's approach attempts to defy nature in that regard. "After I tattoo a client, I want their body to look better," he says. And it seems that this works, for as long as possible.

TATTOO CLIENT PROFILE

JEAN-MARC
TRAVELING HALFWAY AROUND THE WORLD FOR A HORIYOSHI TATTOO

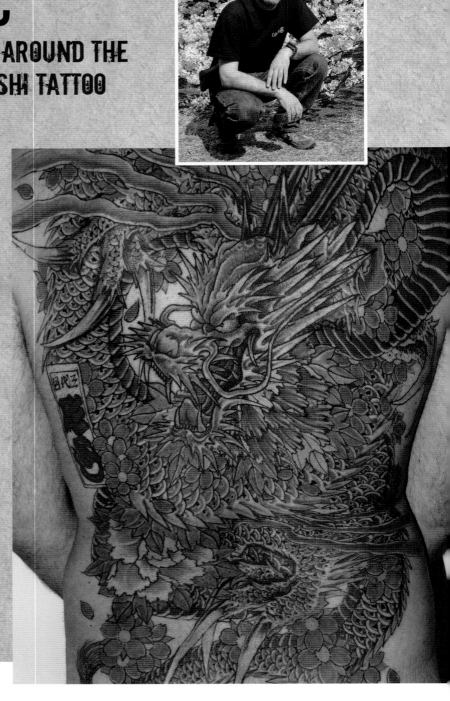

Visiting shrines, buying electronics, and stuffing one's face with raw fish might be enough for most visitors to Japan, but not for Jean-Marc. In spring 2014, the 49-year-old swimming instructor traveled more than six thousand miles from his home in Le Mans, France to Yokohama with one goal in mind: irezumi.

"Granted, there are exceptional tattooists in France, but it's always been a dream of mine to get a tattoo in Japan from a master like Horiyoshi III," says Jean-Marc. "With my 50th birthday in June, and having some money saved up, I thought it was now or never."

Jean-Marc contacted Horiyoshi III via email, requesting whatever tattoo the master saw fit, in keeping with the longstanding tradition of a client offering his or her body as a canvas. The famed tattooist accepted him as a client, and Jean-Marc hopped on a plane to Japan.

Mornings were spent at Horiyoshi III's Yokohama studio, with afternoons and evenings reserved for recovering and exploring the city. This was Jean-Marc's first trip to Japan. "I had

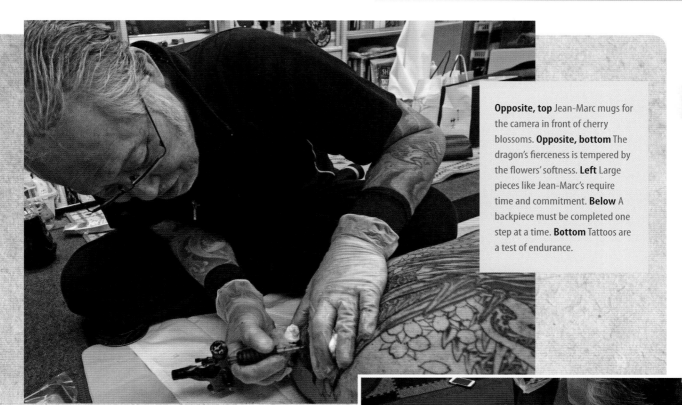

Opposite, top Jean-Marc mugs for the camera in front of cherry blossoms. Opposite, bottom The dragon's fierceness is tempered by the flowers' softness. Left Large pieces like Jean-Marc's require time and commitment. Below A backpiece must be completed one step at a time. Bottom Tattoos are a test of endurance.

never seen Japanese cherry blossoms in person before," he says. They're a constant fixture for him now, because Horiyoshi III inked them on his back, pairing the flowers with a dragon. The whole backpiece, along with a tiger on his bicep, took twenty hours.

"In France, cherry blossoms are not a macho symbol," says Jean-Marc. "But in Japan, they symbolize beauty as well as the fragility of life. Cherry blossoms are closely associated with the samurai warrior's sense of sacrifice and awareness of destiny."

Horiyoshi III also added peonies—which in Japan represent masculinity, wealth, and prosperity—to underscore the tattoo's themes.

"When I returned to France, my friends and my wife were surprised at the beauty of my new tattoos," says Jean-Marc. "Now, I see my dragon and my tiger in their flowered environment, and I'm very happy. For the rest of my life, I have a small part of Japan permanently in my skin."

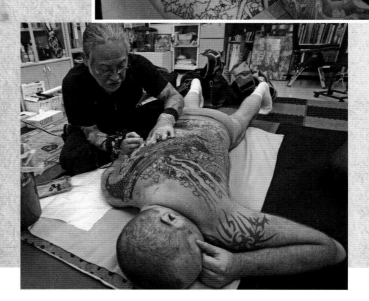

CREATURES LIVING AND MYTHICAL

WHETHER IT'S REALITY, FANTASY, OR SOMEWHERE IN BETWEEN, CREATURES COME TO LIFE IN IREZUMI.

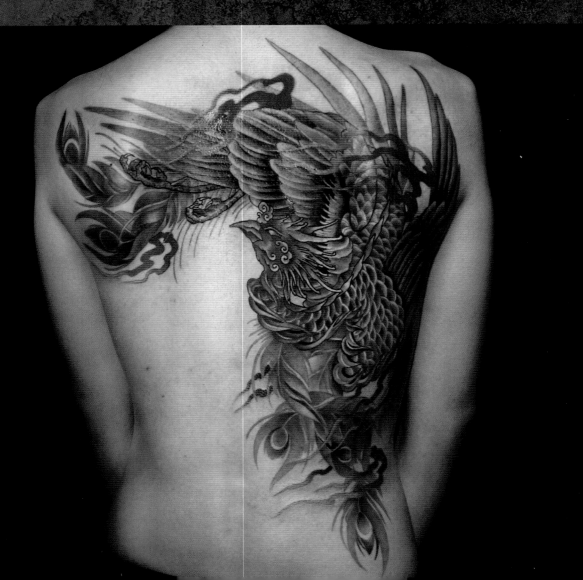

Dragons swirl in the clouds, tigers traipse through bamboo, and carp fight their way upstream. The designs are striking, but as with nature tattoos, there are rules and traditions for creature tattoos. While these tattoos are pictorial and can be enjoyed simply for how they re-create animals on the flesh, if you know what they symbolize, they mean so much more.

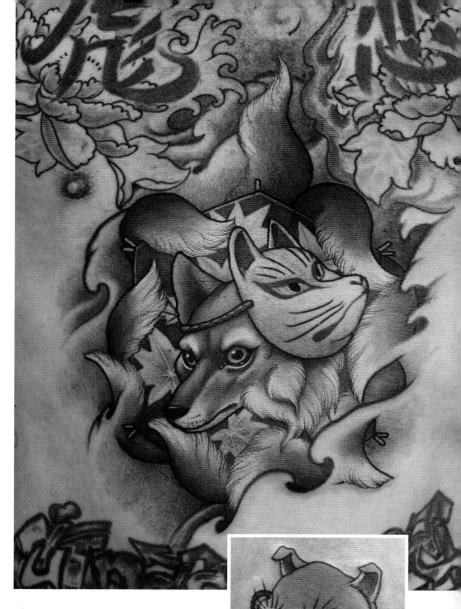

Left Mythical creatures are often accentuated with flames. **Right, above** A nine-tailed fox wears a stylized fox mask. **Right, below** Foxes, being shape-shifters, make logical choices for masks.

FOXES

The fox (*kitsune* in Japanese) is associated with the formless Shinto deity Inari, who is sometimes depicted as male, other times as female, and sometimes as genderless. Inari is not only the god of rice, sake wine, and fertility, but also the god of metal workers and commerce. Stone fox statues often appear at the more than ten thousand officially recognized Inari shrines in Japan, and because the fox guards these shrines, the animal is often confused with the god. The pure white foxes, however, aren't simply the god's messengers, but also guard and protect the shrines. These foxes also carry connotations of wealth and fertility, due to Inari's rice associations.

In Japanese folklore, foxes are also believed to have the ability to morph

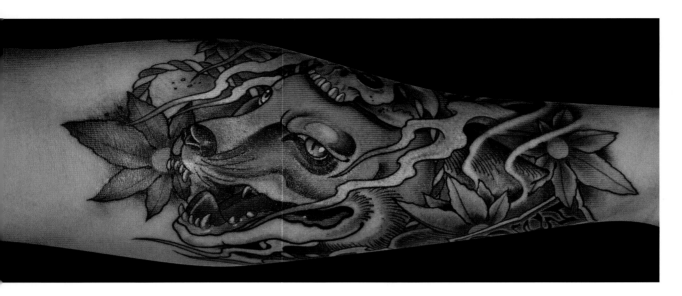

Above A modern interpretation, this tattoo shows a human skull strapped to a fox's head. **Left** With animal motifs, it's not always necessary to depict the entire body. **Right, above** Crafty and cunning, the fox embodies the supernatural. **Right, below** Often confused with the deity Inari, white foxes are closely associated with that god.

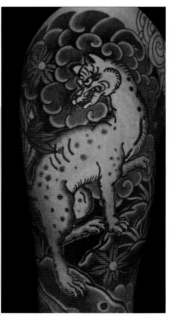

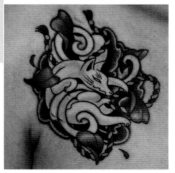

into humans—often (ahem) foxy women, to dupe gullible men out of their money. This explains why seductresses are sometimes referred to as "o no nai kitsune" (尾の無い狐), "a fox without a tail." When these sensual shape-shifters let their guard down—after too much booze, for example—their tails might accidentally plop out. Kitsune are also known to morph into men.

A powerful nine-tailed kitsune in Japanese folkore (as well as Chinese and Korean) is said to be able to possess courtesans and eat people. Legend states that a beautiful woman named Tamamo-no-Mae was actually a nine-tailed fox who made the 12th-century emperor Konoe ill in a ruse to seize the throne. After her escape, the emperor sent troops across Japan to catch her. She was finally shot with an arrow, and turned into a large boulder that, if touched, would cause instant death.

DRAGONS

While the European dragon is more lizard-like, the Japanese dragon, like other dragons throughout Asia, most resembles a snake. Whether it's the Shinto god Susano-o slaying an eight-headed serpent dragon or the depiction of the underwater sea god Ryujin, in Japanese folklore the dragon is often used interchangeably with mythical snakes. The indigenous legends predate the importation of Chinese dragon motifs, which had reached Japan by the seventh century. This highly influential figure is actually a combination of several different animals: the head of a camel, the eyes of a rabbit, the horns of a deer, the scales of a carp, the body of a snake, the paws of a tiger, and the claws of an eagle. In those claws, it holds an orb that some say is a jewel, others claim is a pearl of knowledge. The Naga serpent deities in Indian Buddhism—a religion born in India that spread to China—are perhaps responsible for the snake influence in the Chinese conception of the dragon.

Right The *nobori-ryu* ("ascending dragon") is a prevalent dragon motif. **Below** Dragon fountains, found at Shinto shrines, are places visitors can cleanse themselves.

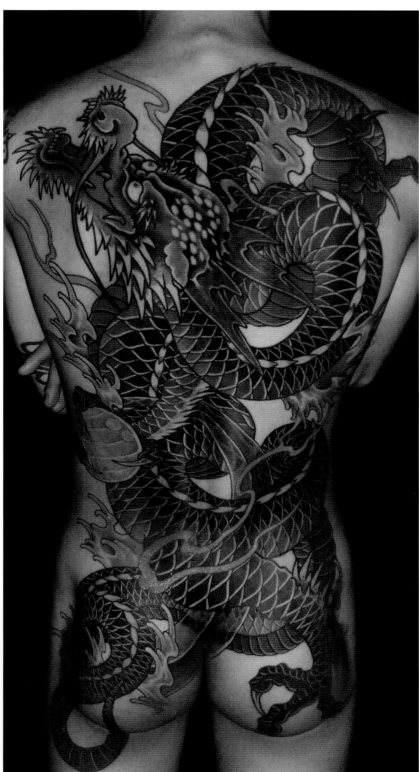

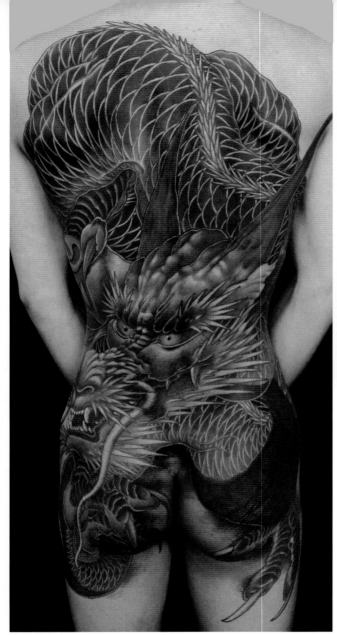

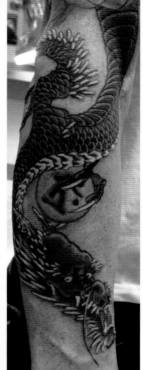

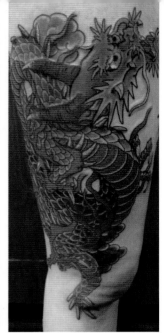

Above left A dragon clutches a *bonji*-inscribed orb representing the wearer's birth year. **Above right** Dragon tattoos do not need to be confined to the back. **Left** Even an entire human back cannot contain all of a dragon's power. **Below left** A storm rages around a dragon as it flies through the sky.

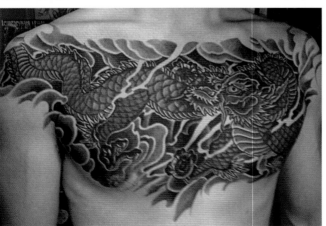

Japanese dragons and Chinese dragons certainly do resemble each other. Both are connected to water, and both have snake-inspired bodies. As in China, the emperor of Japan is associated with the dragon: Jimmu, the first legendary emperor, is said to have been descended from one. These dragon creatures aren't the same, however. The differences are subtle: For example, Japanese dragons tend to be slightly skinnier than their Chinese counterparts and have three claws, not four or five like the Chinese imperial dragons (for more, see page 62).

Dragon imagery is common in Buddhism, another import from China (and, of course, India) via Korea to Japan. As Buddhism spread through Japan from the sixth century onwards, the dragon was also incorporated into the country's native religion, Shintoism. Fountains decorated with dragon imagery became a feature of hand-washing basins in front of Shinto shrines. Dragons, which dislike filth and protect

against disease, were a perfect fit with Shintoism's emphasis on purity and cleanliness.

Typical *irezumi* motifs show dragons swimming in water or flying through the clouds, and can feature an array of deities and heroes. Backgrounds, however, are not necessarily required, and standalone images are popular. Dragons can be shown ascending up the body in a motif called nobori-ryu, or descending in a design known as *kudari-ryu*. Likewise, these can be depicted with a background, or individually as standalone tattoos.

One of the most popular pairings is that of dragon and tiger, which is known as *ryuko, ryoko* in Japanese. Literally, this means "dragon and tiger," but the idiomatic meaning is "two great rivals." Both creatures are incredibly powerful, with dragons ruling the sea and air and tigers dominating the land.

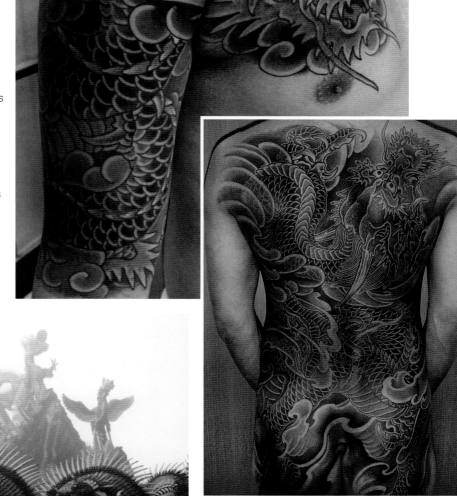

Top Design elements are tightly compacted, yet elegantly balanced as a dragon makes its way up the arm. **Above** The cloud's softness contrasts with the dragon's rigid scales and spikes. **Left** A four-clawed dragon decorates this Taiwanese shrine.

Three Claws or More?
How to Tell a Japanese Dragon from a Chinese One

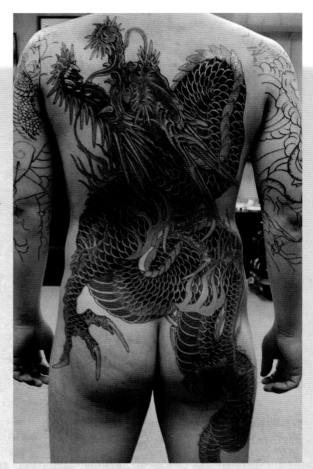

Above The Japanese dragon is easily identified by its three claws.

What's an easy to way to tell a Japanese dragon from a Chinese one? Check the claws. A Chinese dragon has either five, four, or three depending on its imperial rank, while the Japanese dragon typically has three claws. (Note that there are examples of four- and five-clawed dragons appearing in Japan, but in irezumi, the Japanese dragon generally has three claws.) According to Chinese folklore, the five-clawed dragon lost one toe each time it moved further away, which explains why Korean dragons typically have four talons and Japanese have three. In Japan, however, it's reversed, with the story going that Japanese dragons gained a toe—and thus a claw—the further they moved from Japan.

Five-clawed dragons are imperial symbols in China, but it wasn't always that way, because Chinese dragons haven't always had five claws. For example, during the early third century of the Han Dynasty (206 BC–220 AD), dragons were depicted with three digits. Before that, there are examples of dragons with two claws as well as others with four. In the seventh century, a period during which Chinese culture had a strong influence in Japan, Chinese dragons typically had three talons. This could explain why Japanese dragons have three claws, as during this period the country was incredibly influenced by Chinese designs. It also might shed light on some of the oldest surviving dragon depictions in Japan, which are tomb murals in Nara from the late seventh and early eighth centuries that are based on Chinese astrology; they depict three-clawed dragons.

It wasn't until the 14th century that five-clawed dragons were officially imperial symbols in China and prohibited for lay use. By then, Japan already had a strong artistic tradition of dragon imagery, so perhaps Japanese artisans didn't see the need to add more claws. But for the Chinese, the five talons had great symbolism: They represented the five elements and made the mythical dragon more human. The direct connection between the emperor and dragons underscored imperial rule, because the Chinese emperor sat on the dragon throne. The emperor of China was a dragon, and the dragon was an emperor. The claws were a way to consolidate power, which increasingly became a necessity in China when new dynasties came into power.

Unlike China, Japan hasn't changed imperial families. For thousands of years, the royal family of Japan has been constant. Even when powerful warlords were the country's de facto leaders, the emperor remained. The Japanese dragon is associated with ruling and power, but it's merely one of several motifs associated with the Japanese imperial throne, among them an array of flowers and local deities as well as the sun itself.

THE PHOENIX

Originally Chinese, the phoenix is a combination of several different birds, earning itself the nickname "King of Birds." Thus, the phoenix is paired with the peony, which is the King of Flowers. But this is not the phoenix of the Greco-Roman or Egyptian tradition, which rises reborn from the ashes. Rather, this creature, much like the *kirin* (see page 65), appears when a ruler is fair and righteous.

In China, one gets a phoenix by mixing and matching features of various feathered creatures, such as the head of a golden pheasant, the body of a Mandarin duck, the tail of a peacock, and the wings of a swallow. China's oldest dictionary, which dates from the third century BC, describes the phoenix as having the tail of a fish, the neck of a snake, the back of a tortoise, and the head of a bird. Thankfully, the phoenix was tweaked and honed over time, and that original design doesn't dominate the popular artistic tradition!

The creature was imported to Japan, where it can be found on sixth-century metalwork. Over time, artisans altered the phoenix's original design by swapping in domestic birds, such as a Japanese long-tailed chicken and a Japanese crane. Other Japanese motifs, such as cherry blossoms, were included in phoenix depictions.

Written as *hou-ou* (鳳凰), with the kanji characters representing male and female, the phoenix is a personification of yin-yang, man and woman, sun and moon, dark and light. The bird, however, is seen as female, which is one reason it's paired with the dragon, a male symbol. In China, the pairing is often used on wedding rings or wedding invitations. Sometimes the two appear in harmony, but sometimes they are butting heads. When the phoenix's claws are outstretched, the bird is attacking a serpent or a dragon. However, pairing the phoenix and dragon can also symbolize balanced rule: fairness and strength combined with intelligence and military might. The phoenix is often depicted with a dragon in Japanese tattooing as a balanced set.

The phoenix—often shown in a paulownia tree or eating bamboo—is an image that rulers, both fair and unfair, have appropriated over the centuries to demonstrate their benevolence, even if they were total jerks.

Right The normally bright plumage of the phoenix is beautifully expressed here in black and gray. **Far right** The phoenix is one of tattoo's most colorful creatures. **Below** A phoenix adorns a doorway at a Buddhist temple.

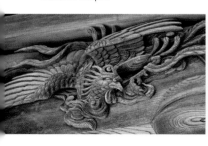

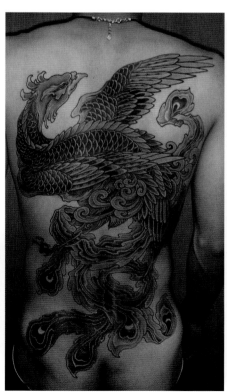

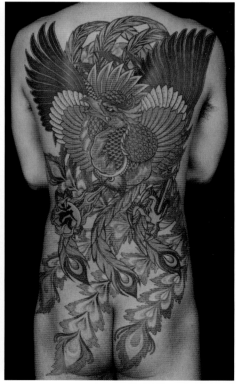

The Phoenix vs. the Vermilion Bird
Are They the Same?

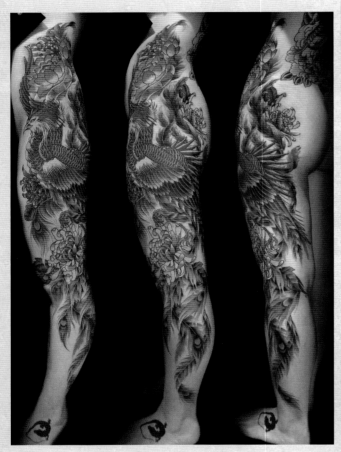

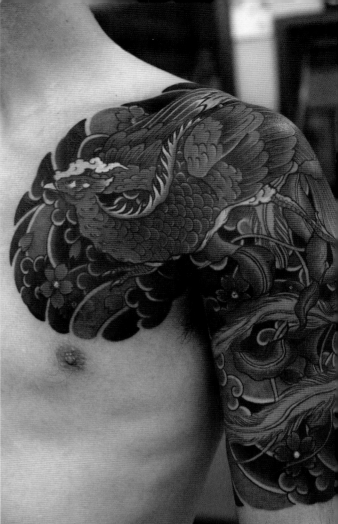

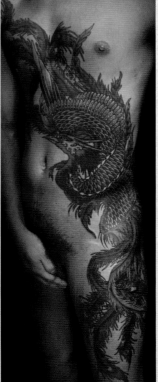

The phoenix sure looks like the Vermilion Bird, which represents the south and summer. No wonder the Vermilion Bird is sometimes mistaken for the phoenix, the creature it certainly could've inspired. Some say they are the same creature; others say they are different. The Vermilion Bird is one of the Four Sacred Animals found in Chinese astrology, which are well over three thousand years old. The others are the Azure Dragon, the White Tiger, and the snake-entwined tortoise called the Black Warrior. The phoenix, King of Birds, is one of the Four Benevolent Animals from Chinese mythology, which also include the kirin, the dragon, and, once again, the black tortoise.

Above The Vermilion Bird, which originated in China, is paired with *sakura*, traditionally a Japanese symbol. The design shows both cultures' influences. Known as *Suzaku* in Japanese, the Vermilion Bird is connected with fire, summer, and the south. **Far left** From the top of the hip to the bottom of the ankle, the entire side of the body is beautifully adorned. **Left** A phoenix spans across this man's body.

THE KIRIN

In ancient China, a popular way to create new creatures was to combine several together. The dragon is one case in point. Another example is the kirin, a mythical horned mish-mash of a creature with deer antlers, a dragon face, cloven hooves, carp scales, and a lion's tail. Like dragons, kirin are able to fly. And seeing a kirin, like seeing a dragon, is auspicious. This creature is a sign of good things to come.

"Kirin" is also the word for giraffe in Japanese. Interestingly, in Chinese, the kirin is called a *qilin* (麒麟), and giraffes are called "long-necked deer" (长颈鹿). In English, the kirin has been dubbed a "Chinese unicorn," which isn't exactly accurate as the creature can have two horns.

The Japanese kirin and the Chinese qilin are different, because Japan modified the mythical animal to suit local tastes. The elegant kirin is closer to a deer and has an ox tail, with a more slender body compared to the squat, lion-tailed qilin.

In the Buddhist tradition, it's said that the kirin won't eat living things, and won't even walk on grass for fear of trampling the vegetation. That's why the kirin prefers to take to the sky. Seeing these mythical creatures, which live for a thousand years, is a special occasion. Kirin only appear when rulers are righteous. Often paired with the peony, the kirin symbolizes high rank, longevity, prosperity, justice, and wisdom—and, since the establishment of a well-known brewery in 1885, Japanese beer.

Below left The single horn often marks the kirin. **Below right** An amalgamation of animals, the kirin is truly a mythical beast.

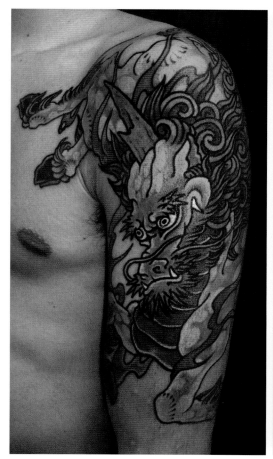

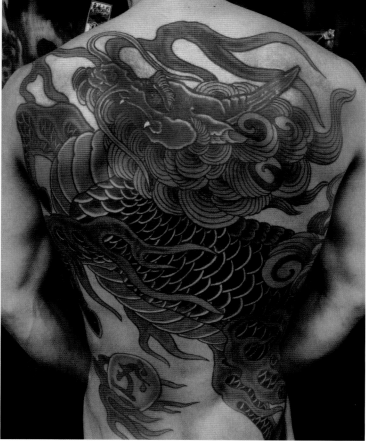

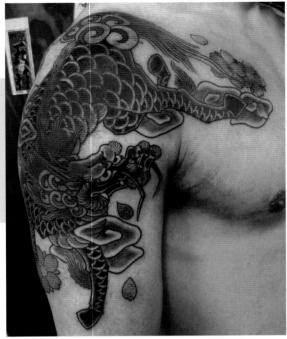

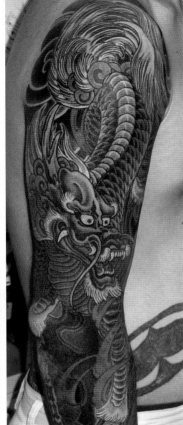

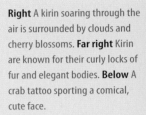

Right A kirin soaring through the air is surrounded by clouds and cherry blossoms. **Far right** Kirin are known for their curly locks of fur and elegant bodies. **Below** A crab tattoo sporting a comical, cute face.

Different Cultures, Different Meanings

Some symbolism is universal. Tigers, for example—everybody understands tigers. Or spiders, which aren't auspicious in Japan or in the West—they're bad news in both places! But other critters have totally different meanings in the Japanese tradition.

Take bats, which generally represent vampires and general spookiness in the West. In Japan, bats are traditionally lucky, because of a pun: Bats are *komori* (蝙蝠) in Japanese, and the character 蝠 can also be read as *fuku*, which sounds like the *fuku* (福) that means good fortune.

In the West, crows are sinister premonitions of evil. And yes, they're scary pests in Japan, too. But a crow, according to Japanese legend, led the first emperor to present-day Nara to settle; the bird is thus associated with the sun, not gloomy overcast skies.

Then there's the crab, which in today's English-speaking world might be used to refer to someone with a nasty disposition (crabby) or a nasty sexually transmitted bug (crabs). In Edo-period Japan, however, the crab was a popular tattoo for prostitutes—it was seen to represent snatching up customers, and in that regard, was a lucky symbol.

Maneki Neko: The Lucky Cat

Known colloquially as the "lucky cat" or "fortune cat" in English, *maneki neko* actually means "beckoning cat." The Japanese gesture for beckoning is made with the palm down, not with the palm up like in the West. The feline is therefore often placed in shop entrances to beckon customers.

The maneki neko typically holds a gold coin to underscore its connection with commerce. Its appearance—with its collar, bell, and bib—evokes the pampered housecats of the Edo period (1603–1868) and the Meiji era (1868–1912).

In Japan, there are numerous stories about the cat's origins. Some have the feline beckoning passersby to save them from danger. Another one recounts how a poor shop owner who barely had enough money to feed himself took in a stray. The grateful cat began waving in customers.

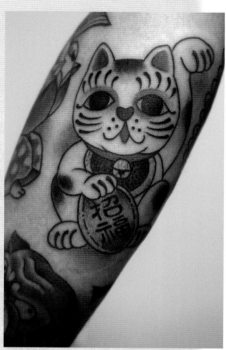

Right The coins can have a variety of meanings. The one here means "super lucky." **Below left** This maneki neko is paired with several Japanese motifs, including the Rising Sun, cherry blossoms, and a Daruma doll. **Below middle** Generally, a raised left paw summons customers, while a raised right paw summons wealth. Two raised paws beckon both. Ka-ching! **Below right** Not all maneki neko are white. They come in a plethora of different colors, but they are typically white, black, or even red.

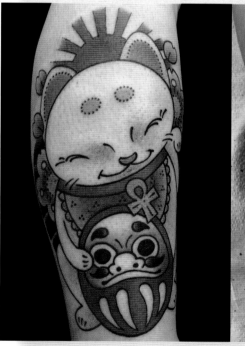

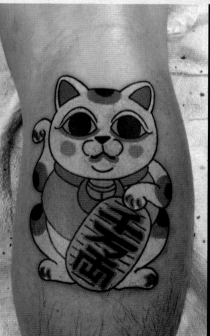

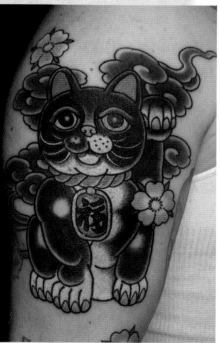

TIGERS

While dragons and phoenixes are creatures of myth, lions might as well have been in Japan—ditto for tigers, as neither is indigenous to that land. Around the seventh century, tiger images were imported into the country along with Chinese astrology. Since Japanese artisans were initially working from Chinese motifs and not from looking at actual tigers, the designs became more stylized. The tigers' eyes, for example, became unnaturally large, but highly expressive.

In irezumi and art in general, the tiger's traditional color is yellow and black. However, as the irezumi color palette has expanded, some modern tattooists use orange—the color that typically represents the animal in the West (see Tigger, Tony the Tiger, etc.). The color yellow is also connected to imperial rule. This is fitting; the Chinese believed that the striped pattern on the tiger's forehead naturally formed the character for king (王).

The tiger is often portrayed with bamboo or climbing on rocks, both of which represent strength. Only a tiger was thought able to penetrate a dense bamboo grove, symbolizing shelter being given to the powerful—a trope common to both irezumi and Buddhism. Irezumi tigers often have their mouths open to ward off evil spirits. This makes them an ideal pair for a closed-mouth dragon, whose mouth is clenched shut to keep the good spirits from escaping. In Chinese astrology, the tiger represents wind, while the dragon is water, so depicting them together creates a wind-water (風水, or feng shui) motif. This, perhaps, explains why tiger-and-dragon pairings are popular in Zen Buddhism—and in irezumi, for that matter.

Left A tiger paired with peonies is an expression of strength and royalty. **Below** Here is a modern tiger interpretation with highly expressive features.

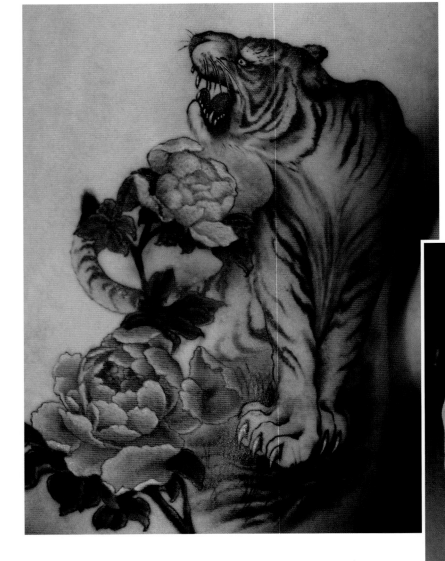

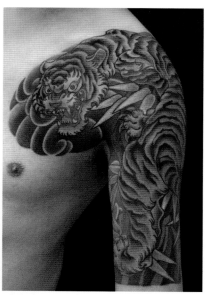

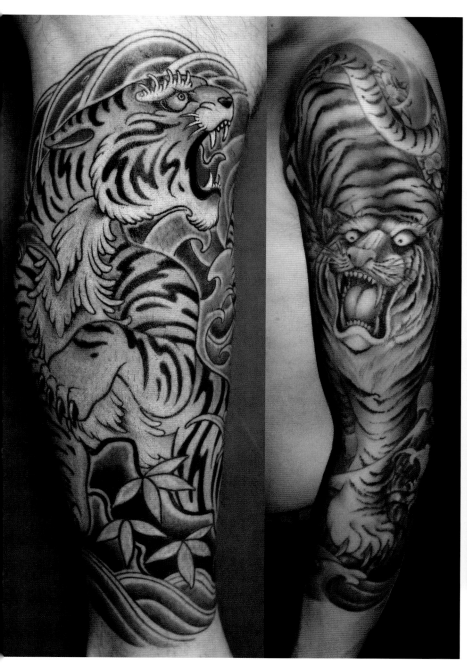

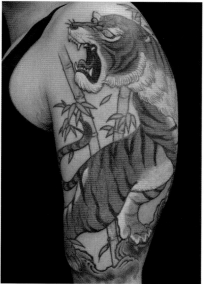

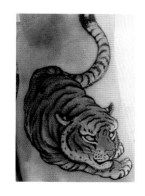

Above left Stripes are a tiger's essence. In this tattoo, they mimic the ebb and flow of the waves. **Above right** Much as for the dragon, lots of space is needed to fully express the tiger's scale and power.

Right, above This tiger tattoo shows the flexibility of the animal's body. **Right, middle** Tigers are often depicted on rocks to show their strength and underscore their mastery of the land. **Right, bottom** Tigers are also displays of reserved power.

GUARDIAN LIONS AND GUARDIAN DOGS

At Buddhist temples and Shinto shrines, sets of stone guardian animals stand watch; peonies are engraved into their statues and reliefs. The guardian lion placed on the left of the shrine or temple entrance is called a *karajishi*, which literally means "Chinese lion." A male creature representing yang forces, the karajishi has its mouth open; its paw is placed on the Buddhist pearl of wisdom. During the Nara period (710–94 AD), two karajishi statues were a common pair of protectors, but by the Heian period (794–1185), the guardian lion was paired with a guardian dog. Located on the right of the shrine or temple's entrance, this guardian, which has its mouth closed, is called the *koma-inu*, or "Korean dog" (literally, a "Goryeo Kingdom

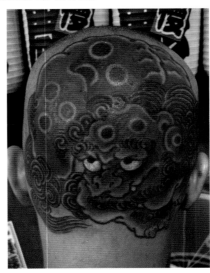

Above The creature's round body echoes the shape of its head. **Below** A karajishi leaps forward through the waves, paired in the classic fashion with peonies.

Dog"). The horn that often juts from the komainu's head is a clue that this isn't a lion, but a different animal entirely. Even though they are different creatures, in Japan, both statues are often colloquially referred to as "koma-inu." Some, however, call both statues "karajishi" or just "shishi."

Together, the two ward off evil, representing yin and yang and creating a balanced *ah-un* set. "Ah" is the first letter of the Sanskrit alphabet and the sound people make in Japanese when opening their mouth; "un" is the Sanskrit alphabet's last letter and the Japanese sound associated with closing the mouth. The theme of ah-un is found throughout Japanese religious art, which will be covered in chapter 4;

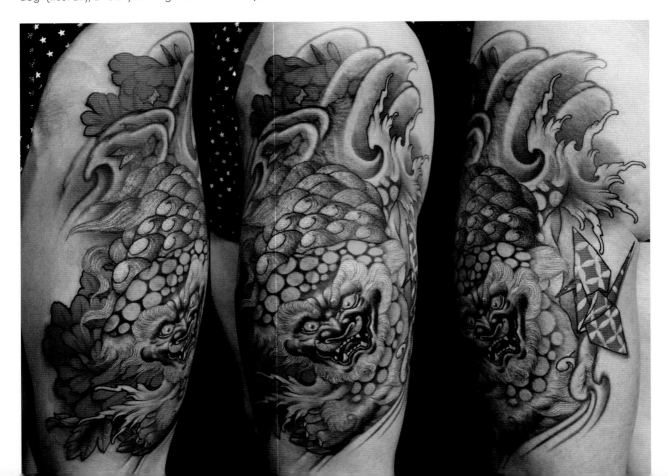

it is a common way to balance paired animals, as well as gods and heroes, in irezumi.

Both the guardian lion and the peony originally come from China, further explaining their traditional pairing. In irezumi, the set is called *karajishi botan* (guardian lion with peony), and symbolizes strength, beauty, and healing. The story is that eating a peony—a medicinal flower—cured the guardian lion of its ills. Some also call the mythical karajishi the King of the Beasts, making it a fitting companion for the peony, which is known as the King of Flowers. The guardian lion and the guardian dog may also be accompanied by cherry blossoms, because sakura are planted at temples and shrines.

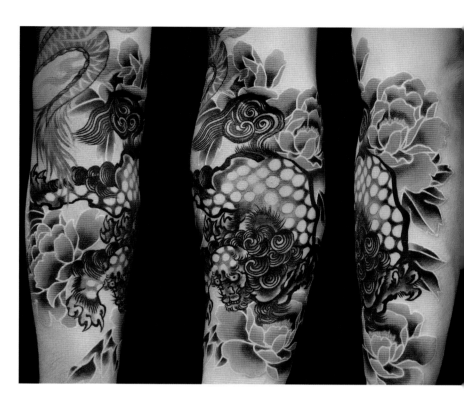

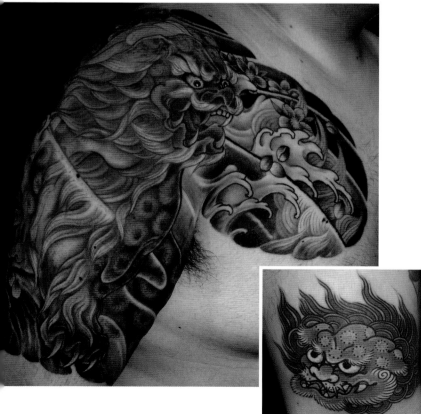

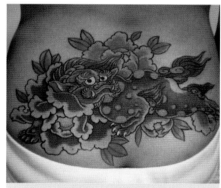

Top The circular patterns that adorn the karajishi's fur can be depicted in various ways. **Above** A karajishi leaps and dances among peonies. **Left, above** Karajishi can also be paired with sakura, because the trees are planted at Buddhist temples. **Left, below** A highly stylized design showing a karajishi with an open mouth.

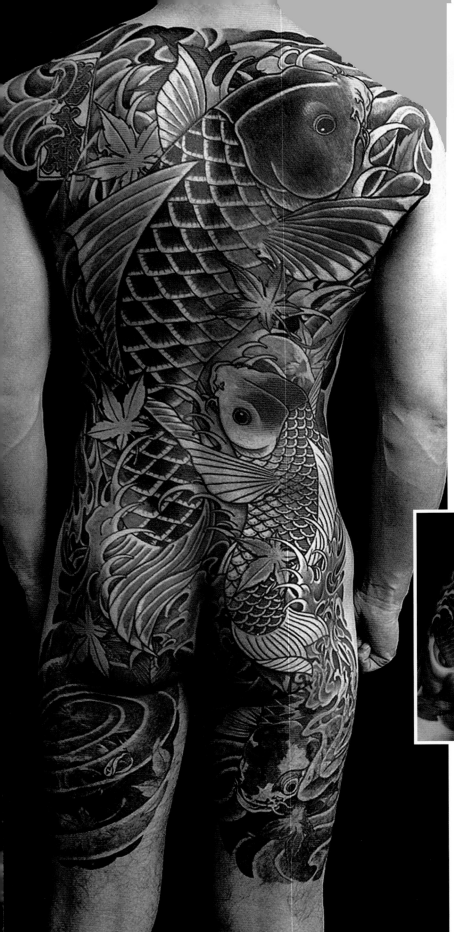

THE KOI FISH

For Japanese, there is no braver or more virile fish than the carp, or koi. Koi are often paired with maple leaves, an irezumi motif that goes back several hundred years. But the fish has strong spring connotations, too, because every May 5, carp banners are flown in Japan by parents of sons to express the hope that their boys will grow strong and healthy. On the banners, the black carp, called *magoe*, represents the father; the red carp, or *higoe*, is the mother; and the blue carp, called

Top A koi pond teeming with fish. **Above** Black koi tattoos typically have yellow ochre accents. In irezumi, koi are often paired with maple leaves in a motif that's been popular since the 19th century. **Left** The black fish represents the male, and the red one represents the female. This design is a classic yin-yang pattern.

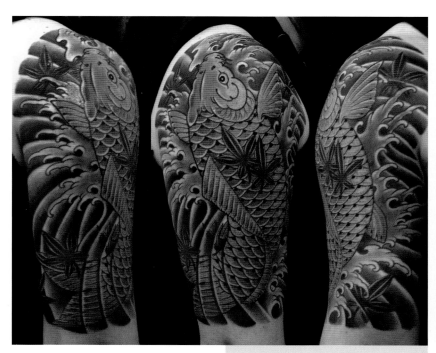

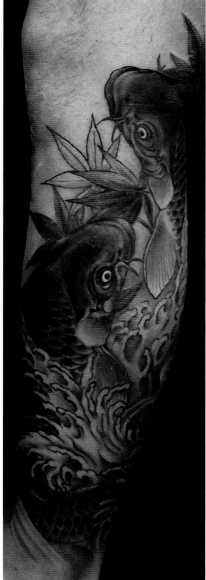

kogoe, is the child. These colors can be used in tattooing to identify the koi or show the relationship between them, or to create yin-yang designs with black and red carp swimming in circles.

Above Even a solid-colored koi has subtle gradations. **Right** The leaping pattern creates a sense of action as these koi move up the arm. **Below** Carp streamers are flown proudly for sons.

The hope isn't just that the boys will grow up strong. According to a well-known legend in Japan, carp that swim up China's Yellow River and pass through the rapids in Hunan known as the "Dragon Gate" turn into dragons. In Japanese, the idiom "ascending the dragon's gate" (登竜門) means "overcoming barriers to success." Images of carp swimming through rough waters symbolize strength and determination. Because of this association, koi can be paired with dragons in irezumi.

Perhaps because koi are such strong fish and are known to jump ten feet out of the water, there's a story of Japan's version of Hercules, Kintaro, wrestling a giant carp in a show of strength and bravery—a story reproduced in countless tattoos. Few irezumi motifs are more masculine than the koi.

In reality, however, the fish are slightly more docile. Actual koi, often found in placid ponds at Buddhist temples, assemble for feeding when they hear the clap of hands.

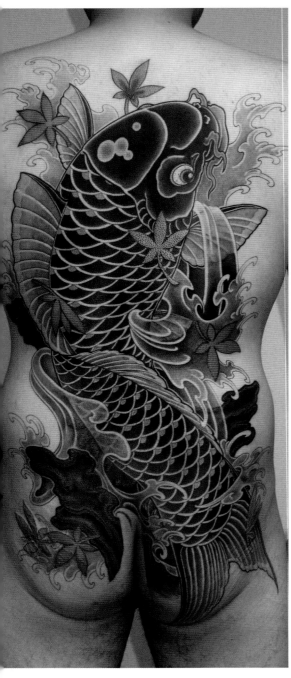

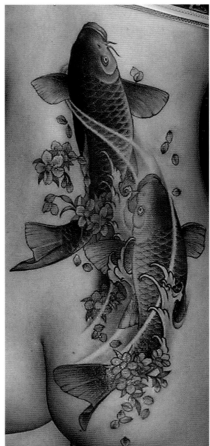

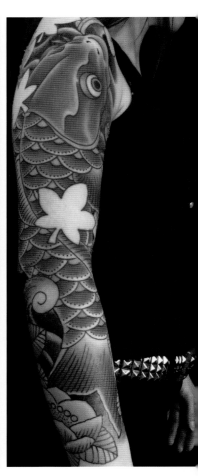

Left In this ascending design, waves splash outward in the koi's wake. **Above left** Cherry blossoms give a spring feeling to this koi tattoo. **Above right** A massive koi covers the arm. **Right** A carp is shown leaping through the air and flipping over on its back.

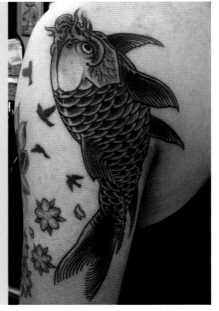

Fishy Puns
Large-Scale Wordplay

Pronounced "koi" in Japanese, the carp is *li* (鯉) in Chinese, which sounds like *li* (利), the word for profit. Because of this auspicious connotation of making money, the carp is often depicted in Japanese tattooing with the peony, a beneficial flower that represents high rank and was used for medicinal purposes. Other puns are used in tattooing to refer to wealth, such as "goldfish" (金魚, *kingyou*) making the obvious reference to "gold" or "money" (金 , kin).

The sea bream (鯛, *tai*) typically shows up in tattooing as an attribute of the lucky god Ebisu, the Japanese god of fishermen and a protector of small children. Ebisu (see page 97) is depicted with the sea bream because the Japanese name of the fish, "tai," is a wordplay on the word *medetai* (めでたい), which means "joyous." This is why even today the first meal cooked for babies consists of a large sea bream, a fish often used to mark happy celebrations. The sea bream's reddish color evokes comparisons to cherry blossoms, a flower paired with the fish.

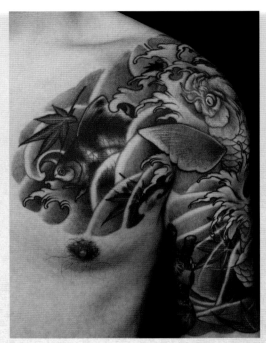

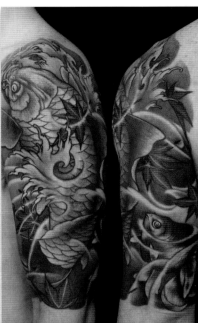

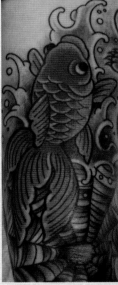

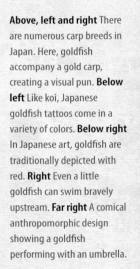

Above, left and right There are numerous carp breeds in Japan. Here, goldfish accompany a gold carp, creating a visual pun. **Below left** Like koi, Japanese goldfish tattoos come in a variety of colors. **Below right** In Japanese art, goldfish are traditionally depicted with red. **Right** Even a little goldfish can swim bravely upstream. **Far right** A comical anthropomorphic design showing a goldfish performing with an umbrella.

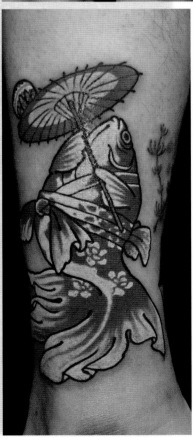

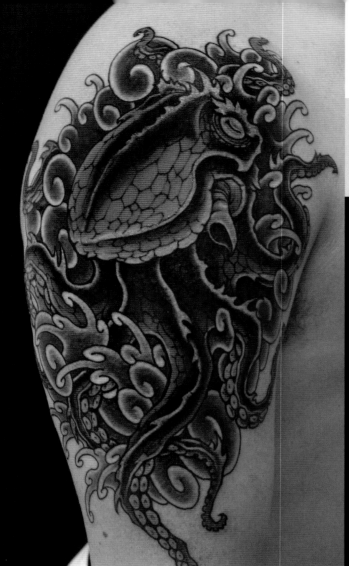

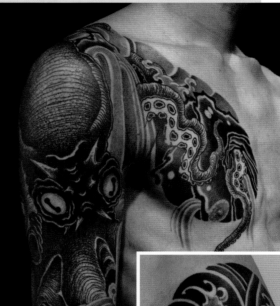

Left A modern take on the octopus motif. **Below** A heavily inked tattoo of a heavily inked sea creature. **Bottom** In octopus tattoos, the shape of the tentacles can often echo the waves and the water.

THE OCTOPUS

In modern times, octopus imagery has strong sexual connotations thanks to the ridiculously suggestive use of tentacles in manga, anime, and video games. The motif is not new, however; one of Japan's most famous and respected artists, Hokusai, pioneered it back in 1814 with the woodblock print *The Dream of the Fisherman's Wife*, which featured a woman getting hot and heavy with an amorous cephalopod.

While such erotically charged associations have become infamous in the West, this underwater invertebrate means more than tentacle porn in Japan. Often shown as either cute or comical, the octopus was also the personal physician for Ryujin, the underwater sea dragon, which might explain why, in the past, Japanese doctors were fond of carrying octopus amulets. And in tattoos, the octopus's ink can make for a clever visual pun.

CRANES

Able to fly between heaven and earth, the crane represents peace and also longevity, and is said to be able to live a thousand years (in reality, the crane lives 60 years—not too shabby!). According to Japanese belief, if you fold a thousand origami cranes over the course of a year, your dreams come true. Making origami cranes is something that most Japanese know how to do, as they learn when they are little. Today, the country's space program has prospective astronauts fold cranes as part of the application process, in order to gauge their precision.

While the mythical phoenix is an imperial symbol, and is known as the King of Birds, it's not Japan's most iconic feathered friend. That honor goes to the Japanese red-crowned crane, which is associated with the imperial household and even used in commercial imagery. Japan Airlines, for example, uses a red crane as its logo. Red, of course, is closely associated with the sun and Japan itself, and there's a red "crown" on this crane's head, hence the name.

There really is no better bird to sum up Japanese sensibilities and symbols than the red-crowned crane. Understandably, in irezumi it is often paired with the red sun, as well as

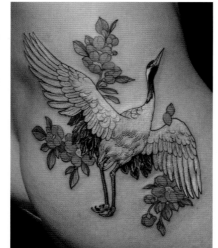

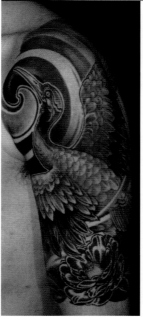

with the tortoise, another symbol of longevity. In Japanese, there is a saying, *"Tsuru wa sen nen, kame wa man nen"* (鶴は千年、亀は万年, "A crane lives a thousand years, a turtle lives ten thousand years"). Putting both together is an auspicious way to represent longevity. The crane can be paired with the evergreen pine or the bamboo, both of which also represent longevity and transcend the seasons. The crane is also symbol of fidelity, since it mates for life and performs elaborate "dances" when courting a mate.

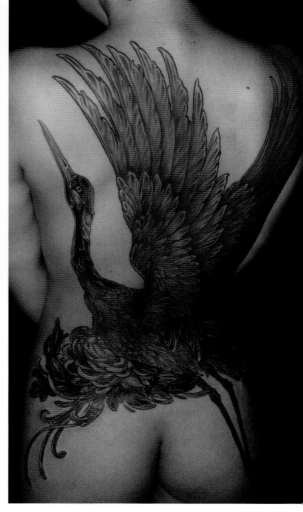

Top Two Japanese symbols: the red-crowned crane and cherry blossoms. **Above** When paired with the camellia flower, the red-crowned crane can be an expression of winter. **Right** A crane playfully leaps upward, its wings accentuating the wearer's back. **Left** Because the red-crowned crane migrates between China and Japan every year, the bird is important to both cultures.

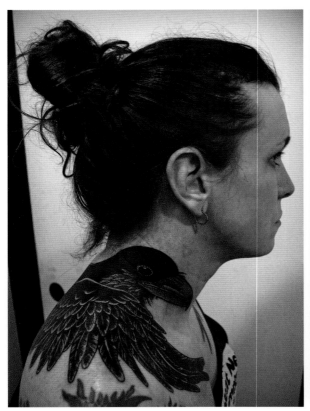

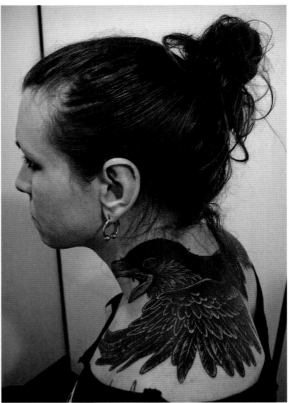

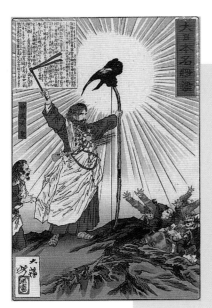

Above, left and right A two-headed crow with open and closed mouths spans the neck and the shoulders. **Left** Emperor Jimmu arriving at the Yamato Plain.

CROWS

While not traditionally featured in irezumi, the crow has started to emerge as a Japanese tattoo motif in recent years. The animal does appear in ancient Japanese texts, however: A crow called Yatagarasu guided the first emperor, the legendary Jimmu, from his birthplace in Kyushu to the Yamato plain, which would become the ancient capital of Nara. In Japanese art, Yatagarasu is shown surrounded by rays of light. The original texts made no mention of the bird having three legs, but the three-legged design was later incorporated. Today, crows might be viewed as pests or even as frightening; however, this three-legged crow is a symbol of the sun, which is why it's often depicted with Rising Sun–style motifs and at Shinto shrines. It's also the symbol of Japan's national soccer team.

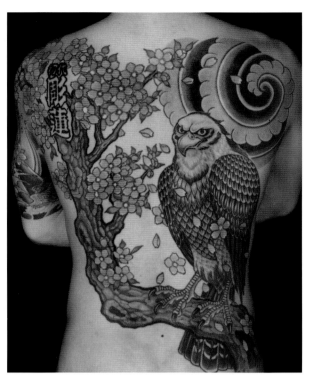

FALCONS AND HAWKS

Note that the Japanese language uses the same word (*taka*) for both falcons and hawks. The visual difference is that falcons have a notched beak, while hawks do not.

Taka are strong, with a piercing gaze. This explains why the bird has long been a symbol of the samurai, and the bird is a common design on men's kimono. In irezumi, the bird of prey is paired with snakes, with the taka either swooping down to seize the snake in its beak, or with the reptile wrapped around its body. It's a depiction of killing or being killed. Thematically, the motif is much deeper: The taka represents power, and the snake is longevity.

The bird is also auspicious. Dreaming of a taka, Mount Fuji, and an eggplant on the first day of the new year is considered lucky. In the dream, the taka represents strength, power, and the ability to fly high. Mount Fuji is Japan's highest mountain, and thus represents the pinnacle; "eggplant" (茄子, *nasu*) is a Japanese play on words with the term for "to succeed." This combination of motifs isn't common in irezumi, but it shows that the taka does have connotations of good luck in Japan.

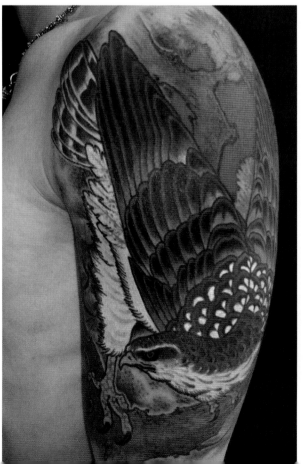

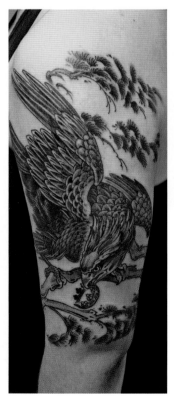

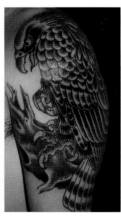

Left, above A symbol of masculinity, the taka perches on a sturdy branch. **Far left** Taka are often paired with pine trees, symbols of enduring strength. **Left** A taka opens its wings, about to take flight. Once again, it is paired with a pine tree. **Above** Taka are famous for their formidable talons.

SNAKES

This reptile's associations are complex and varied.
The snake is seen as phallic and sexual as well as
dangerous. However, like the dragon, the creature
is protective and connected to water. In the past,
the snake was also seen as immortal because it
shed its skin, adding to its mythic qualities.

There are Shinto shrines dedicated to white
snakes, or *shirohebi*. Rarely seen in Japan, white
snakes are believed to be signify good fortune and
are therefore worthy of worship.

Since snakes stay in their burrows during the
colder months, they make a logical pair with spring
motifs, such as sakura and peonies, to mark the
time when they emerge from underground.
Pairings with fall motifs such as maples do exist,
but winter motifs, like pine with plum and bamboo,
would not make sense seasonally, since the snakes
are not yet above ground.

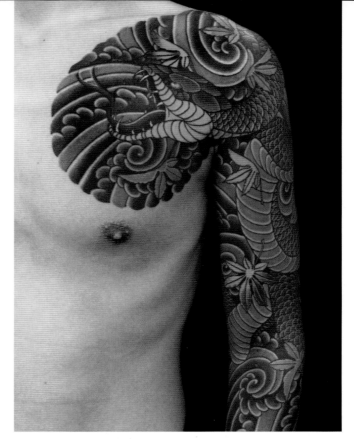

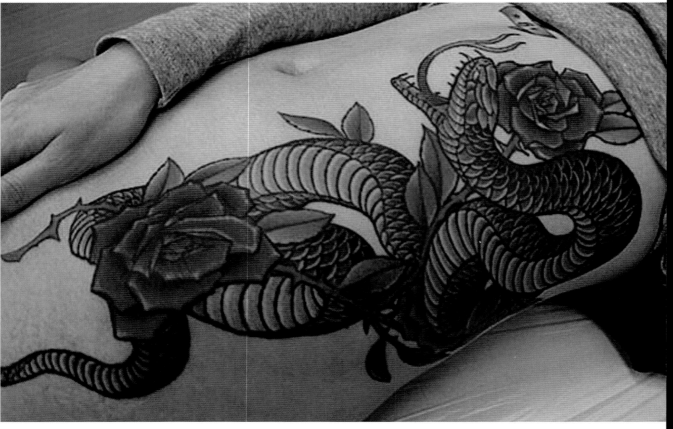

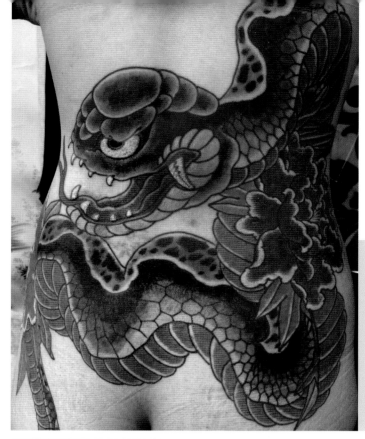

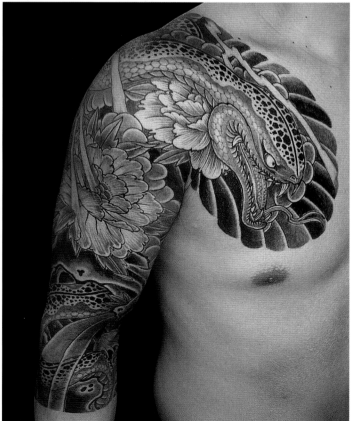

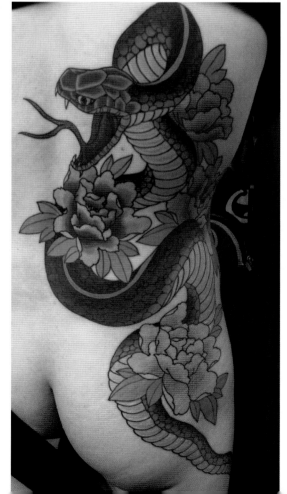

Opposite, above In this sleeve, the changing leaf colors show how summer transitions into fall, the time period when the snake moves underground. **Opposite, below** Snakes are often paired with peonies, but here roses take their place. As in the West, roses are rich with symbolism in modern-day Japan, representing love, passion, and the prickly side of beauty. **Left** Snaking its way around the back, this enormous serpent is depicted with a peony, a symbol of spring. **Left, below** Sometimes snake scales are expressed with abstract patterns. **Below** Snakes come out of hibernation in the spring.

BUTTERFLIES

Graceful. Elegant. Beautiful. In modern Japan, butterfly tattoos are popular with woman. They're seen as feminine, and have longstanding associations with happiness.

In the past, however, macho warriors would wear butterfly designs into battle; they even became a popular samurai-clan crest. This could be because the insect's grace was a direct contrast to the blood on the battlefield, but also because the butterfly was associated with longevity and the souls of both the living and the dead.

Butterflies make an ideal one-point tattoo, or they can be incorporated into a larger design.

Left Butterflies are popular stand-alone tattoos. **Below left** Butterfly tattoos are not reserved for women. **Below right** The patterns on a butterfly's wings represent its life force. The Japanese way of depicting butterfly wings is highly stylized.

SPIDERS

In Japan, spiders have a variety of connotations. They're seen as hard-working and, in the countryside, beneficial, because they catch and eat insects. They're also seen as malevolent.

It's not just any spider you see in Japanese tattooing, but giant ones called *tsuchigumo*. The term, which has a double meaning, can refer to renegades and savages who were disloyal to the emperor as well as to the mythical giant arachnids. These tsuchigumo are not only shapeshifters, but also devour humans.

Note that the terrifying *ushi-oni* (ox demons) sometimes resemble spiders with ox heads. These demons are supposedly found in western Japan, typically near the coast or lakes; they also eat people. Yikes!

Below left Not to be confused with the *yokai* ghoul with a similar name, the Joro spider is found commonly throughout Japan. The yellow and black indicate that this is a female spider. **Below** The skulls adorning the tsuchigumo underscore its fearsome nature. **Bottom** In Japan, spiders can be auspicious.

TATTOOIST PROFILE HORIMASA

BRINGING CREATURES TO LIFE

Late afternoon, and it's humid and rainy. The Japanese-style pub in this sleepy, country town west of Tokyo is practically empty. Horimasa downs a well-deserved beer after a long day of work.

"This is my 16th year of tattooing," says Horimasa, who's famous for his highly expressive, detailed animals and yokai. And he didn't even start learning how to tattoo until he was 34 years old. "I was working as a bricklayer, and I started studying irezumi on a lark," he says, pausing. "Then, I realized I could make a career out of it." That he has. People come from all over Japan—and the world—to be tattooed by him.

"Until five or six years ago, I only did *tebori*," he says, lighting a cigarette. "But in recent years, I've been using a tattoo machine, because most of my Japanese customers have been requesting that for practical reasons—it's faster. These days, mostly my foreign customers request tebori, because they wish to experience it."

Horimasa first started getting tattoos as a young man in the late 1980s. "At that time, not just in small towns like this, but anywhere in Japan, tattoos were the mark of a bad boy," he says.

"I think my first tattoo might have been a falcon. Or was it an eagle?" He's not even sure—the piece has long been covered up by another tattoo.

Horimasa is decked out in a black T-shirt and black pants. Where the shirt ends, his tattooed sleeves continue, stringing together an array of black ink designs. It's hard to make out what's what, with so many old tattoos covered up with new ones.

When he was first starting out, Horimasa borrowed a tattoo machine from an acquaintance and tattooed a bonji (Sanskrit character) on his leg to practice. "From that first experience, I felt like I could be tattooist. I also started drawing and sketching art at that point, but tattooing preceded that," he recalls, taking another sip from his beer. When he wasn't practicing on himself, Horimasa was practicing on others. Members of Gunma's large Brazilian community, in particular, comprised

his nascent clientele as he cut his teeth, tattooing simple designs. "I wasn't doing Japanese-style tattoos at that time, because, honestly, I didn't want people to say I was doing them incorrectly."

Horimasa threw

himself into studying, learning as much as he could about Japanese irezumi designs and techniques. "Because I was a bricklayer at the time, I didn't have much money to buy books to study tattooing on my own. So what I'd do was go to the bookstore and stand there and memorize the books from cover to cover." He hasn't stopped studying, and his studio now looks like a library, with stacks of woodblock-print books containing the work of artists like Hokusai, Kyosai, and Kuniyoshi, as well as numerous tomes on Buddhist art. Post-it notes are wedged between the pages, marking artwork and passages he particularly likes or finds inspiring.

When he was still a greenhorn, Horimasa was blown away by the work tattooists like Horiyoshi III (page 11) were doing. As he became increasingly interested in Japanese motifs, he kept practicing them over and over. Many of his early efforts were based on Horiyoshi III's designs. "At that time, I was still getting started, and was criticized for imitating him," Horimasa recalls, being incredibly honest and open about those days when he was still finding his own voice. "It was frustrating, sure, but what that criticism did was forced me to move away from Horiyoshi's influence and develop my own style that's different

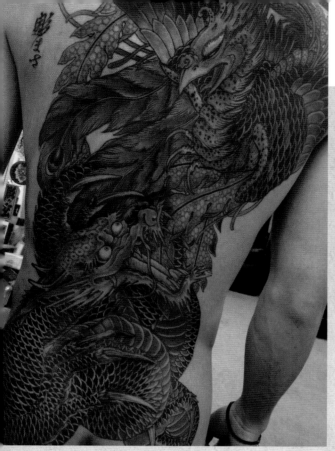

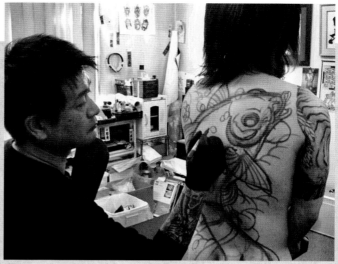

Opposite, bottom Though he is a master of bodysuits, Horimasa happily tattoos single-session pieces. **Above** Horimasa begins the long process of laying out a backpiece. **Left** A dragon and a phoenix face off in this dynamic backpiece. Note how the feathers are contrasted with the dragon's scales and how negative space gives the work even more movement.

from anyone else's. I wanted to go to the next level and tell these stories my way." Horimasa explains that honing one's own style is really a large part of a tattooist's work. Mastery of the motifs is also essential.

"I like doing *yurei* and yokai," he says (yurei are vengeful ghosts, and yokai are monsters from Japanese folklore; for more information, see pages 115 and 116). "I think foreigners are rather fond of yokai, but it doesn't seem like there's a good understanding of them. Heck, even for Japanese, so much of the nuance isn't understood, either," Horimasa says as he fires up another Marlboro.

"That being said," he continues, exhaling, "Japanese people do grow up hearing children's fables. So, whether the creatures are real or not, people in Japan often have an innate sense of what animals and what

symbols have which attributes." Of course, in irezumi, many of the motifs can be traced back to other countries and other religions. "There's no end to how deep you can go," says Horimasa. "At what point do you stop?"

Take dragons, for example. "The five-clawed dragon is Chinese, and the three-clawed is Japanese," he says. "But, in many cases, the three-clawed Japanese dragon is simply a reinforcement of a stylistic choice over an extended period of time by a series of artists." By that, Horimasa means the three-clawed dragon became a set motif that artist after artist followed. It's to the point where a Japanese three-clawed dragon is drawn with three claws simply because a Japanese dragon has three claws, and for no other reason.

"For tattooing in Japan, most designs draw their key distinguishing

features from traditional woodblock prints," he says, extinguishing his cigarette. The tattooist might be inspired by certain prints, but he or she then needs to tailor that interpretation to fit the client's desire as well as the clients' body. At the same time, the tattooist must stay true to the imagery and its associations and history. "Without adhering to certain rules or conventions that exist in Japanese motifs, you lose that Japaneseness. It's still art, of course, but it's no longer irezumi."

Horimasa sips the foam from another beer. "At a certain point, everything comes down to taste," he says. "It's up to the tattooist to decide how the elements are arranged in the piece. But many of the tropes, whether they're real animals or mythological ones, rely on an understanding of the shared Japanese culture." And that is what makes irezumi—well, irezumi.

MAKOTO
THE RIGHT TIME TO GET TATTOOS

"I got interested in irezumi during junior high," says Makoto. A family friend was tattooed, and Makoto was able to get an up-close look at an irezumi of Kintaro wrestling a giant carp. But it wasn't until he was in his 30s that Makoto finally got inked. There was a reason for the delay—actually, two.

"When my son and daughter were small, I wanted to take them to the public pool and to hot springs," says Makoto. "So until they were old enough to go with their friends, I held off on getting tattoos." In Japan, many public pools and hot springs have strict rules regarding inked patrons, typically banning them outright from entering.

Now in his late 40s, Makoto has made up for lost time, with irezumi covering his chest, stomach, back, shoulders, and both legs. Among the various motifs decorating his body there is a Vermilion Bird on his back, an Azure Dragon on his stomach, a White Tiger on his left shoulder, and a Black Warrior (a black tortoise entangled with a snake) on his right one. "Those are the Four Sacred Animals," says Makoto.

As explained on page 64, these four animals, originally from China, represent the four cardinal directions and the four seasons: The Azure Dragon symbolizes east and spring; the Black Warrior represents north and winter; the Vermilion Bird is associated with south and summer; and the White Tiger is linked to west and autumn. Paintings of these four animals have been found in ancient Japanese tombs that are well over a thousand years old. They didn't simply indicate directions, but also protected the tomb from evil spirits.

"I picked all these motifs and then consulted with the tattooist about the layout," explains Makoto. Each of them has a deep meaning for Makoto. A truck driver since age 18, he is the president of a trucking company that transports industrial waste. "We have 14 people on staff working hard and 15 trucks," he says. "Trucking is a hazardous line of work, and I got these tattoos to protect myself from accidents and injuries."

Even though Makoto sports an irezumi bodysuit that he reckons has cost around $10,000, he's not finished. "I'd love to get tattoos showing a flurry of cherry blossoms," he says. "That would be pretty great, don't you think?"

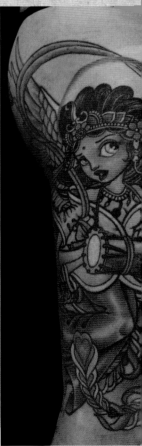

Above left A modern take on the Black Warrior. **Above middle** On Makoto's chest, there is a Fujin and Raijin pair, while a stylized Azure Dragon covers his stomach. **Above right** The White Tiger. **Below left** A modern version of a *tennyo* plays the drum. **Below middle** The Vermillion Bird covers Makoto's back. **Below right** A contemporary Oniwakamaru (see page 110) design.

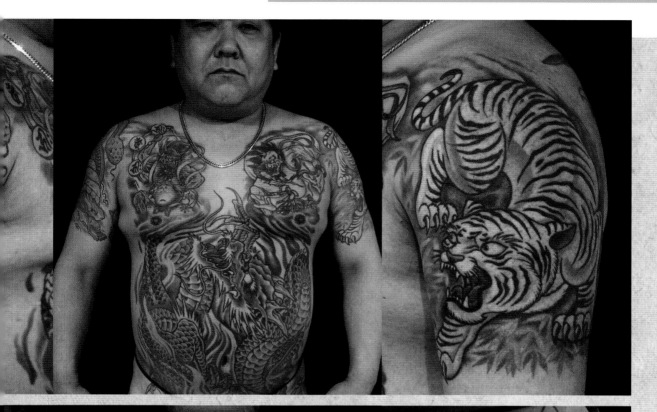

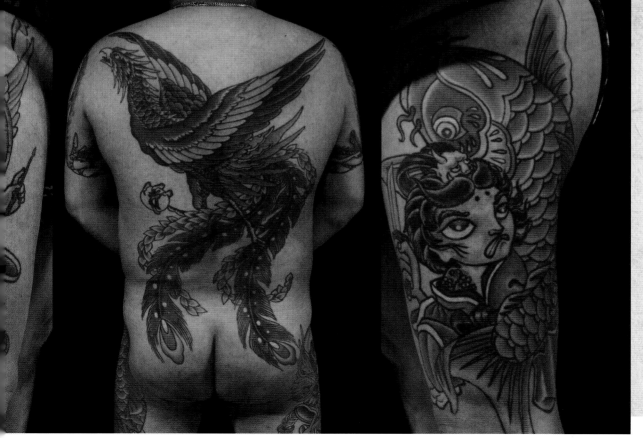

GODS AND GUARDIANS, HEROES AND DEMONS

Tattoos in Japan are a space in which the heroic and the hated, as well as the divine and the demonic, can congregate. *Irezumi* can be spiritual; they can offer protection; they can be something to aspire to; or they can be a reminder of humankind's delicate and flawed existence.

Right Ryuotaro, the Dragon-King Boy, faces off against his mother, who has been turned into a dragon. In his right hand Ryuotaro holds her mirror, which reveals her human face.

GODS AND GUARDIANS

Japan is a polytheistic nation. Shintoism, the country's indigenous religion, is widely practiced alongside Buddhism, which came from India via China and Korea. Shinto rituals are often used for birth, and Buddhist ones for death. Because of this fluidity, irezumi designs mix deities and protectors from both religions. Gods and guardians from other religions are also part of the irezumi lexicon and do appear in tattoos.

Note that while Buddhist tattoos are considered sacrilegious in some parts of Southeast Asia, they generally are not in Japan. This could be because the inked images are not typically displayed openly.

KANNON: THE GOD OF MERCY

Originating in India, Kannon is the Buddhist deity of mercy and represents compassion. In Japanese, "Kannon" (観音) combines the characters for "observe" (観) and "sound" (音), underscoring the idea that Kannon can see and hear all pain. If you are having problems, then Kannon knows.

The bodhisattva Kannon was originally portrayed as a male, but can be shown as female in Japan—or, at least, can appear feminine. In irezumi, the feminine form is most common. There is a scriptural basis for the gender-bending, because according to the Lotus Sutra, the empathic Kannon can shape-shift to take pity. In some forms she looks like a loving mother; in another, she has a thousand arms to help as many people as possible, with an eye in each hand to see and help suffering.

Thousand-Armed Kannon is a fairly common irezumi design. As in painting and sculpture, all

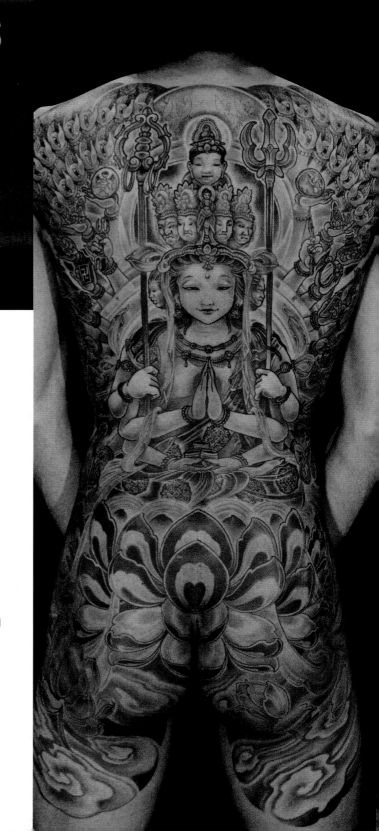

Right The hands of a Thousand-Armed Kannon fan out along the shoulders; they are balanced by the lotus petals below.

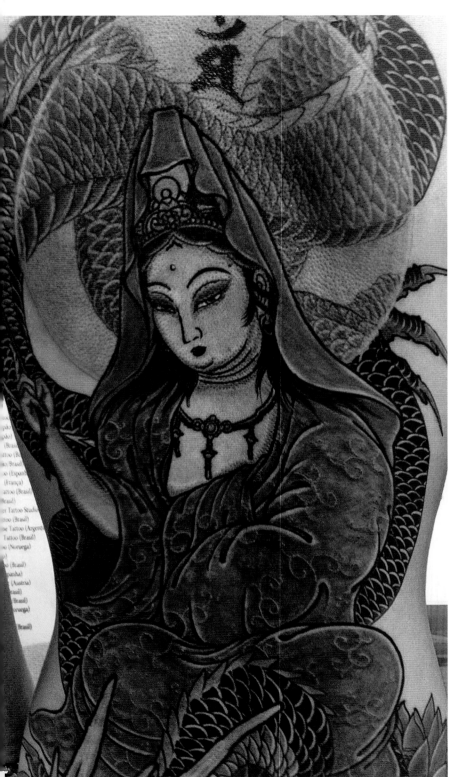

thousand arms are not actually depicted, for the obvious reason that doing so would be incredibly taxing. Instead, the number shown is 42: Two of Kannon's hands are pressed together in prayer, with the remaining 40 fanning out and holding an array of objects with symbolic meanings. A lotus flower, for example, represents enlightenment, while the Wheel of the Law represents Buddhist teachings. The number 40 is significant because each of the arms represents 25 worlds in Buddhism (and 25 times 40 is a thousand).

While Kannon has more than 30 forms, including the thousand-armed variety, not all of them are common irezumi motifs. Popular ones include Kannon riding a carp, which symbolizes the difficulty in reaching enlightenment, because—as in the parable of a carp jumping over the Dragon Gate to be transformed into a dragon—becoming a Buddha is no easy task. Another design shows Kannon riding a dragon, which evokes the deity's compassion and the dragon's strength.

The Affectionate Mother Kannon, which shows a female Kannon draped in robes and sometimes holding an infant, does appear in irezumi. There is a Christian reworking of the motif for non-Buddhists. During the 17th century, persecuted Japanese Christians, known as *kakure kirishitan* ("hidden Christians"), would pray to Virgin Mary statues and paintings created to resemble Affectionate Mother Kannon. Called Maria Kannon, this image often contained hidden crosses; it, too, is found in modern-day irezumi.

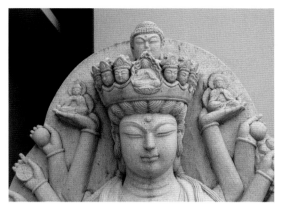

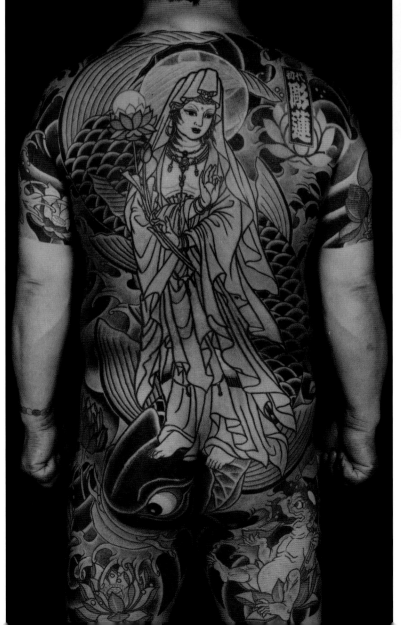

Above left A stone Kannon statue shows the deity's varied expressions. **Above** Kannon gently holds a lotus flower, a Buddhist symbol.
Left Dragons aren't the only creatures depicted with Kannon. Here, she stands atop a giant carp.
Opposite Kannon is borne on the back of a dragon.

DAINICHI: THE SUN BUDDHA

Dainichi, the "Great Sun" Buddha, is the central figure of the Esoteric Buddhist sects. The deity surpasses even the historical Buddha, Siddhartha of ancient India, in devotion among Japanese believers in mystic Buddhism. Dainichi is omnipresent and found in everything, so it's not surprising that this Buddha also turns up in irezumi.

In irezumi, Dainichi is often depicted sitting on a lotus with a halo of fire in the background. Esoteric Buddhism uses an array of complex and, yes, esoteric rituals and mystical practices, and it also puts emphasis on symbolic hand gestures called mudra. It's no accident that mystical Esoteric Buddhism is known in Japanese as Mikkyo, or "secret teachings." The mudra Dainichi makes is called the Mudra of Six Elements, referring to the five elements of earth, wind, fire, water, and the void, plus a sixth: the mind.

Drawing upon a rich artistic tradition dating back well over a thousand years, Dainichi is shown in an elaborate robe, sporting jewelry and wearing a crown. Like Amida (for more, see page 95), Dainichi is depicted with three chin rolls. For the Japanese, who have traditionally venerated the sun, Dainichi's solar connotations no doubt helped bring this Buddha closer to the national consciousness.

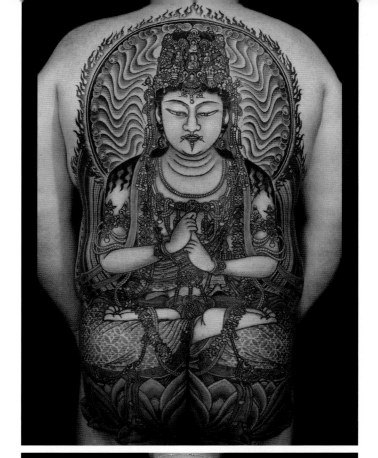

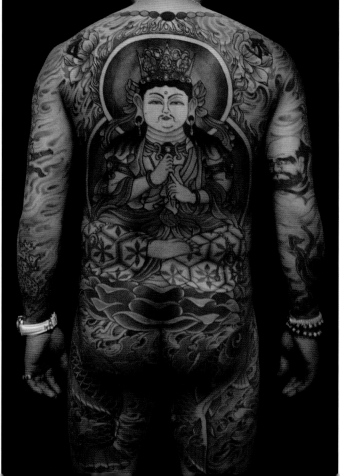

Right, above It's easier to express Dainichi's ornateness in a large backpiece. **Right, below** The Great Sun Buddha can be depicted without heavy coloration.

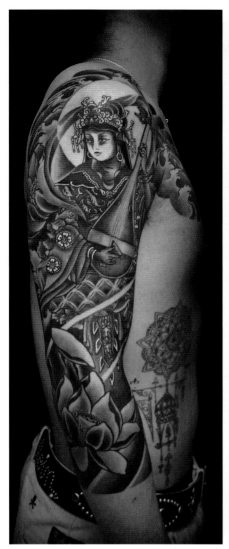

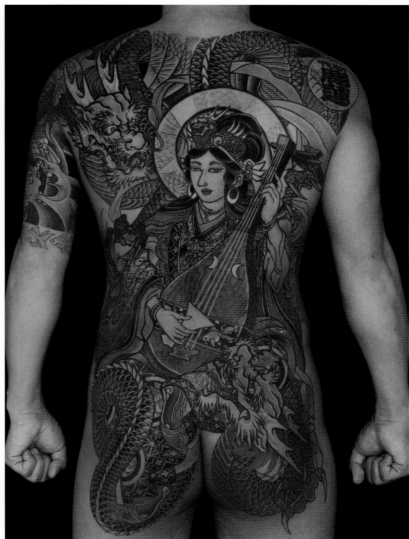

BENZAITEN: THE RIVER GODDESS

Originally an ancient Indian river goddess, Benzaiten is worshipped in both Japanese Buddhism and Shintoism. Few deities are as popular as Benzaiten, who is closely associated with water and the arts. The goddess takes different forms, including an eight-armed Benzaiten, but her most common appearance in tattooing is two-armed. In irezumi, Benzaiten is often shown surrounded by waves and playing the *biwa*, a Japanese lute. This softer Benzaiten imagery became popular in Japan after the 1200s. Because of her associations with water, Benzaiten can be depicted with dragons or even snakes, especially auspicious white ones. Her flowing robe echoes the curved body of the dragon and the waves of the water. She is also one of the Seven Gods of Good Luck.

Above left Benzaiten is shown plucking her biwa. **Above right** Even dragons are entranced by Benzaiten's musical virtuosity.

BISHAMONTEN: THE PROTECTOR

Bishamonten, a demigod of war and a protector against foreign invaders as well as a guardian of the Buddhist faith, was originally an Indian deity. Decked out in armor, the fierce-looking Bishamonten holds a small treasure monument in his left hand and a staff or a trident in his right. The monument, or *stupa*, is said to contain relics such as the Buddha's ashes, teeth, or hair clippings; these represent the core essence of Buddhism. Bishamonten, who is one of the Seven Gods of Good Luck, can dispense good fortune and wealth, and can also punish wrongdoers and protect against illness, since disease is wrought by evil.

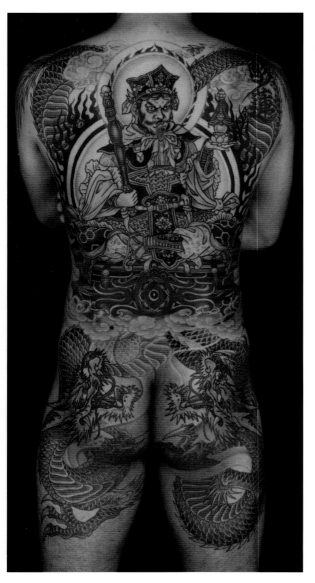

Left A stern-faced Bishamonten is depicted with a classic red and black palette.

DAIKOKUTEN: THE GOD OF PROSPERITY

Both the god of wealth and the god of the kitchen, Daikokuten was originally a fierce Indian deity, said to be an incarnation of the Hindu god Shiva. But in Japan, Daikokuten was combined with Okuninushi, a Shinto god of farming and commerce, because their names can be read similarly in Japanese. By the 1500s, Japanese images of this deity, found in both Shinto and Buddhism, showed a rotund and smiling god. Daikokuten is a benevolent spirit for rice paddies, with big earlobes that resemble Ebisu's—a god he is often mistaken for. Like Ebisu, he is one of the Seven Gods of Good Luck. With a sack of treasures slung over his left shoulder, Daikokuten carries a wooden mallet in his right hand that he uses to pound out wealth. This depiction appears in tattooing, as do close-ups of Daikokuten's smiling face.

Right Daikokuten holds a money-dispensing magical mallet, which is an easy way to identify the deity.

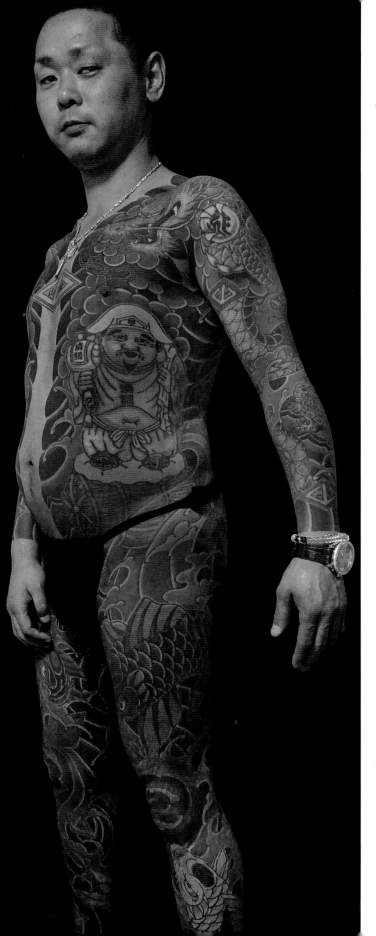

AMIDA: THE BUDDHA OF LIGHT

Known as the Buddha of Infinite Light, Amida is more venerated in Japanese art, sculpture, and tattooing than the founder of Buddhism, Siddhartha. Amida is a popular irezumi motif because of the infinite compassion the god offers, especially to those who have done wrong; as well as the promise that believers will never be abandoned. In irezumi, Amida is typically dressed simply with a slightly or fully exposed chest and depicted with three neck rolls. The deity sits atop a lotus flower, offering welcome into the Pure Land.

Prior to the 12th century, Japanese Buddhism was more aristocratic than it is today. Complex rituals and texts written in Chinese distanced the religion from the common field worker. However, a monk named Honen helped bring Buddhism to the masses by stating that all one needed to do to enter the celestial Pure Land was to say, "Namu Amida Butsu" ("I sincerely believe in Amida Buddha") and mean it with all one's heart.

This doctrine was reinterpreted, and one of Honen's followers, a monk named Shinran, founded perhaps the country's largest Buddhist sect, Shin Buddhism. This doctrine taught that saying "Namu Amida Butsu" didn't guarantee entrance into the Pure Land; it was instead a show of profound gratitude to the Buddha of Infinite Light. Regardless of interpretation, "Namu Amida Butsu" is a popular kanji tattoo in Japan (for more, see page 20).

Left Amida's hands are joined in a gesture of intense concentration. Buddhism has many different symbolic hand gestures, and Amida is typically depicted making this one.

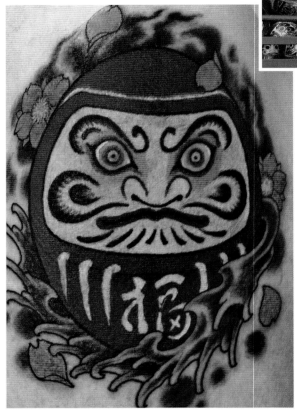

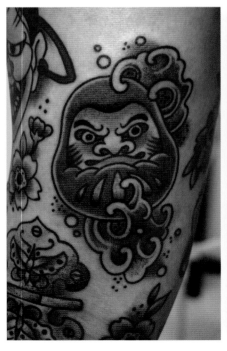

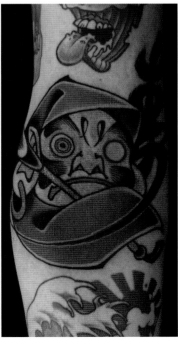

Above A collection of Daruma dolls. **Left** An intense gaze from Daruma's lidless eyes. **Below left** Daruma's compact size makes him ideal for small one-point tattoos. **Below right** This brush-wielding Daruma has yet to paint in his remaining eye.

Another legend says Daruma cut off his eyelids after falling asleep during meditation, explaining his wide-eyed expression. During a nine-year meditation, it's also said, his arms and legs became so weak and atrophied that they fell off (this is why Japanese Daruma dolls don't have arms or legs). Depictions of the monk in meditation represent uncompromising determination.

In Japan, there is a belief that painting in the eyes of a Daruma doll (or painting in the eyes of, for example, a tiger or a dragon mask) brings it to life. When a new project is started, one of the Daruma doll's eyes is painted in with a brush. When the project is completed, the second eye is filled in. A Daruma tattoo with one blank eye can show that the wearer has an unfinished goal, while tattoos with both eyes convey completion.

THE MONK DARUMA

Hailing from southern India, the monk Daruma (aka Bodhidharma) is said to have founded what is now called Zen Buddhism. Daruma is beloved in Japan, with a traditional game called Daruma Otoshi ("Knock-Down Daruma") in which a little hammer is used to smack out the bottom block from a stack of five colorful blocks. Today, children in snowy areas of Japan enjoy building *yuki daruma* ("snow Daruma"), which, unlike three-part Western snowmen, have only a body and a head.

As there are few hard facts about Daruma, many legends have sprung up about him. According to one rather suspect tale, the bushy-bearded Daruma got the monks at China's Shaolin Temple into martial arts.

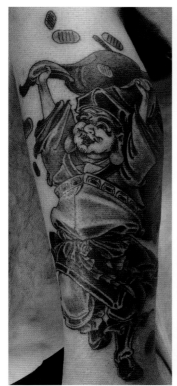

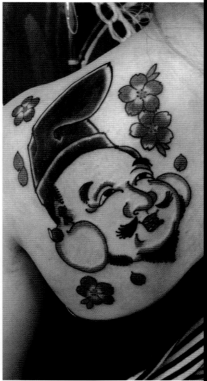

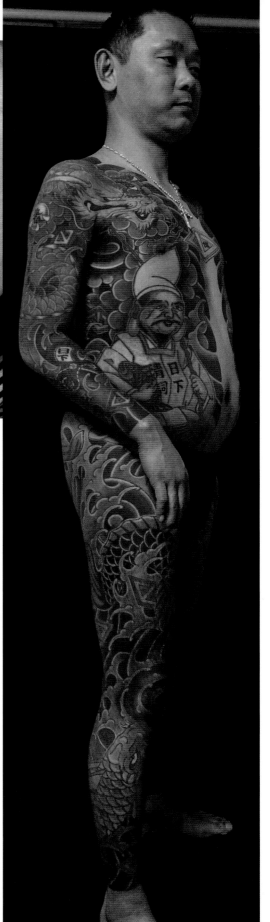

Above left Since Ebisu and Daikokuten can be difficult to tell apart, they are often mistaken for one another. Here, Daikokuten is depicted under falling coins. **Above right** Ebisu can also be identified by his distinctive headwear. **Right** Ebisu proudly clutches a prized red sea bream.

EBISU: PATRON OF FOREIGNERS

Famous as the god of business and fishing, Ebisu is typically depicted with a fishing pole or carrying a sea bream, an auspicious fish which is used in congratulatory celebrations. Ebisu has large earlobes, which in Japan are a sign of a wealthy person, and is typically shown smiling or laughing. These visual associations are, of course, also found in irezumi depicting the god.

Ebisu is often mistaken for Daikokuten, another Lucky God. The resemblance may be more than passing, since some legends say Daitokuten is Ebisu's father. Shinto shrines have been dedicated to Ebisu since the 12th century, and unlike the rest of the Lucky Gods, who come from India or China, Ebisu is now considered homegrown. However, he hails from modern-day Hokkaido, Japan's northernmost island, which was considered "foreign" by Japanese until the 20th century. This explains why Ebisu is also the patron of foreigners. He's also the only Lucky God to have both a beer and a luxury jeans line named after him. Talk about fortunate!

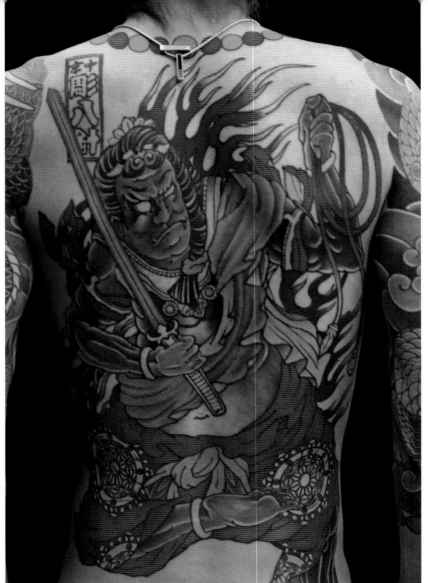

FUDO MYOO: IMMOVABLE WISDOM

The toughest-looking Buddhist deity, Fudo Myoo is a favorite of macho tattoo enthusiasts. This deity represents the wrath of the Dainichi (Great Sun) Buddha against evil. His name means "Immovable Wisdom King," and his strength is underscored by the rock throne upon which he sits.

Fudo Myoo is one of Buddhism's fiercest defenders. In his right hand he holds a sword (or sometimes an axe) representing both power and knowledge. His left hand usually holds a noose, which he uses to bind evil.

Fudo Myoo's expression is stern, with one fang pointing up while the other points down. A backdrop of flames represents cleansing by fire. Esoteric Buddhist sects in Japan perform fire ceremonies called *goma*, derived from the ancient Indian rituals, to destroy bad energy. During such purification ceremonies, Fudo Myoo is evoked.

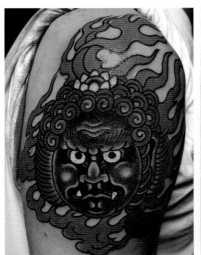

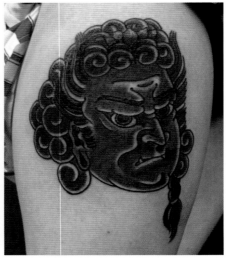

Left, above Fudo Myoo raises his sword and rope. **Bottom left** Fudo Myoo is usually encircled by flames...**Left** ...But not always. **Opposite, above left** In this somewhat unusual depiction, the typically seated Fudo Myoo takes a step forward. **Opposite, above right** This is a classic Fudo Myoo design. Outside Japan, the Wisdom King is also known as Acala. **Opposite, below left** Fudo Myoo's skin is usually shown in shades of blue or black. **Opposite, below right** Seated firmly upon rocks, Fudo Myoo is immovable.

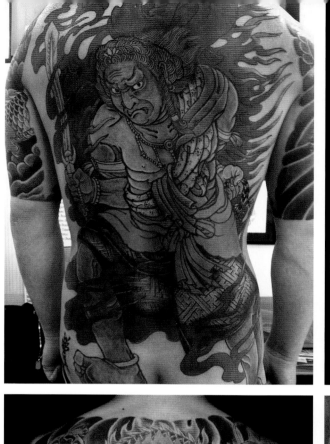

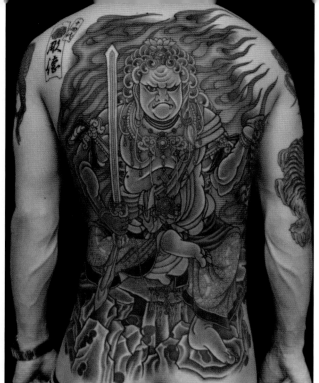

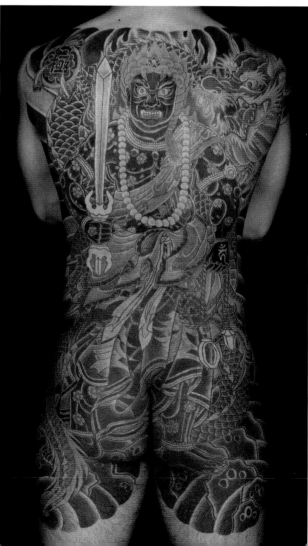

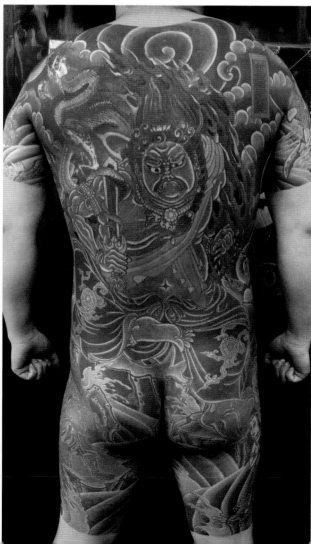

FUJIN AND RAIJIN

Fujin (風神) literally means "Wind God," while Raijin (雷神) means "Thunder God." Originally Indian deities that were adapted in China and later in Japan as Shinto gods, the cloud-dwelling Fujin and Raijin are typically paired in tattooing. So, for example, if one gets a Fujin tattoo on one shoulder (or an arm), then it makes sense to get Raijin on the opposite one for balance.

The set forms an *ah-un* pair, with Raijin sporting an open "*ah*" mouth to expel evil spirits and Fujin a closed "*un*" one to hold in the good spirits. "Ah" is the first letter in the Sanskrit alphabet, while "un" is the last. These mouthed gestures, which are common in Japanese art, appear throughout irezumi to balance pairs of gods or beasts (for more, see page 70). Raijin is red (or sometimes white) and surrounded by thunder drums. Fujin is often green and carries a bag of wind. The two are also among the 28 attendants of the Thousand-Armed Kannon bodhisattva (see page 89).

Right Here, Raijin is paired with the White Tiger (see page 64).

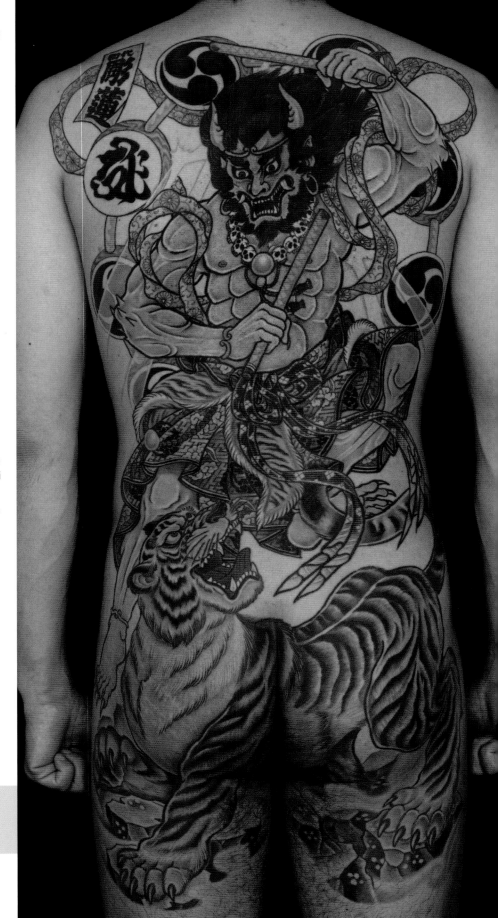

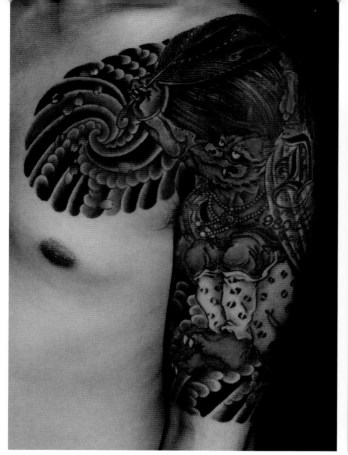

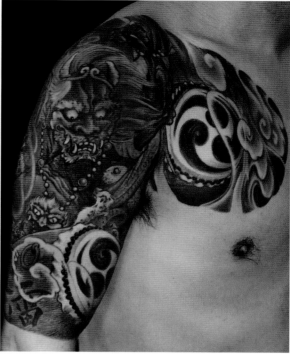

Above left Fujin is highlighted by a whirlwind of cherry blossoms. **Above right** *Mitsudomoe* symbols cover the faces of Raijin's drums. This symbol, which is important in Shintoism, also appears on Japanese roof tiles because it's believed to protect against fire. In addition to designs like this with triple *tomoe*, *hitotsudomoe* (single tomoe) and *futatsudomoe* (double tomoe) motifs also exist. Raijin, however, is usually shown with the mitsudomoe.

Below left The single-horned Fujin is depicted with a dragon-design chestpiece; both Fujin and the dragon are associated with wind. **Below middle** Lightning bolts shoot out from Raijin's circle of drums. **Below right** Gales of wind billow forth from Fujin's sack.

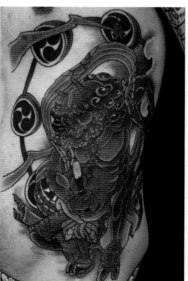

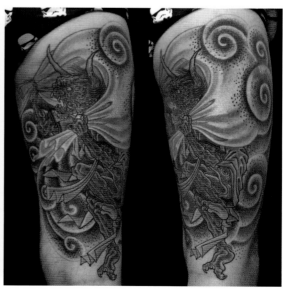

HOTEI: THE LAUGHING BUDDHA

Perhaps the most rotund of all the Seven Gods of Good Luck, Hotei wears loose-fitting clothes that expose his belly fully. In the West, he's often called "Laughing Buddha" or "Fat Buddha." Hotei is a wandering Buddhist monk from China—though according to some, he might have been an incarnation of a bodhisattva. He sometimes is depicted carrying a satchel, which is said to hold all mankind's needs including fortune and food, and a fan that grants good luck. Out of all the Lucky Gods, Hotei appears to be the happiest.

THE NIO GUARDIANS

The entrance at a Buddhist temple in Japan is typically flanked by a pair of buff Buddhist guardians called Nio, which literally means "benevolent ruler." They are also called *kongorikishi* (金剛力士) or, literally, "*vajra* wrestlers." (The vajra, which means "thunderbolt" or "diamond' in Sanskrit, is a ritual object resembling a small club that can be wielded as a weapon.) Like the guardian lions (see page 70) and Fujin and Raijin (see page 100), the Nio are a balanced ah-un pair.

The guardian known as Agyo is located on the temple gate's right side. With his hand raised and his mouth open, he is suppressing evil, keeping it out of the temple. On the left side of the gate is Ungyo, whose mouth is closed, keeping and protecting the good inside the temple.

In irezumi, the location of the Nio must correspond to their location in front of a temple. For example, if you get an opened-mouth Agyo tattoo, it has to be on the right side of the body. To make a balanced pair, a closed-mouth Ungyo tattoo must be on the body's left side.

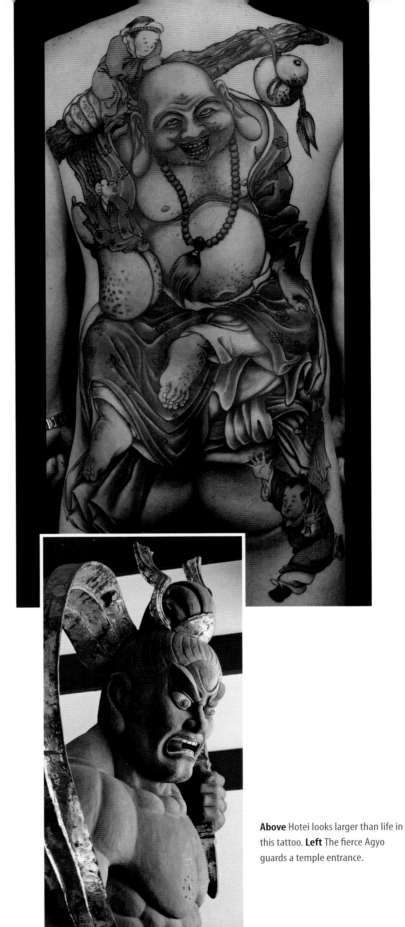

Above Hotei looks larger than life in this tattoo. **Left** The fierce Agyo guards a temple entrance.

TENNYO: CELESTIAL BEINGS

Drawing upon a long, rich tradition of Buddhist painting and sculpture, *tennyo* (天女, heavenly women) are celestial beings often depicted in the clouds, surrounded by cherry-blossom petals or peonies. Tennyo are decked out in five-colored robes: blue-green, yellow, red, white, and black. Some tennyo, called *karyobinga* in Japanese, have phoenix-like plumage and are known for their musical abilities.

With their phoenix connotations, tennyo can also be paired with dragons in irezumi. In her hand, a tennyo might hold a lotus flower, the longstanding Buddhist symbol of enlightenment; a drum and a drumstick, to echo the sounds of Buddhist teaching; or a lute representing the ephemerality of happiness.

Left Tennyo can also be brought to life with smaller designs. **Below left** A tennyo embodies the phoenix's grace and beauty. **Below** The open space in this tennyo tattoo gives it a calm and airy feel.

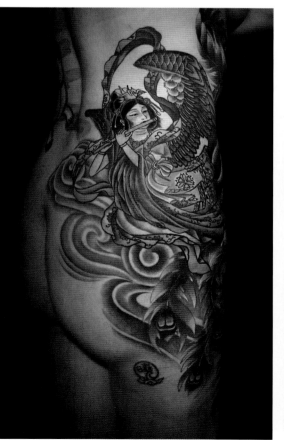

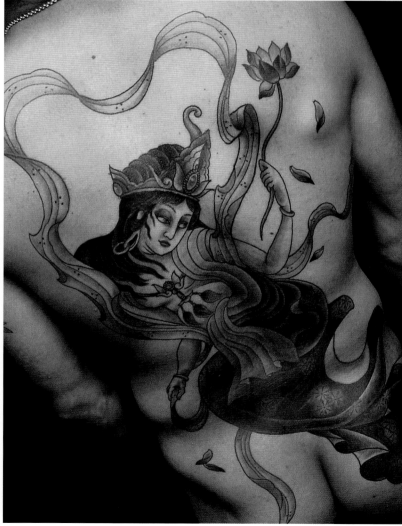

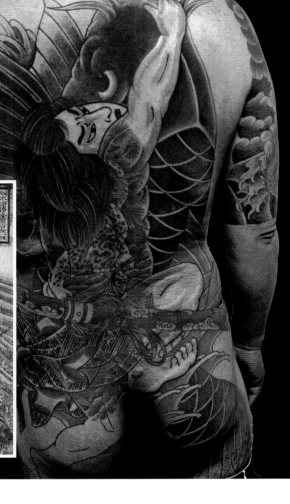

FOLK HEROES

Appearing in folklore and literature, these men and women have captured people's imaginations for centuries. They are inspirational, whether for their unflinching bravery or unwavering loyalty.

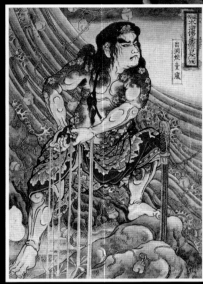

Right Tattooed *Suikoden* hero Shutsudoko-doi wrings out his drenched clothes after a narrow escape in this Utagawa Kuniyoshi woodblock print. **Far right** Heroes offer not only dramatic tableaus, but meta-tattoos within tattoos.

THE 108 SUIKODEN HEROES

Irezumi came into their own during the 19th century, thanks in part to a series of woodblock prints depicting the *Suikoden*, one of China's great literary classics, known as the *Water Margin* in English. The *Suikoden* follows the adventures of 108 honorable bandits and ruffians.

Japan had seen translated versions since the 1750s, and in the early 19th century artist Katsushika Hokusai completed the first illustrated *Suikoden*. Four of the heroes in the story are described as having dragon, flower, or wave tattoos. Hokusai showed these tattoos in his images, substituting Japanese motifs such as cherry blossoms or pine needles when appropriate.

With the text written in an accessible way that most Japanese could understand and featuring Hokusai's illustrations, the book was a smash hit, helping kick off a big *Suikoden* craze in Japan. For the history of tattooing, however, the *Suikoden* series that artist Utagawa Kuniyoshi did in 1830 had an even greater impact on irezumi.

Whereas Hokusai had shown just four tattooed heroes (there were only four in the original Chinese novel), Kuniyoshi depicted 16 of them, with huge irezumi motifs. Characters who didn't have tattoos in the original Chinese text were suddenly covered in permanent ink. Prior to Kuniyoshi's *Suikoden* illustrations, large decora-

tive tattoos had certainly existed in Japan, but he helped standardize irezumi at that time while also inspiring a generation of tattooists and tattoo enthusiasts. Kuniyoshi's art not only became a rulebook for how irezumi should look, but also showed what was possible.

As the century progressed, people would get motifs like those of the *Suikoden* heroes, or designs of them, creating a fascinating meta-image: a tattoo of a tattooed hero—what's known as *nijubori* or "two-layer tattooing" (for more, see page 106). Even today, the *Suikoden* heroes continue to inspire, and tattooists keep looking to Kuniyoshi's art for guidance.

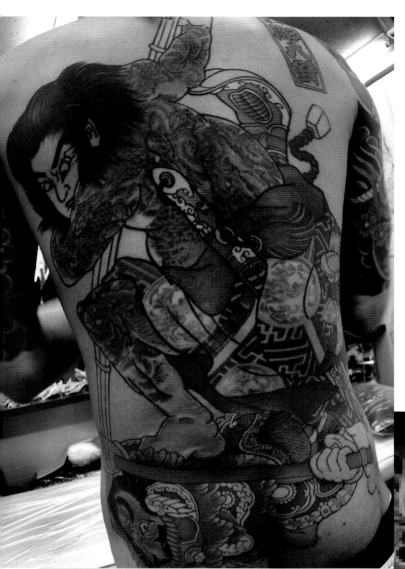

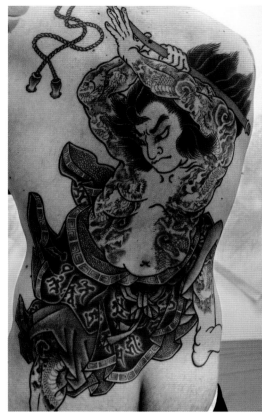

Above Among tattoo enthusiasts, Kyumonryu Shishin (Shi Jin in Chinese) is one of the most popular Suikoden characters. His name refers to the nine dragons he has tattooed on his body. In this tattoo, he is shown defeating the bandit Chokanko Chintatsu, who's covered in a full suit of armor. **Above right** Here's another prominent Kyumonryu Shishin, with the tattooed *Suikoden* hero striking a dramatic pose with his pole. While Kyumonryu Shishin is covered in ink, not all the popular *Suikoden* heroes are. **Right** A former priest, Kokusempu Riki (Li Kui in Chinese) is a hard-drinking gambler known for his short fuse and the two axes he carries. In this image, he's attacking the temple that expelled him. Note that, unlike Kyumonryu Shishin, he's not covered in irezumi.

SUIMON YABURI

Literally "destroying the floodgate," this is perhaps irezumi's most famous *Suikoden* tableau. One of the 108 heroes, Rori-hakucho Chojun (Zhang Shun in the original Chinese), is shown as he attempts to bust open the floodgate so the other heroes can lay siege to the rebel forces. He's discovered as he tries to open the gate, and enemy archers pelt him with arrows, killing him. The Suimon Yaburi motif shows the hero, sword clenched in his teeth, committing a brave, selfless act. Carp are sometimes added in the tattoo's waves, symbolizing strength and courage.

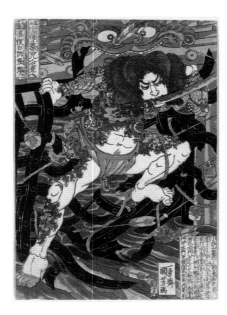

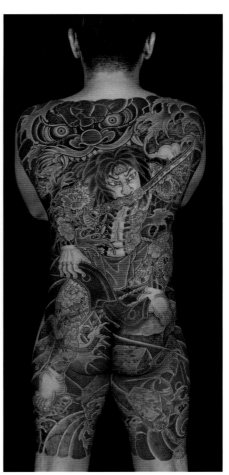

Above The original Kuniyoshi composition is a ukiyo-e masterpiece. **Right** Even if a tattooist is influenced by Kuniyoshi's work, he or she might put an individual spin on the composition and add unique flourishes. **Below** Tattooed heroes are irezumi's two-for-one deal: tattoos of people wearing tattoos.

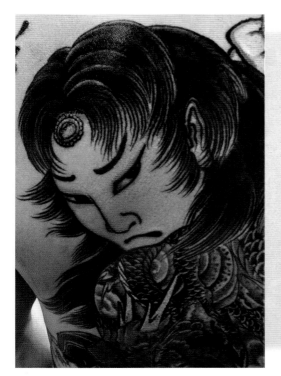

Tattoos within Tattoos
Japan's Meta-Irezumi

Sporting nine dragon tattoos, martial-arts master Kyumonryu Shishin (Shi Jin in Chinese) was one of the four characters with irezumi in the original Chinese version of the *Suikoden*. Kyumonryu Shishin is an example of nijubori, or "two-layer tattooing": The character is not only an irezumi motif, but he also has his own tattoos. Among enthusiasts, another popular example of two-layer tattooing from the *Suikoden* is Kaosho Rochishin (Lu Zuishen in Chinese), who's known as the "flowery monk" for his cherry-blossom tattoos. Since these characters tend to be large backpieces, tattooists have the space to detail the heroes' own irezumi. Other inked *Suikoden* heroes are likewise tattoos within tattoos, creating a playful visual expression.

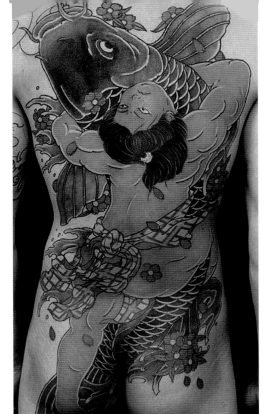

KINTARO: THE GOLDEN BOY

Kintaro is Japan's own folklore version of Hercules, based on a real tenth-century samurai named Kintoki Sakata. Tall tales of his childhood spent hanging out with his woodland animal friends are the stuff of legend. In irezumi, this strong boy is often depicted wrestling a giant carp under a waterfall, a popular print motif from the Edo period. When he's not tussling with tough fish, he's fighting (or riding) bears. However, the struggling carp story is the most common Kintaro design in Japanese tattooing.

While the popular tradition might depict Kintaro with a slightly ruddy complexion and a bib that reads "gold" (金) in kanji, in irezumi he's typically bright red, with the koi fish tattooed in black ink to create a dynamic yin-yang image. Woodblock prints from the 18th and 19th centuries depicting Kintaro in a similar manner are a direct inspiration. Since carp are viewed as powerful fish in Japan, this choice of image shows just how strong the Golden Boy is.

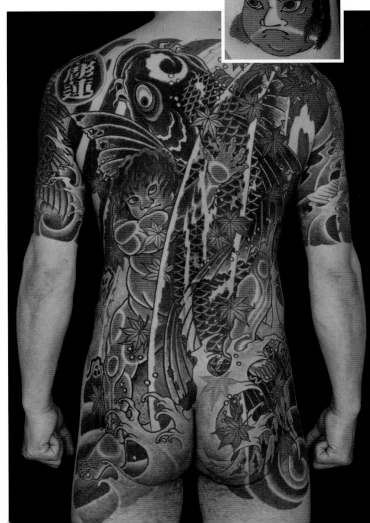

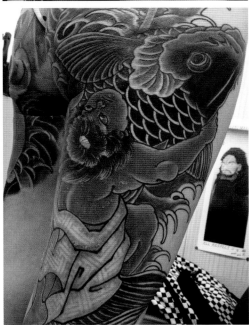

Top Kintaro tussles with the koi, while the *sakura* indicate a spring setting for this tattoo. **Above** Heroic tattoos don't necessarily have to be on the back. **Right, above** They can even be one-point designs. **Right** The maples set this Kintaro tattoo in the fall, while flowing and crashing water gives it a sense of depth.

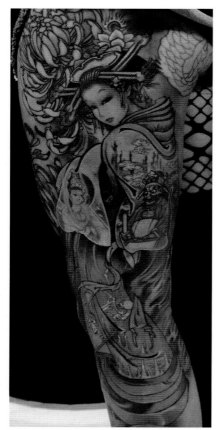

JIGOKU DAYU: THE COURTESAN OF HELL

Literally "Hell Courtesan" in English, Jigoku Dayu is a reformed high-class courtesan who achieved enlightenment thanks to the Zen monk Ikkyu. The back of her robe is covered with images of skulls, flames, and Emma-o, the Buddhist ruler of Hell—all of which symbolize her debauched time as a prostitute. The robe's front, however, depicts Kannon, the Buddhist deity of mercy, underscoring the understanding the Zen monk showed her. In irezumi, Jigoku Dayu is typically paired with cherry blossoms, symbolizing fleeting beauty; or with chrysanthemums, which symbolize the imperial throne and also have funeral associations. Chrysanthemums allude to the term *tayu*, which refers to a courtesan's highest rank, but also add a sense of doom and death. Jigoku Dayu is a popular motif among both men and women, and an ideal one for those who've turned a corner in their lives—or at least aspire to do so.

SHOKI: THE DEMON SLAYER

Shoki the Demon Slayer, a character from Chinese folklore, was extremely popular in Japan during the Edo period—and there are numerous woodblock prints to prove it! Shoki was no demon; he was the guy called in to slay 'em. Among the many legends, the most common ones tell of Shoki expunging a demon that was making the eighth-century Tang emperor Xuanzong sick. Because of this, Shoki has become a protector against evil and illness. This may explain why, in some parts of western Japan today, small ceramic Shoki dolls are placed on roof tiles, over doorways, and in front of windows to keep out evil spirits and—more importantly—disease. Shoki tattoos serve a similar function, but on the closest, most immediate level possible: one's own body. In irezumi, Shoki is typically shown quelling an *oni* demon. He may also be depicted with a tiger, an animal believed able to cure sickness.

Left, above Here, Jigoku Dayu is paired with chrysanthemums. Note the intricate designs on her robe and the flames that surround it. **Left** Once again, a chrysanthemum makes an appearance. Jigoku Dayu's robe, however, is emblazoned with lotus flowers, and her appearance isn't one of beauty, but horror.

Far right Benkei's weapon juts out toward the viewer, leading the eye up to his torso, which is riddled with arrows. **Right** An intense Shoki faces off with an equally intense demon.

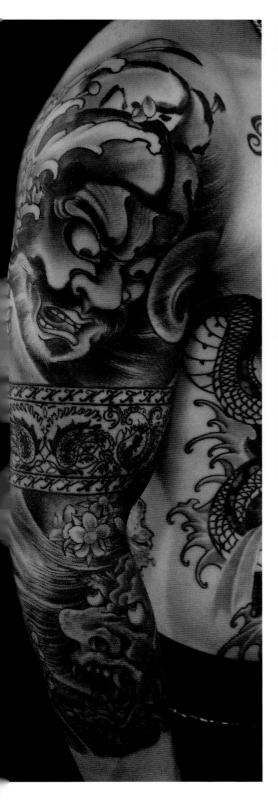

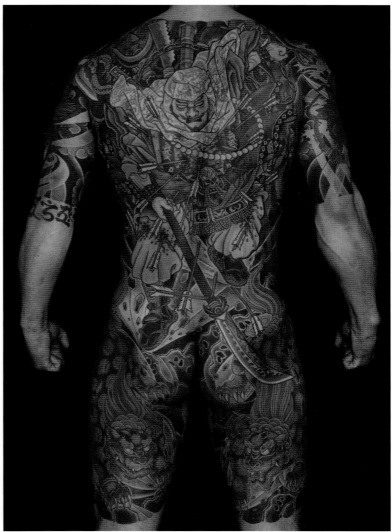

BENKEI: THE GREAT WARRIOR

This great 12th-century warrior monk was known for his strength, enormous size, and loyalty. According to legend, Benkei spent 18 months in his mother's womb; when he was finally born, he was three times larger than normal babies, with teeth and long hair. As a boy, he was called Oniwakamaru, or Demon Child (for more, see page 110).

In one of the most famous stories, Benkei fought off more than 300 soldiers in front of a castle so that his lord, Minamoto no Yoshitsune (aka Ushiwakamaru), would have enough time to honorably commit seppuku. At the end of the battle, the enemy soldiers noticed that Benkei was pierced with arrows and had died in a standing position.

This tableau, showing a determined Benkei with sword drawn, riddled with arrows, makes for a powerful irezumi design, underscoring themes of loyalty and determination. This is why isn't uncommon to see Benkei, a loyal friend and servant, paired with his master Ushiwakamaru, one of Japan's most famous and tragic samurai, in irezumi.

ONIWAKAMARU: THE DEMON CHILD

Oniwakamaru is sometimes confused with Kintaro (see page 107), because both fought giant carp. In irezumi, Benkei is often depicted in a design called "Oniwakamaru Conquering the Carp" (鬼若丸の 鯉退治, *Oniwakamaru no koi taiji*). A young Benkei has his knife drawn, ready to plunge it into the giant fish that has been terrorizing a village. Benkei—unlike the ruddy carp-wrestling Kintaro, who is often buck naked—has pale skin and is clad in a kimono.

Right Unlike Kintaro, Oniwakamaru carries a blade. He sometimes has it clenched between his teeth, as in this woodblock print by Utagawa Kuniyoshi.

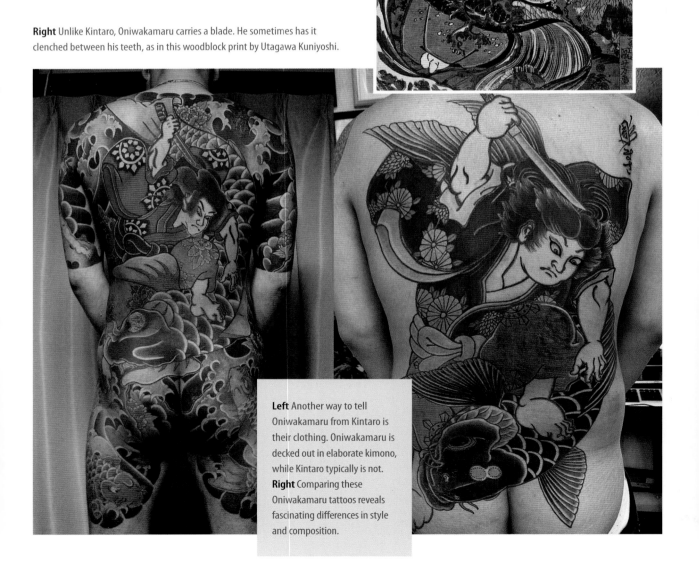

Left Another way to tell Oniwakamaru from Kintaro is their clothing. Oniwakamaru is decked out in elaborate kimono, while Kintaro typically is not.
Right Comparing these Oniwakamaru tattoos reveals fascinating differences in style and composition.

TAMATORI-HIME: THE SELFLESS HEROINE

As the legend goes, the Chinese emperor sent gifts to Japan after the powerful politician Fujiwara no Kamatari died in 669 AD. Fujiwara established the dominant Fujiwara clan, which controlled Japanese politics until the 12th century, and had sent his daughter to live in China with the emperor.

One of the gifts, a priceless pearl, ended up underwater, stolen by the Dragon King during transit. Fujiwara's son, Fujiwara no Fuhito, pledged to retrieve the precious gift. During his search, he met a beautiful woman named Ama. The two fell in love, and Ama gave birth to a son.

When Fujiwara no Fuhito finally revealed that he was trying to get the stolen pearl back, Ama pointed out that she was a diver. (The word *ama* means "diver"; Japan has a long tradition of women free-diving for seaweed, lobsters, and pearls.)

Knife in hand, Ama dove deep under the water and snatched away the pearl from the sleeping Dragon King, who awoke and was soon in hot pursuit. To escape, Ama slashed her breast and inserted the pearl, knowing that dragons were repulsed by blood. When she was pulled out of the water, Fuhito saw that she was empty-handed. But as she lay dying, Ama said, "My breast." The pearl was retrieved.

The irezumi motif tends to depict Ama at the moment she holds the pearl in one hand and her blade in the other. She can also be paired with a dragon. Ama is usually shown topless, as these free-drivers wore little clothing until the mid 20th century. The legend of Tamatori-Hime

(Jewel-Snatching Princess) has come to symbolize not only the love in a woman's heart, but a brave, selfless act to help the lives of others.

Right In this Utagawa Kuniyoshi woodblock print, Ama clutches the pearl in one hand and brandishes a knife in the other. **Below** Ama doesn't have tattoos in the legend, but some horishi do incorporate them. Seeing how there are stories of ancient Japanese divers sporting tattoos to protect themselves against dangerous sea creatures, irezumi are a fitting addition.

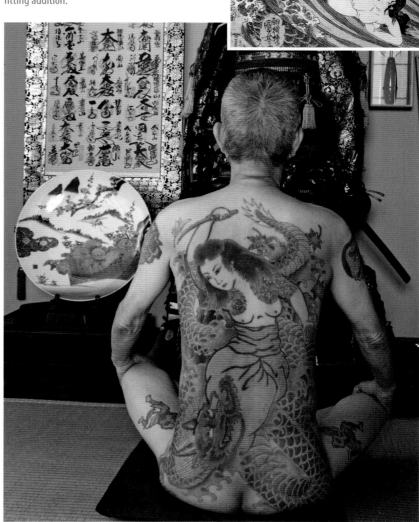

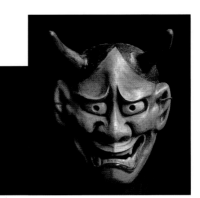

FEARSOME DEMONS

Some of Japan's most famous demons are not pure evil. They can be nuanced representations of powerful emotions, offer protection, or depict the fragility of life and the brutality of all it encompasses.

THE HANNYA MASK

Depicting a serpent-demon with horns, this Noh mask is perhaps one of Japan's most iconic artistic designs. The Hannya mask makes an appearance in several Noh plays, transforming an attractive woman into a demon to demonstrate how something beautiful can turn into something terrifying.

The origin of the name Hannya isn't clear. One theory says it refers to a late 15th-century mask carver named Hannya-bo. Another says the name refers to Buddhist notion of *hannya* (般若, wisdom).

In Noh—and in irezumi for that matter—horned Hannya masks are depicted in different colors. The white ones are for upper-class characters, while red variations are for lower-class characters or true demons.

In Japan, horns represent anger. Even today, the Japanese gesture for being pissed off is putting your pointer fingers on each side of your head. When a woman is married in a traditional Shinto marriage ceremony, she wears a headdress called a *tsunokakushi*, or a "horn concealer." Make of that what you will!

The Hannya mask is not simply angry or scary. As with all Noh masks, the carved expression appears to change depending on the angle it's viewed from. The Hannya mask, however, is particularly complex,

allowing actors to convey a range of emotions with a tilt of the head. At one angle, the Hannya mask can express the character's rage, while at another it shows jealousy. It can even show sorrow. This iconic mask is the pinnacle of Noh theatrical expression, able to show a range of emotions that other masks simply cannot match.

In irezumi, Hannya masks are sometimes stand-alone pieces. But they can also be grouped with other masks, such as one of a *tengu* (see page 118) or a white fox. This design is called *o-men chirashi* (お面チラシ, a scattering of masks).

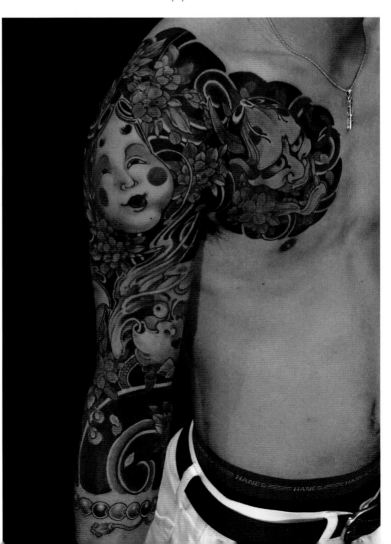

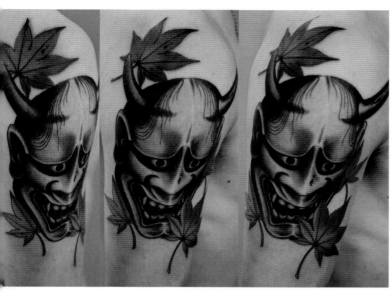

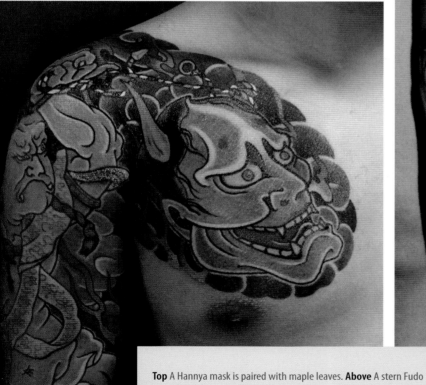

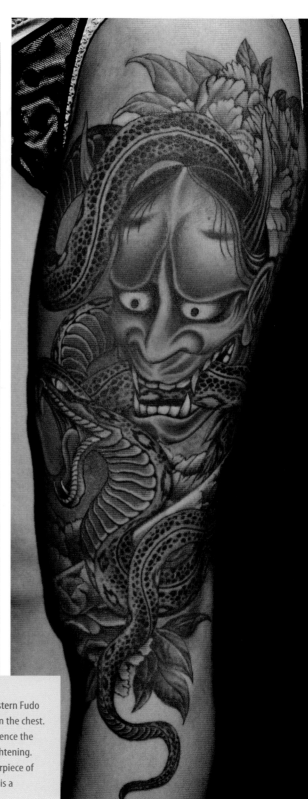

Top A Hannya mask is paired with maple leaves. **Above** A stern Fudo Myoo on the arm is joined by a Hannya mask and flames on the chest. **Right** The snake and peonies are both spring symbols—hence the pairing. The Hannya mask makes the snake even more frightening. **Opposite, top** In Noh theater, the Hannya mask is a masterpiece of carving and design. **Opposite, bottom** An o-men chirashi is a suitable way to unify a sleeve with different motifs.

ONI: THE JAPANESE OGRE

Translated as "ogre" or "demon," oni are muscular and brutish. In irezumi as well as the popular tradition, oni have red, blue, or green skin, and carry clubs or spears. In tattoos they are sometimes shown with three eyes instead of just two. They also have three fingers (sometimes four) on each hand and horns on their heads to help differentiate them from humans. They are not of our world—thank goodness.

Originally shapeless, oni took on form after passing through the Demon Gate, which is located in the northeast according to Japanese cosmology. The northeast is called *ushitora* (丑寅, which literally means "ox tiger") and is considered an unlucky direction.

In irezumi, as well as throughout Japanese folklore, oni are depicted

with the fangs of tigers, and are often shown wearing a tiger-print loincloth (sometimes, however, irezumi oni wear a plain loincloth). In irezumi, oni can be paired with tigers due to these associations, with a typical motif being a tiger stepping on an oni or an oni mask—thereby stamping out evil. The horns on their heads, which make the oni look extra demonic, are from bulls. The female oni, called an *onibaba* ("demon hag"), is depicted with a horned Hannya mask. The onibaba is not muscular or decked out in tiger stripes like her male counterpart, but that doesn't mean she's any less frightening.

While oni have been known to eat humans in a single gulp, not all oni irezumi should be viewed as evil personified. Oni can also be used to ward off evil, as evidenced by the *onigawara* roof tiles found on Buddhist temples. These tiles with oni carvings, which are found on the building's corners, have a symbolism much like that of gargoyles in medieval Europe, and frighten away evil spirits. Oni tattoos can function in a similar way. In modern times, oni are sometimes shown as rather cute, but irezumi largely adhere to the traditional demonic depiction.

Above left The oni's red skin contrasts with the yellow tiger skin it wears. **Left** Oni heads also make suitable stand-alone tattoos.

NAMAKUBI: SEVERED HEADS

Namakubi, meaning "freshly severed head," are one of irezumi's grimmer motifs. They show battered and bloodied faces, including those of samurai warriors and geisha, with short blades or arrows piercing their cheeks or skulls. The faces

are sometimes wrapped in rope, implying that they were carried or strung up. The end result is both frightening and disturbing—which is the point. These are supposed to be blunt reminders of life's brutality.

Namakubi appear

in Buddhist imagery as well, often run through with tridents or spears. In that case, however, they represent the grisly demise of Buddhism's enemies.

Namakubi designs were not created in a vacuum. Decapitation was a part of life in samurai Japan, being meted out not only as punishment, but also as a humane part of seppuku. After a samurai cut open his stomach, a sword-wielding spotter called a *kaishakunin* would then slice off the suicidal samurai's head so he could die quickly instead of bleeding out.

Among the samurai class, there was a tradition of collecting the severed heads of enemies. The heads of lower-status losers got dumped in a pile, while those of more elite rivals were purified in sake and placed in lacquered boxes. Severed heads were also publicly displayed as a gruesome warning to anyone even thinking of defying the ruling class.

While they look traditionally Japanese, namakubi tattoos are oddly universal, showing the darkness of those who dish out this punishment and the bravery of those who accept it, whether in feudal Japan, 18th-century France, or modern-day Afghanistan and Iraq.

Above left Red looks striking when it's tattooed as blood, and the borderless shading makes it look like it's spraying everywhere.
Left In namakubi designs, the faces and heads are often pierced with weapons.

VENGEFUL YUREI SPIRITS

Yurei are spiteful spirits, often with a grudge to bear. Maybe they were murdered. Maybe they committed suicide. Maybe they lost a child, or perhaps they want to commit revenge. For whatever reason, they are unable to move into the next world. There are numerous yurei legends, but there's one thing they all share: sheer terror!

Left Flames and wind swirl, making this yurei tattoo even spookier. **Left, below** There are different variations of the *kosodate yurei* (child-raising yurei) legend, but they typically tell of a woman carrying a baby. When followed, the woman is found in a freshly dug grave holding a crying infant.

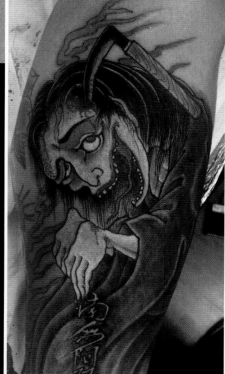

Right If you look closely, you can see part of the Buddhist prayer Namu Amida Butsu (南無阿弥陀仏) written below the yurei. This prayer is said to be effective against evil spirits. For more on Namu Amida Butsu, see page 95.

MONSTROUS YOKAI

Yokai are more than simply Japanese monsters. They're the creatures of the country's folklore. Sometimes they're good, and sometimes they're very bad. No wonder parents have traditionally used yokai to scare children from doing things like going into creeks and rivers alone—or even acting like brats. And no wonder kids have used them to scare each other. There are yokai throughout Japanese pop culture, and it shouldn't be surprising that they also appear in irezumi.

Here are some, but definitely not all, of the most prevalent yokai in tattooing.

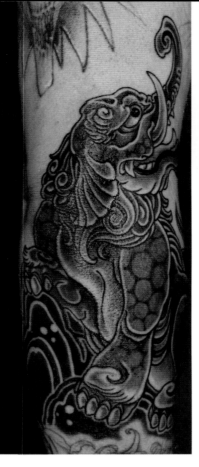

BAKU: EATER OF DREAMS

This creature eats dreams. The *baku* is a hodgepodge of animals, sporting the head of an elephant, the body of a bear, the claws of a tiger, the tail of an ox, and the eyes of a rhino. While certainly not the best-looking beast around, the baku is considered auspicious because it devours nightmares.

Above A baku carving at a Buddhist temple in Japan. Similar carvings are also found at Shinto shrines. **Left** While the baku is one ugly beast, it's a powerful talisman tattoo.

CHOCHIN OBAKE: PAPER-LANTERN GHOST

This is a lantern that has spent a long period of time in the service of people. It has sprouted not only an eye (usually only one!), but also a long tongue. This yokai doesn't usually cause physical harm, but rather inspires fright.

The *chochin obake* is a type of *tsukumogami*, which are essentially haunted relics. These objects have become animated over many years of use. This idea is tied to the Japanese religious belief that everything, even the objects we own, has a soul.

Right These lantern goblins can be easily identified by their protruding tongues. Some are one-eyed, but there are two-eyed versions. Chochin obake are even known to sprout arms. **Far right** This two-eyed chochin obake has a flame for a tongue. Note that the paper-lantern ghost is sometimes confused with the wrathful yurei Oiwa, which Hokusai famously depicted in a woodblock print with two eyes and stringy hair. That spirit, however, is different from the chochin obake.

KASA OBAKE: THE UMBRELLA GHOST

This yokai is often considered a tsukumogami. Relatively harmless, the *kasa obake* is known to sneak up on people and lick them.

KAPPA: WATER GOBLIN

An aquatic species of yokai, *kappa* are able to live in rivers, lakes, and other wetlands thanks to the water-filled dish on their heads. These yokai are also known to grab swimmers' ankles, pull them underwater, and drown them. Oh, and kappa can also remove the intestines of the unsuspecting by sticking a fist up the person's, um, anus.

Left Kappa depictions can be cute, as seen with this stone sculpture.

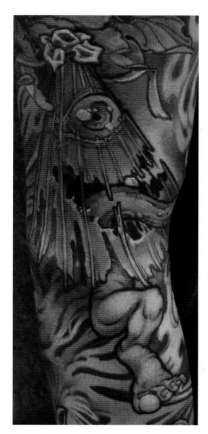

Above Instead of a handle, these ghouls have a man's leg. Kasa obake are also called *karakasa obake* (から傘お化け, paper umbrella ghosts). **Right** Here, a kappa is paired with a spring motif of cherry blossoms and a snake. **Far right** A kappa strikes a dramatic pose, with waves crashing all around.

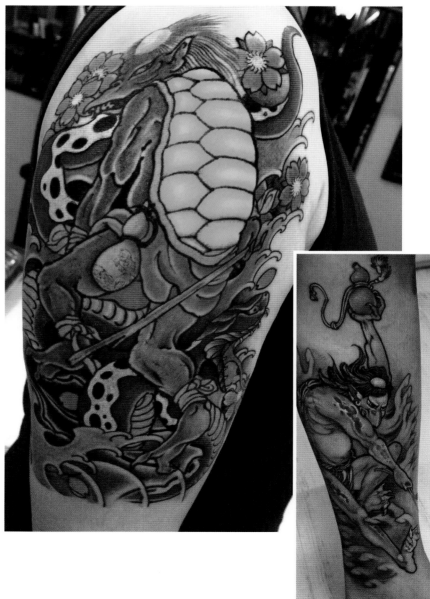

TENGU

There are two species of tengu: the crow-like *karasu-tengu* and the red-nosed *hanadaka-tengu*. Karasu-tengu are famous for their ability to wield katana swords. Hanadaka-tengu, who are also handy with swords, appeared on so many playing cards during the 19th century that these yokai became closely associated with games of chance. Hanadaka-tengu are sometimes mistaken for the great Shinto deity Sarutahiko Okami, who also has a long nose and a ruddy face. Karasu-tengu, on the other hand, with their crow-like beaks and black feathers, are not.

Below A cheeky pairing of a karasu-tengu with a hanadaka-tengu. A pine tree is in the background. **Right, above** Karasu-tengu are usually depicted in garb resembling that of a Buddhist monk. It's said that these demons have the head of a dog, the beak and feathers of a bird, and the hands of a human. **Right, below** Actual tengu masks typically have gold-colored eyes, but in irezumi they are yellow. **Far right** Here, Ushiwakamaru (for more, see page 109) learns divine sword-fighting from a karasu-tengu as Sarutahiko Okami watches from above.

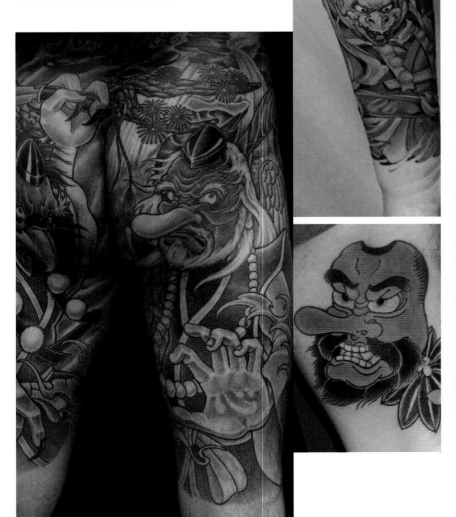

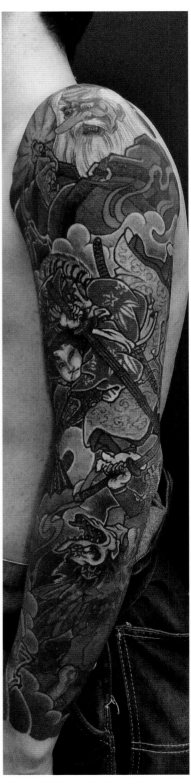

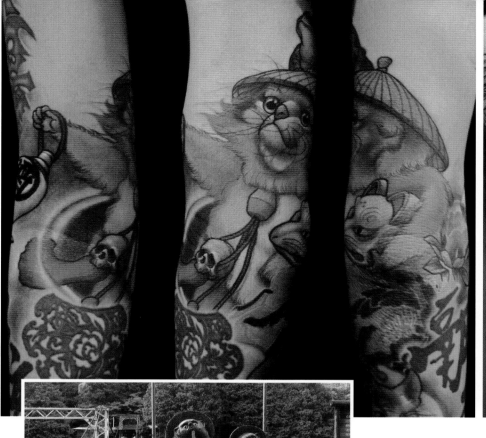

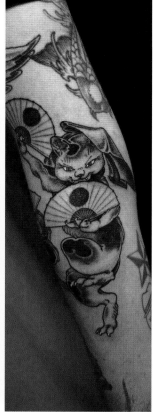

NEKOMATA CATS

These split-tailed felines can walk upright and even dance. They're not only able to converse with humans, but can raise and control the dead to bring vengeance on the living, which can entail killing and eating them. Lovely.

LUCKY TANUKI

A mischievous shape-shifter with enormous testicles, the *tanuki* is one of Japan's most beloved yokai. Tanuki are known to use their scrotums for blankets, tables, and even clever disguises. That old man in a shawl? No, that's just a tanuki with his nut sack wrapped around his noggin. Ceramic tanuki are often placed in front of houses and shops for good luck. The idea is that with nards as big as tanuki have, plenty of good things will come your way, because the Japanese word for testicles (*kintama*) literally means "gold balls."

Top left A modern tanuki depiction showing the mischievous critter carrying a *kitsune* fox mask. **Top right** A *nekomata* does a fan dance. **Above** A group of ceramic tanuki spotted outside a train station in rural Kyoto. **Right** Nekomata can also be accomplished shamisen players. Even with those claws, they still need to use a pick.

STACE FORAND

FALLING IN LOVE WITH JAPANESE ART

Walking through the swinging bar-style doors, Stace Forand grabs a seat at his station at the Steveston Tattoo Company in Richmond, British Columbia. The inside of the studio looks like a saloon where tattoos, instead of drinks, are served.

It's late, and the studio is quiet after a busy day of work. Near Forand's station, a green Hannya mask hangs on the wall, next to a cabinet he personally decorated with three *maneki neko*. Perched on top is a Daruma statue. "I have more of my most personal stuff at home," says Forand. That includes his beloved Japanese art books.

"I had ditched class and was hanging out in the library," recalls Forand, who was then 19 years old and a student at the Alberta College of Art and Design in Calgary. (He never saw art as a career, though; as he says, "that sounds pretentious.") As he was going through the dusty stacks, he found a book that would change his life forever: Kuniyoshi's *108 Suikoden Heroes*. He pulled the big, heavy book off the shelf, sat down, and flipped through the pages. The

tattooed heroes came alive and leapt off the page. "Each image got more and more elaborate," says Forand. "At that point, I realized that this was what I had been looking for."

Now 26 years old, Forand says, "The design and artistic fundamentals were strong, sure, but it was a natural gut reaction. I loved what I saw." And what he saw, a world away in Canada, was the basis of irezumi grammar.

"Growing up in the West, the only tattoos I had seen were on bikers," says Forand. Biker tattoos are cool, sure, but the irezumi Kuniyoshi depicted were unlike anything Forand had come across. "These images had soul," he recalls. "They took me out of this world and into another one entirely."

Inspired, he started thinking about tattooing as a career choice. When he should've been studying for

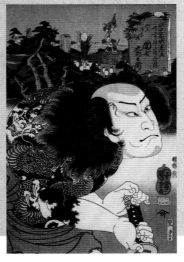

school, Forand was hanging out in tattoo shops, trying to learn all he could, gleaning as much knowledge as possible. He got his first tattoo machine, which wasn't wired properly and "basically blew up." It wasn't until he went to Japan when he was 20 that he finally got a proper machine—you know, one that doesn't explode.

"I felt like I had to go to Japan," says Forand. "I just had to." Irezumi had changed his life, and now the country beckoned. He spent a month backpacking across Japan, going to from temple to shrine, mega-city to small town. The art, the architecture, and the culture were inspiring. "But I needed to take something back with me that wasn't in a book." Forand rolls up his right sleeve, revealing a beautifully colored tattoo. "This is Kokuzo, the Buddhist god of artists and craftsmen," Forand says. When he first found that out, he was gobsmacked. "I thought that was crazy, because Kokuzo was the first

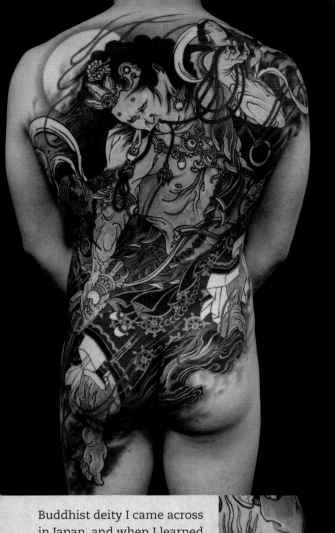

Buddhist deity I came across in Japan, and when I learned that this was the god of artisans, I thought, 'This is why I came here.'" Kokuzo is paired with a dragon in his tattoo because Forand was born in the Year of the Dragon. "I've always loved dragons," he adds, rolling down his sleeve to cover up the tattoo.

Forand isn't as proud to show off his other ink. Like many tattooists, his body is covered in a hodgepodge of work—some of it good, some of it not. "When I was just starting to get into tattoos, I got a whole bunch of Japanese-style stuff on my back that wasn't done so well—a Fudo Myoo, a Raijin, dragons, flowers, fire, a samurai warrior, you name it," he says. "But I haven't gotten them covered up with other work because they are a reminder to me that I don't want to do the same thing to other people. I want them to be proud of their tattoos. I want to be better for the sake of my clients."

When he's not tattooing, he's drawing. When he's not drawing, basically, he's eating or sleeping. Still young, Forand knows that so much of tattooing is putting in the extra work to improve one's craft—and that he's most certainly doing.

While Forand takes heavy inspiration from Kuniyoshi and the *Suikoden*, he's certainly not trying to copy them. "I'm not a Japanese tattooist," he says. "But in my own work, I try to honor Kuniyoshi's *Suikoden*. The reason is because it's given me a life. I owe everything to the *Suikoden* and Japan's irezumi culture. Forever, I'll be working in the service of that." Well over a hundred years after their creation, Kuniyoshi's ukiyo-e prints still inspire, and still—as Forand explains—take people out of this reality and put them in another one.

From the top of the cabinet next to Forand's chair, the one-eyed Daruma statue looks out over the studio. "I colored in one eye after I got back from Japan," he explains. The blank second eye is colored in when a goal is reached. What's his? Forand pauses, turning his head slightly to the side as if in thought. "I have too many goals," he says. "But I think if I ever went back to Japan, to actually work as a tattooist and not just to travel, that would bring me full circle, and I'd color in that second eye."

AKI
A SECRET TATTOO TO PROTECT OTHERS

"I thought the tattoo would take a year to complete, but goodness, it's taken two and a half," Aki says with a laugh. Her back is covered with an image of Koyasu-gami, the deity of easy child delivery.

After getting interested in irezumi in her late 20s, Aki decided she wanted a classic Japanese motif. "During consultations with the tattooist Horiren, who did this piece, my job naturally came up during the course of conversation, and the idea for this design was born."

Aki is in the healthcare profession. "Since my work is connected to childbirth, I wanted the tattoo's

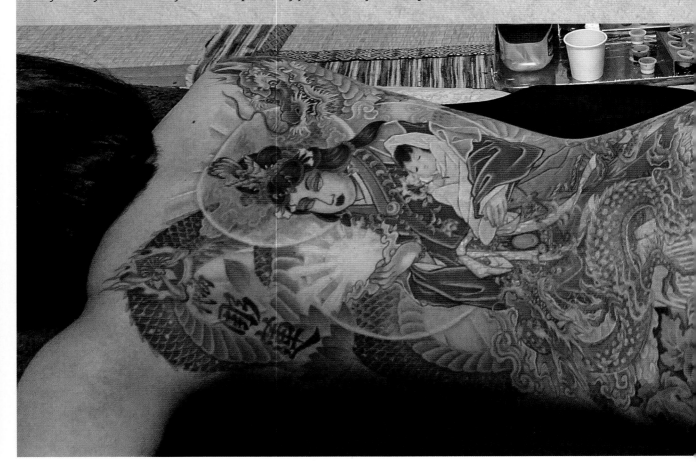

theme to depict a prayer for an easy delivery and to show the bond between mothers and her children." Her tattoo remains covered and hidden, because in the conservative Japanese medical field, in which doctors and nurses aren't allowed to have hair of any hue other than black, the tattoo could actually cost Aki her job—even if she got it to protect the mothers she serves.

Besides Koyasu-gami, the tattoo features a dragon parent and child, along with a white tiger parent and child. In Chinese mythology, the dragons rule the east, while the white tigers rule the west. Putting both together gives the tattoo an all-encompassing scale. A pomegranate, with its numerous seeds, is one of Koyasu-gami's tropes; it symbolizes fertility, as do the grapes. A peony is added for its medicinal associations, for its fertile spring connotations, and for its beauty.

The tattoo is nearly finished— except for the eyes. In Shintoism and Buddhism, the eyes are added to sculptures and paintings last, because they animate the creation, bringing it to life. "The plan is to tattoo the eyes at a Shinto shrine, but that is still being finalized," says Aki. "I'd like to receive a prayer for mothers and children, birth and reincarnation."

While this large backpiece is Aki's first tattoo, she is keen to gradually get more work done. However, that's not her only goal: "I want to live my life as an upstanding person and not do anything to bring shame to this tattoo."

Below The elements in this elaborate backpiece, a masterwork of composition, underscore the themes of fertility, birth, and protection. The color work is particularly impressive.

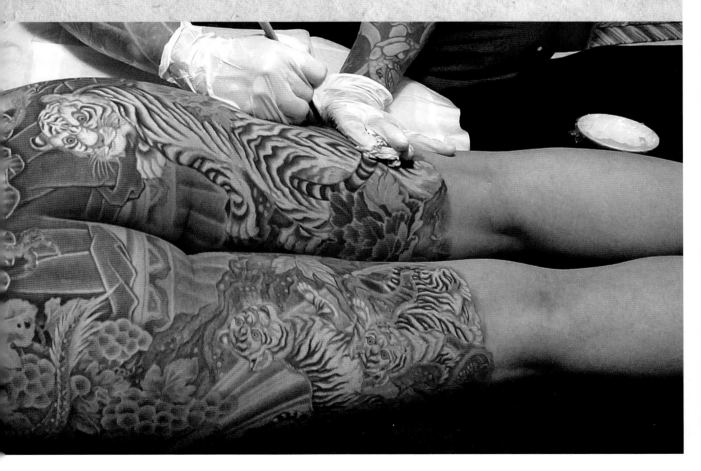

THE FULL BODYSUIT

The bodysuit is the fullest expression of irezumi. Everything comes together in one cohesive whole. For tattooers, the bodysuit can represent a singular vision—and the ultimate artistic challenge, with a thematic work created in real, living three-dimensional space. For clients, it represents hours, days, and years of pain, endurance, and, yes, money.

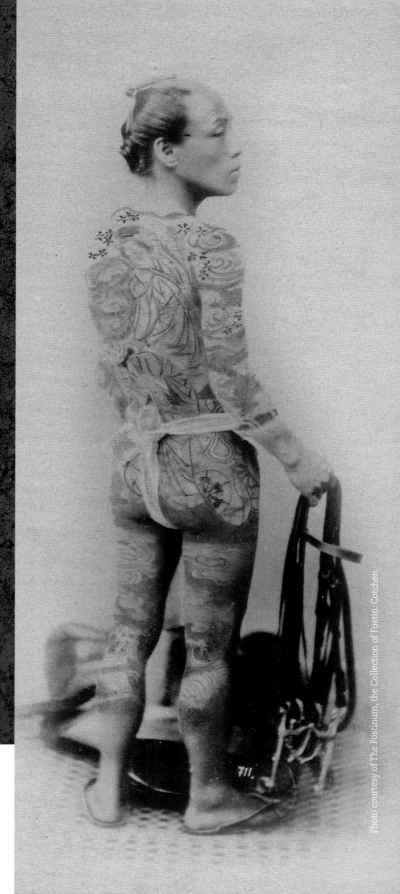

Right Taken by Felice Beato, this bodysuit photo dates from the 1880s. It was hand-colored and printed by Kusakabe Kimbei.

Photo courtesy of The Fostinum, the Collection of Fostin. Cotchen.

Like *irezumi*, bodysuits did not develop overnight. It's believed that large decorative works originally evolved as a way of covering up punitive tattoos that were applied as a penalty for breaking the law.

Over time, irezumi became increasingly elaborate. It would be a mistake, however, to assume everyone with tattoos got them to hide their past. During the Edo period (1603–1868), some people with bodysuits left the section from their armpit to near their elbow untattooed as proof that they didn't have punitive arm markings. By then, tattoos were already trendy among the country's youth.

The working class embraced irezumi. Messengers and palanquin bearers, as well as carpenters and locksmiths, had tattooed bodysuits. Most famous of all, perhaps, were the firefighters, many of whom were covered in tattoos. Throughout the 19th century, people who did physical labor were likely to get tattoos as symbolic protection for the body. And it was during this period that the Japanese bodysuit reached a golden age of expression that continues to influence modern-day tattooing.

There isn't one set type of bodysuit—clients can choose patterns from an array of styles. In that respect, irezumi are similar to tailored clothing, customized to one's liking. Of course, the difference is that this is a permanent suit.

Traditionally, it was men who would get bodysuits; women would get large backpieces, leaving the rest of their skin tattoo-free. Today, however, the distinction isn't as marked, and both men and women get whatever they like. Regardless of gender, the backpiece typically includes the buttocks, and can encompass the back of the thighs. This area, which would traditionally be covered by a thigh-length kimono jacket, is ideal for large tattoos, and is considered a single canvas in irezumi.

Bodysuits take years to complete—some might take as little as three years, but others might take decades or an entire lifetime—and it's not unheard of for a client to spend the equivalent of $30,000 or more.

Exposed Flesh
Tattoos for All to See

In Japan, there is a caveat for tattoing: Most people do not get irezumi on areas of flesh that are exposed when clothes are worn. This means that, in order to avoid being discriminated against for having tattoos, the neck, the face, and the hands must be left untouched (the top of the head, however, can be covered by hair and thereby hidden, so tattoos there are OK). Many tattooists won't tattoo people's faces, and might be reluctant to ink the hands of locals without a serious discussion first. Such visible tattoos can affect daily life in Japan, making things like getting a regular job, a bank loan, or even an apartment difficult. That being said, tattooists in Japan are known to have inked these exposed areas, although the face is typically left unadorned.

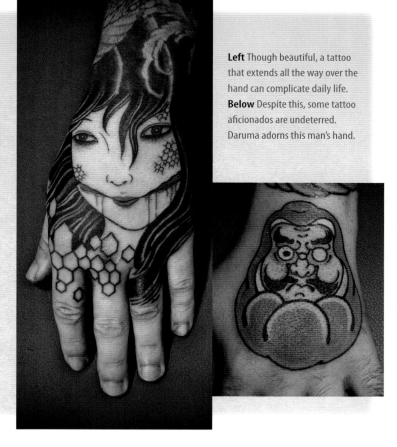

Left Though beautiful, a tattoo that extends all the way over the hand can complicate daily life. **Below** Despite this, some tattoo aficionados are undeterred. Daruma adorns this man's hand.

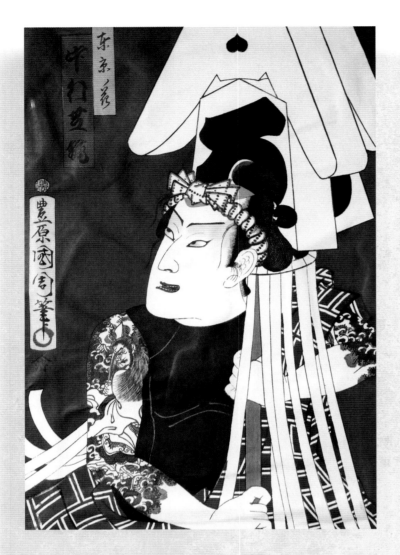

Firemen as Folk Heroes
Japan's Early Bodysuit Enthusiasts

In early March of 1657, the city of Edo (present-day Tokyo) was ravaged by fire for three days. Well over half the city was burned to the ground, and more than a hundred thousand people lost their lives in the Great Meireki Fire.

With wooden buildings packed closely together, fires were common in Edo. The Great Meireki Fire was by far the absolute worst, but other "great fires" throughout the centuries that followed killed thousands of people. To help combat the city's tinderbox problem, more men were enlisted into local firefighting brigades to protect each part of the city.

Putting out fires meant more than dousing them with buckets of water or simple hand pumps. Stopping the blaze from spreading was important. Firefighters carried hooks that they'd use to tear down adjacent structures to prevent the flames from engulfing the entire block. Understandably, many of these early firemen were manual laborers who worked in construction and knew how to level a building.

Edo firefighters became famous for more than just their ability to scale bamboo ladders and tear down houses. They were rough and bawdy, known for getting in fights. That might explain why the word *gaen*, the term for an Edo-period firefighter, took on another meaning: ruffian. They were also known for their irezumi bodysuits, which featured water-themed motifs taken from the *hanten* workmen's coats they wore, which they dipped in water before battling blazes. Hanten were covered with the brigade's symbols on the outside. On the inside, there were ornate water-themed designs like waves, dragons, koi fish, or Kintaro wrestling a giant carp.

By the 19th century, firefighters were the folk heroes. Getting a tattoo is painful, and irezumi became a way for them to show their bravery even before they quelled a blaze.

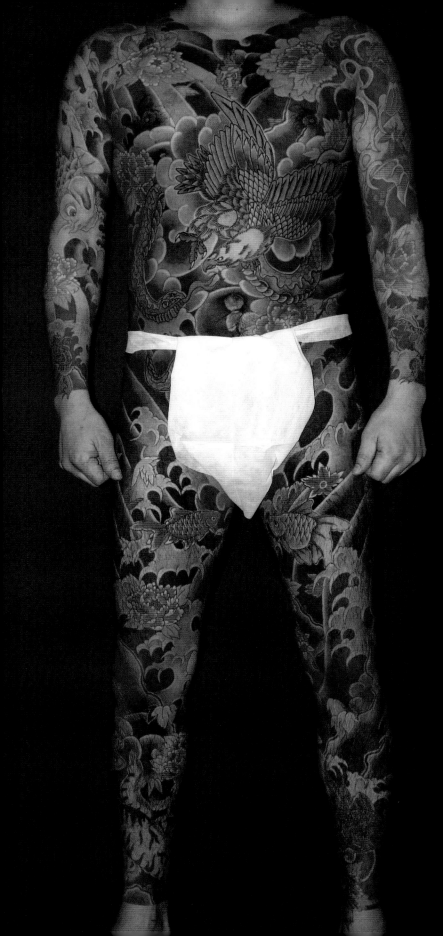

TYPES OF BODYSUITS

Japanese bodysuits are designed to be concealed under clothing. The various styles offer different ways to do so, whether that means going all the way to the wrist like a long-sleeved shirt or having the tattoo cut off at the biceps like short sleeves. Some bodysuits stop at the thighs like shorts, while others continue down to the ankles like a pair of permanent pants.

SOUSHINBORI: THE FULL BODYSUIT

Soushinbori is the full-tattoo bodysuit that goes from the wrists to the neck and then down to the ankles, leaving only above the neck, the hands, and the feet uninked. While it is a "full suit," the genitals aren't always adorned, because that layer of skin is thin, not exactly ideal for tattooing, and incredibly sensitive. Popular designs to cover the male bits, however, include snakes or long-nosed Tengu devils.

Soushinbori may also be called *donburi*, after the porcelain bowls that rice meals are typically served in, which feature elaborate designs everywhere except the unadorned top and the bottom rims. During the Edo period, another term for this type of bodysuit was *gaenbori*, which referred to tattoos worn by the local firefighters. The term gaen also means "ruffian," while *bori* refers to engraving or carving.

Left From stem to stern, only the hands, feet, neck and head remain untouched.

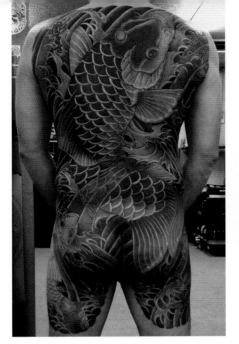

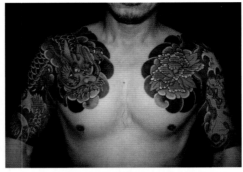

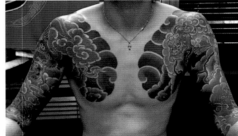

HIKAE: SHOULDERS AND ARMS

The verb *hikaeru* can mean "to restrain oneself," and this classic layout does just that. *Hikae* cover the shoulders and arms, making it possible to easily hide the tattoos with a v-neck shirt. There are two common types of hikae: "deep," which extends over the breast and sometimes surrounds the nipples, and "shallow," which does not extend over the breasts.

KAME NO KOU: THE TORTOISE SHELL

As the literal meaning of *"kame no kou"* implies, this design covers the entire back and thighs like a turtle's shell.

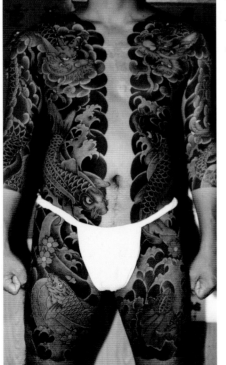

MUNEWARI: THE SPLIT CHEST BODYSUIT

Mune means "chest," and *wari* means "split." In this style, the arms, breasts, and back are covered in irezumi. However, a space running down the middle of the chest to the crotch is left untattooed in the classic split-chest design, which is said to be inspired by the traditional Japanese workmen's coat. *Munewari* is also called *jinbeibori*, after the light, loose-fitting summer robe called a *jinbei*. It's not unusual for the open space to be filled with a line of kanji—perhaps a motto that the wearer finds inspirational.

NAGASODE: LONG SLEEVES

The term *nagasode*, which means "long sleeves," is also used to refer to shirts. Nagasode irezumi cover the entire arm and end at the wrist. There are two lengths of sleeve: *kubu* and *tobu*. Kubu ends before the wristbone, while tobu goes beyond the wristbone, stopping right before the hand.

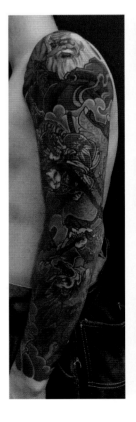

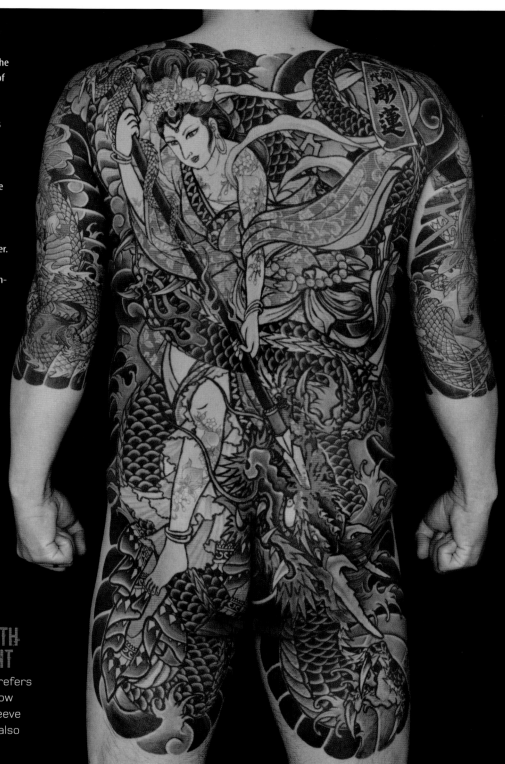

Far left This Japanese backpiece extends beyond the buttocks to approximately the midpoint of the thigh. Left, above An example of a shallow hikae, though more extreme examples also exist. Left, below A deep hikae allows for a slightly larger canvas, expanding design possibilities. Opposite, bottom left A solid strip of open skin flows down the front of the body. Opposite, bottom right A full Japanese sleeve extends from the wrist all the way to the top of the shoulder. Right A classically balanced backpiece framed by seven-tenth-length sleeves.

SHICHIBUSODE: THE SEVEN-TENTH SLEEVE BODYSUIT

In irezumi, *shichibusode* refers to sleeves that stop below the elbow, as if a long sleeve is pulled up. The term is also used in clothing.

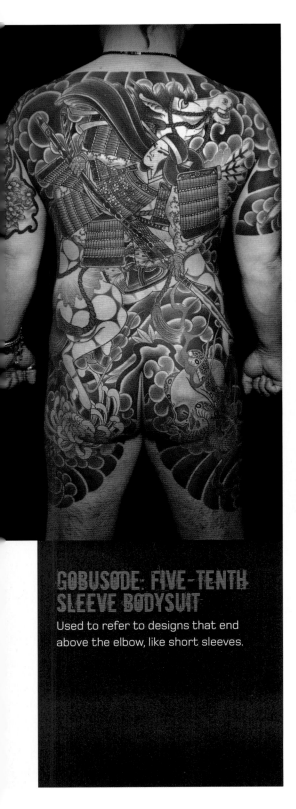

GOBUSODE: FIVE-TENTH SLEEVE BODYSUIT

Used to refer to designs that end above the elbow, like short sleeves.

SENAKA: THE BACK

For irezumi, this is the largest, most ideal area the body offers. As previously mentioned, a backpiece can include the buttocks and extend down to the back of the thighs.

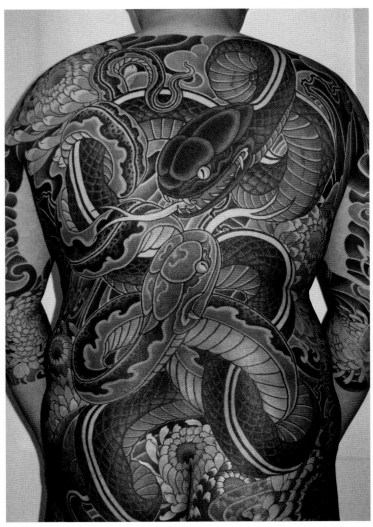

Above A full back allows for the depiction of large, detailed motifs. Note the untattooed areas around the armpits. **Left** These half-sleeves create an additional layer of decoration around the central motif.

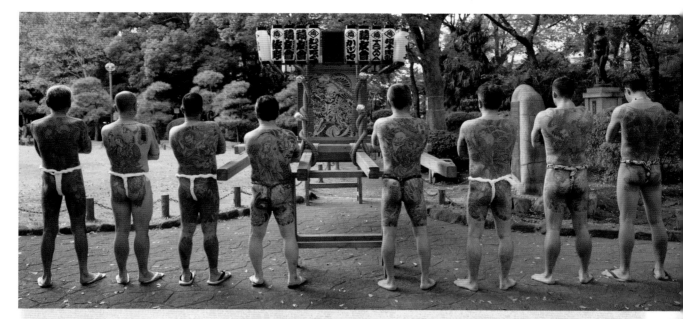

Displaying A Bodysuit
Get a Good Look

Yes, there is a proper way to display a bodysuit: *fundoshi*. The typically white loincloth offers a fitting contrast to a full bodysuit and doesn't distract from the tattoos like regular underpants might.

Worn by Japanese men for well over a thousand years, this traditional underwear has all but been replaced by Western-style boxers and briefs. Fundoshi are still sold, however, and there are some men who swear by them, saying they are more comfortable, especially during the sweaty summer months. And although Japanese women didn't wear underwear until the late 19th and early 20th centuries, fundoshi for women have become available in

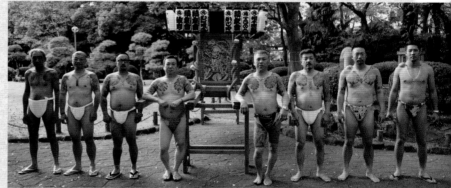

Top Men proudly show their backpieces for this group photo. **Above** Everyone's back is covered, and a variety of styles can be seen.

recent years.

Many modern Japanese have no idea how to put fundoshi on. It has become common to see people displaying full bodysuits while wearing a thong, which is a suitable workaround for the fundoshi-less. Just make sure the thong is white, because darker-colored garments can blend in with the tattoos, inadvertently changing how the bodysuit appears.

Decked out in fundoshi, irezumi enthusiasts display their tattoos in more than photos. During some Shinto *matsuri* (festivals), most famously the Sanja Matsuri in Tokyo, it isn't uncommon to see tattooed individuals riding atop the portable shrines or simply walking around in fundoshi, displaying their tattoos—all of which under-scores the religious connection tattooing has in Japan.

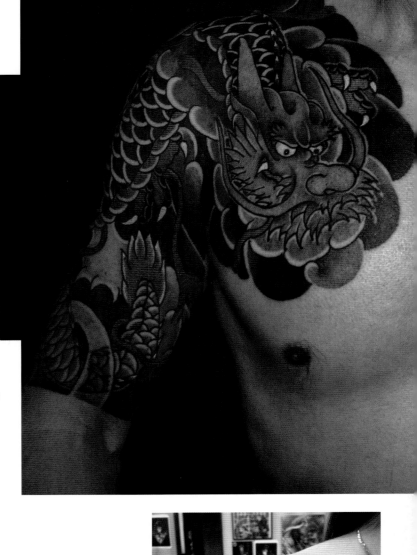

TATTOO BORDERS

In irezumi, the borders are known as *mikiri*. Since Japanese tattoos aren't isolated one-off designs, but large pieces with backgrounds that can cover much of the body, their edges are a key design element. Irezumi must have mikiri, and they are part of the work's initial design conception. There are several styles to choose from, many of which are named after nature motifs. The most common are *botan-giri* and *bukkiri*.

BOTAN-GIRI

This wavy mikiri makes its border with a series of shapes that evoke the round petals of a *botan* (peony). Despite being inspired by the flower, the botan-giri is typically made up of waves and clouds.

BUKKIRI (OR BUTSU-GIRI)

This sharply defined mikiri has a straight edge that looks like it was sliced with a katana.

JARI MIKIRI

Literally "gravel border." In this design, the irezumi's edge gradually fades out with a series of small dots.

AKEBONO MIKIRI

Akebono means "daybreak"; this somewhat ambiguous border gradually becomes less intense in color, just like the rays of the sun.

MATSUBA MIKIRI

Inspired by pine needles, *matsuba mikiri* uses a series of straight lines to create a border. It's rarely seen in modern irezumi.

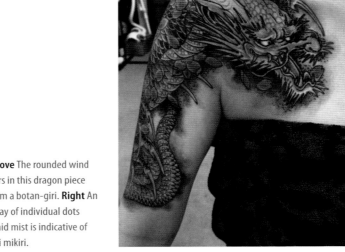

Above The rounded wind bars in this dragon piece form a botan-giri. **Right** An array of individual dots amid mist is indicative of jari mikiri.

Left The clean, straight cutoff beneath this dragon is an unmistakable bukkiri-style border. **Below** The slow, gentle fadeouts of akebono mikiri are often fitting for religious tattoos. **Below right** Don Ed Hardy checks out Dr. Fukushi's preserved bodysuit collection.

The Bodysuit Collector

While researching dermatology, Dr. Masaichi Fukushi, a pathologist at the University of Tokyo, became interested in how tattooing affected moles. By the mid 1920s, that turned into an interest in irezumi motifs and designs and a sideline in collecting and preserving bodysuits.

Working at a charity hospital, Dr. Fukushi encountered patients with bodysuits—some of which were still works in progress. He would offer to pay the costs to have the patients' irezumi completed on the condition that he could remove the tattoos from their bodies while performing their autopsies after death.

Dr. Fukushi collected more than 3,000 photos and made detailed, copious notes about irezumi—important work that was lost during American bombing raids in World War II. The preserved skins, however, made it through the war. Dr. Fukushi and his son amassed a collection of 105 tattooed hides, which are currently housed in the Medical Pathology Museum of Tokyo University. Unfortunately, the museum is not open to the general public.

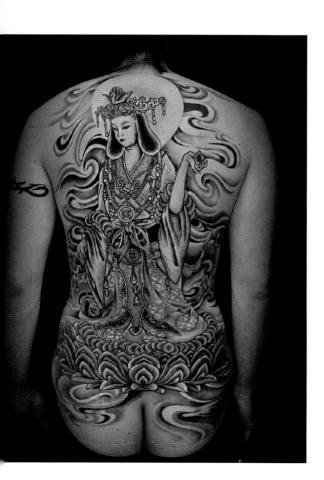

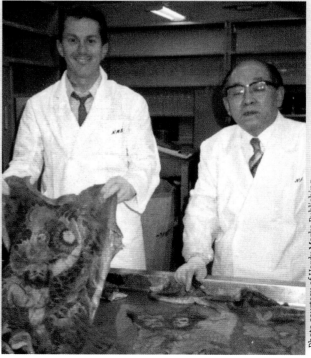

Photo courtesy of Hardy Marks Publishing

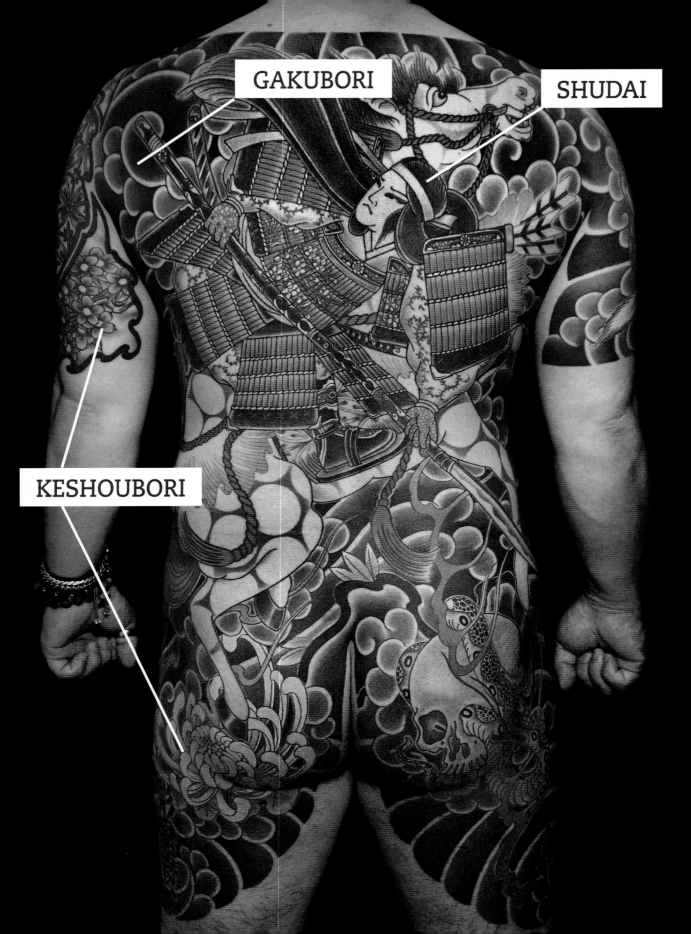

GAKUBORI

SHUDAI

KESHOUBORI

BODYSUIT LAYOUTS

Tattoo enthusiasts outside Japan commonly assume that in a full bodysuit, water iconography should be confined to the legs, the torso should be covered in earthly or heroic designs, while the arms and upper body should be reserved for cloud motifs. It's the classic earth, man, and heaven configuration seen throughout Japanese art.

This isn't the only layout, however. Entire bodysuits can be water-themed, with the *shudai* (subject) in the backpiece being a dragon in the waves or Kintaro wrestling the giant carp. It's also possible to set an entire bodysuit in the heavens, with a deity like a dragon or *tennyo* in the cloud design. The important thing in irezumi is that the bodysuit's layout makes sense, both thematically and as a reflection of reality.

SHUDAI

The tattoo's "subject" or central motif. Usually this is a god, an animal (mystical or real), a hero, or even an element from nature, such as a flower.

KESHOUBORI

Often called "trimmings" or "decoration" in English, these are the motifs that support the central design. Typical *keshoubori* include cherry blossoms, maple leaves, peonies—anything that helps underscore a main theme.

Left The layout of this bodysuit shows irezumi's highly evolved visual language. **Right** The tattooist's signature, called a *horimei*, can be seen on the upper shoulder. It's also not unusual for horishi to simply tattoo their signature next to the work, free of any *senjafuda*-style trappings (for more on senjafuda, see page 137).

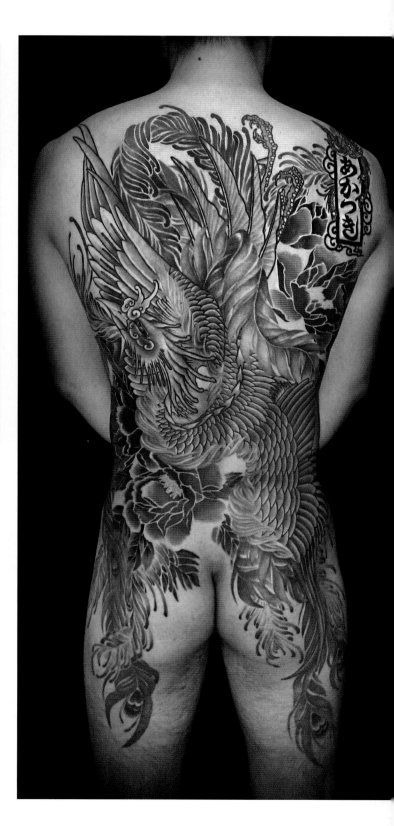

GAKUBORI

Here, *gaku* means "picture." This design is used to fill in the background with elements like clouds, waves, wind, and fire. Think of *gakubori* as a way tattooers can frame the entire piece, helping to set the stage for the tattoo. In gakubori, things like clouds and water are obviously not bound by don't-mix-the-seasons conventions, as they exist year-round.

NUKIBORI

This refers to the areas that are left untattooed. Skilled tattooists know that the parts of flesh that are not inked are just as important as the parts that are. Untattooed areas can serve as a contrast or even as part of the shading. The use of *nukibori* is limited only by the tattooist's creativity; it can appear anywhere within a tattoo. The term is also used in relation to Japanese tattoos that do not have tattooed backgrounds. The untattooed areas, naturally, are the nukibori.

HORIMEI

Literally, the tattooist's name. As in Japanese woodblock prints, the artist's name is enclosed in a rectangular box resembling a seal. Tattooists typically—but not always—put their horimei on large backpieces and full bodysuits as a way to sign their work. During layout, an oblong box or simply the artist's name is added near the client's shoulders. However, this is usually filled in last, after the tattoo is completed, just as painters only sign a work when it's finished.

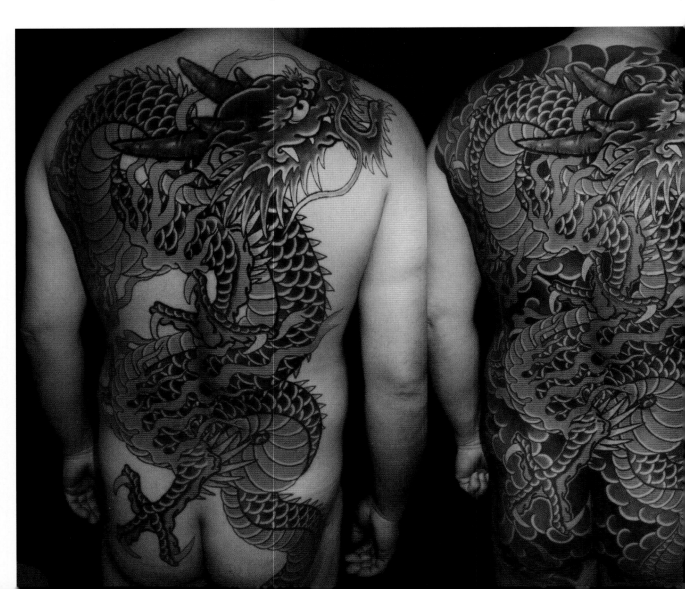

Below left and center Nukibori versus gakubori: The photo at left shows a backpiece with only the shudai, a large dragon, surrounded by uninked skin; the next photo shows the same tattoo with the gakubori filling in the empty space. **Below right** The contrast offered by nukibori can be used to tremendous effect. In the case of this phoenix, the expanse of untattooed skin allows the colorful bird to enhance the body's beauty.

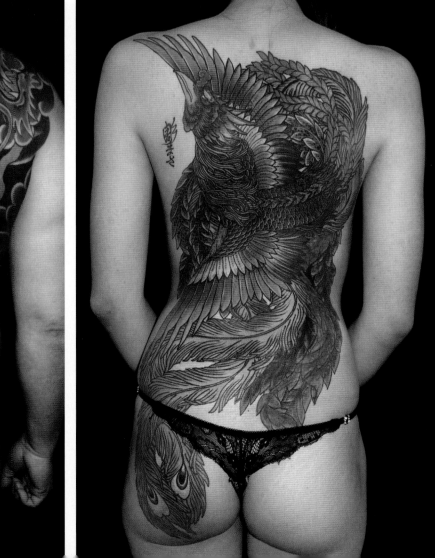

Senjafuda
"Here's My Card"

The way horimei are inked also takes inspiration from senjafuda, which are paper seals bearing one's name, much like old-school business cards. Visitors to a shrine or temple would affix their senjafuda to the rafters to mark their visit. Today, there are mass-produced sticker versions, but some artisans continue to make them the traditional way: by printing them from carved woodblocks. Some Japanese tattooists, especially those who specialize in traditional motifs, use senjafuda as business cards.

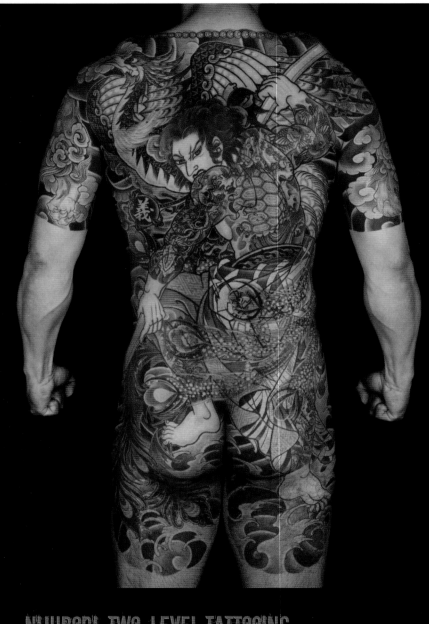

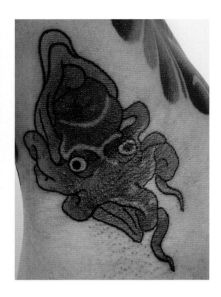

KAKUSHIBORI

These designs are typically funny or sexy, making them silly asides in serious bodysuits. *Shunga* (erotic print) designs are popular, as are the more comical Noh masks. There's a good reason why these irezumi are typically gags: They're not easily seen. *Kakushibori*—literally "hidden tattoos"—are located on the obscured areas of the body, such as the armpits or the inner thighs, both of which are painful places to get inked. Because of that, kakushibori are often nukibori designs, with large areas left untattooed and free of heavy colorwork or shading. However, some tough types have been known to get bright red tengu tattoos in their armpits. Other kakushibori spots include the genitalia and the bottom of the foot. (Since the skin peels easily, this area of the foot is not recommended, however.)

NIJUBORI: TWO-LEVEL TATTOOING

Nijubori are tattoos on two levels. In the case of the *Suikoden* heroes, for example, the central subject is also tattooed. Thus, you get a meta-image, a tattoo within a tattoo. For more, see page 106 in chapter 4.

Above As in the ukiyo-e images that this backpiece echoes, the tattoos on the shudai are skillfully done, demanding that the viewer look closer to appreciate the details.

Above A small, fun tattoo inked onto the open armpit adds an air of playfulness to the often overwhelming scale of a full-body tattoo.

The Yakuza
Japan's Underworld

Irezumi often elicit a Pavlovian response in Japanese people, making them immediately think of organized crime. Because of this, tattoos are seen as scary. Irezumi aren't only for gangsters, though—and they never have been.

Certainly, there have been plenty of bad eggs throughout Japan's tattoo history. Besides punitive irezumi (see chapter 1), there are stories of a roving band of Edo-period thugs who would flash their matching Daruma tattoos to intimidate others. Gamblers were also quick to take to irezumi. Like today, though, there were also regular folks who got tattooed. During the 1800s, irezumi became increasingly common (and even fashionable) among the working class, especially carpenters, builders, metalworkers, messengers, palanquin bearers, firemen and the

running horse-grooms who trotted alongside the horses. These folks worked with their bodies and wanted symbolic protection for themselves. Today, irezumi continue to be popular among blue-collar and bohemian types.

When tattoos were outlawed in 1872, anyone who had them was, by default, a criminal. Showing you had tattoos was a way to say, "Hey, I broke the law." This made tattoos look threatening. Even though the ban was lifted after World War II, those connotations remained— and, for many, continue to this day. But as one Japanese tattooist explained, "We must be thankful to the yakuza for keeping this country's tattoo tradition alive." That's true: When tattoos were outlawed and tattooists were under the real threat of being arrested for their work, the underworld kept

them employed.

In Japan and abroad, tattoos are a yakuza stereotype—a seemingly surefire way to i.d. members of organized crime groups. But how do you spot a yakuza tattoo? Sometimes you can't. An easy way to tell, however, is whether or not the design encompasses a particular yakuza organization's crest. These can be worked into the designs, appearing alongside tattooed flowers, heroes, creatures, and deities.

Tattoos are not a yakuza requirement, and there have been reports that some younger members are choosing not to get them to blend in. Anecdotal or not, tattooists who specialize in inking these underworld inhabitants say they still see a steady stream of young yakuza customers who are eager to get tattooed.

Left South Osaka is a well-known underworld mecca.

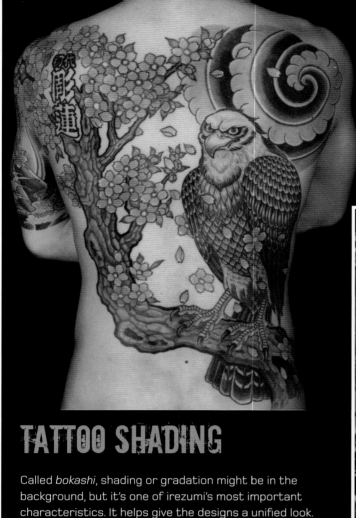

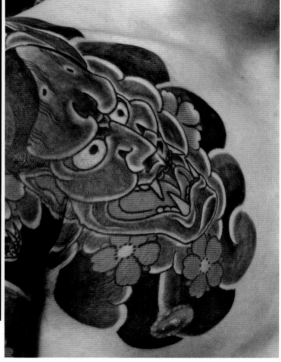

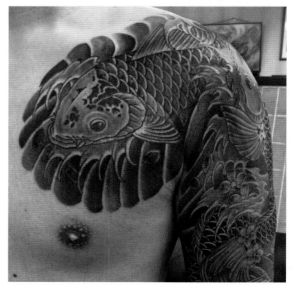

TATTOO SHADING

Called *bokashi*, shading or gradation might be in the background, but it's one of irezumi's most important characteristics. It helps give the designs a unified look.

AKEBONO BOKASHI

Like the akebono mikiri (page 132), this "daybreak" style of shading doesn't show a clear line of distinction. Different shades blur into each other. This general term is also used for traditional Japanese lacquerware.

USUZUMI BOKASHI

Literally, "diluted ink shading," the term *usuzumi* is also used to refer to the color gray, which best describes this hue. For *usuzumi bokashi*, the tattooer dilutes and separates ink gradations in a step-by-step process. *Mizu bokashi* (water shading), a method in which the tattooist dips the needles directly in water, can produce similar results.

TSUBUSHI

If bokashi is all about gradation, then *tsubushi* is all about the uniform application of color. The term *beta-tsubushi* refers to thick, heavy coloration.

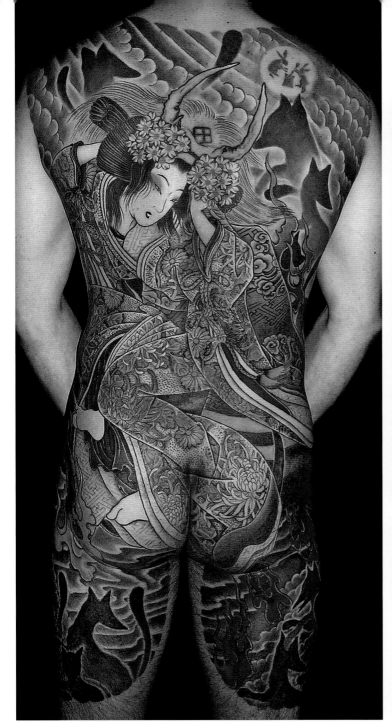

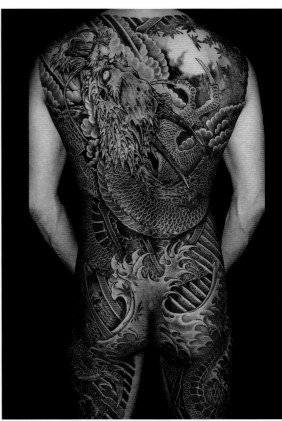

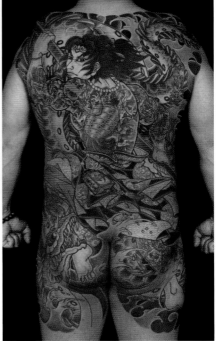

Above Detailed backpieces require a significant investment of both time and money.
Right, above Because the back is such a large canvas, tattooists can even ink a dragon's
individual scales with exquisite detail. **Right** The shudai in this backpiece has his own
bodysuit, making for a fascinating meta-tattoo.

TATTOOIST PROFILE HORIREN

EVERY BODYSUIT TELLS A STORY

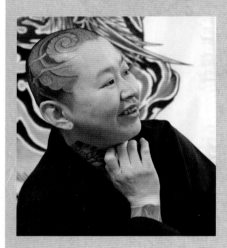

A tiny pink romper suit, bearing a line of fancy script that reads "Horiren the First," hangs on the wall. "I gave away the blue one the other day," says Horiren. It's a bright early-spring morning, and sunlight floods into the south Osaka apartment. Throughout the studio are photos of people's kids.

"My clients are like a family, all connected through irezumi," she explains. "I don't take anyone I haven't been referred to or don't know personally." Because Horiren is tattooing people she knows, the resulting irezumi often reflect the customer's life. They tell a personal story.

In Japan, where people with tattoos must keep them covered when navigating society, full bodysuits make life more difficult. Nonetheless, more and more customers are coming to Horiren for large works. Why? "Because without their tattoos, they feel naked," she says. "Their body is vulnerable, and their skin is unprotected."

Tattoos entered Horiren's life by chance—or, perhaps, by fate. After working in the video-game industry, she found herself in Australia. A short vacation ended up turning into a three-month sojourn. "In Sydney, I came across a tattoo shop, and without hesitation, I went in and got my first tattoo." And at the age of 24, Horiren, who had never been interested in irezumi before, fell in love with tattoos. "I was fascinated the moment I got a tattoo—it couldn't be erased." She didn't stop at one, and got around ten more. "I became a collector, but now I want all those early tattoos covered up," she says, laughing. "They're so bad."

It hit Horiren on the flight home: She could draw, so why didn't she just draw something and show it to the tattooer? "At that moment, at 30,000 feet, I decided to become a tattooist myself."

After returning to Japan and working as a muralist, Horiren saved up enough cash to quit her job and began teaching herself how to tattoo—an unusual approach in Japan, where lengthy apprenticeships are still common. "The first year, I practiced on myself," she reminisces.

Hoping to get more experience, Horiren began approaching the young, tough-looking types hanging out in front of convenience stores. Where most people would see trouble, Horiren saw something else: willing subjects. She told them she was a tattooist and asked if she could practice on them.

While she was still learning the ropes, Horiren wouldn't take money for the tattoos she did, believing that her work wasn't quite up to snuff; she only asked customers to cover the cost of the needles. One of her customers, who was getting a full bodysuit, told her that he was going to prison. "He asked me to put my name on his back," Horiren recalls—a nod to the tradition of a tattooist signing a large backpiece as a painter would a canvas. At that time she didn't have a tattooer name, but as Hasuda was the name of her neighborhood, she picked the character *hasu* (蓮), which means lotus flower; it can also be read "*ren*." Thus Horiren was born. "Then he said, 'I want you to have this.' He gave me a huge stack of cash. I never saw him again."

Now, after tattooing for over 15 years, Horiren is eager to have irezumi get the respect they deserve in Japan. "It's still an uphill climb, because the Japanese government doesn't recognize tattooing as a profession or grant licenses or certifications.

Bureaucrats just see this as a hobby," says Horiren. To change the way Japanese people view tattooing, Horiren believes it's necessary to travel abroad to explain the meaning and significance of traditional Japanese tattoos. If irezumi are viewed as an important part of Japanese culture outside of the country, then hopefully people inside the country will reassess their opinion.

Tattooing alone isn't enough for her: Horiren also does paintings for Shinto shrines and Buddhist temples during festivals, which puts her art in a context that's easier for many people to appreciate.

However, her sense of civic duty isn't simply a way to promote irezumi. After 2011's Great East Japan Earthquake ravaged the country, Horiren went to the areas hit hardest: Iwate, Miyagi, and Fukushima. As she recounts her volunteer experience of picking up debris and salvaging personal belongings, the nuclear symbol on her neck suddenly makes more sense. It's more than a permanent reminder of a tragic event. This was a moment in her life, just like all the other tattoos that make up her own bodysuit—and just like the tattoos she does for her customers.

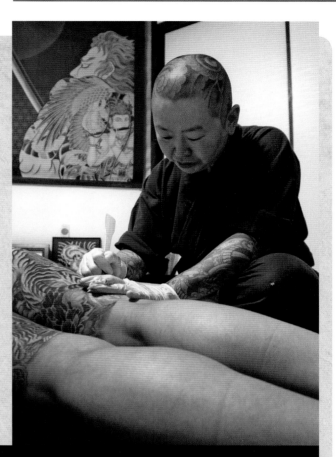

Opposite, top Horiren in her Osaka studio. Above Horiren uses the shamisen-bori technique as she works on a bodysuit. Left Various shamisen-like picks used in the increasingly rare shamisen-bori style of tebori.

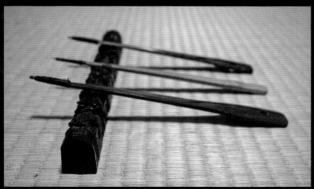

Besides *tebori*, Horiren also practices *shamisen-bori*, a method of tattooing that is on the verge of extinction. There are only three tattooists left in Japan who still use it exclusively: One is the master tattooist Toshika-zu Nakamura; the other two are his apprentices. "I'm not an official apprentice," says Horiren, "but Nakamura-sensei was nice enough to show me this method."

Shamisen-bori takes its name from the banjo-like three-stringed traditional Japanese instrument. The tattooist affixes needles to a fan-shaped shamisen pick—which is much larger than a guitar pick—by wrapping them with thread and sealing them in place with hot wax. "Unlike a regular tebori tool, which you hold like a pool cue, the shamisen-bori *nomi* is held like a pencil, giving you tremendous control," Horiren explains. "When piercing the skin, you go in at an upward angle, instead of a downward one, making each prick above the next."

FREDERIK
CLASSIC TATTOOS WITH A GOURMET FLAVOR

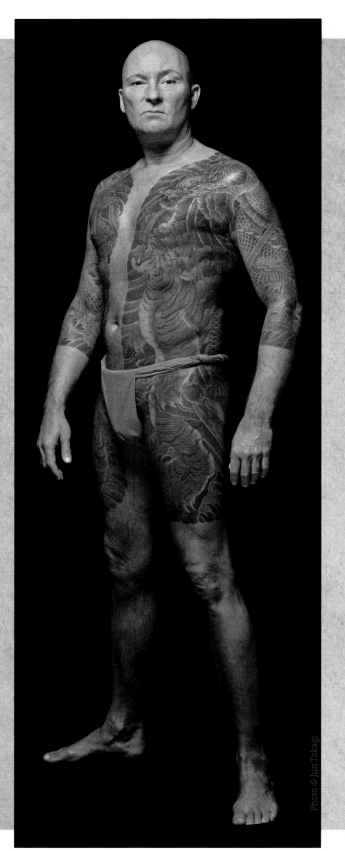

Under Niels Frederik Walther's pristine chef clothes is a bodysuit of dragons, tigers, waves, winds, and flowers. "In Japan, this would be considered a lifestyle choice," says Walther. Because that's exactly what it is.

A well-known chef in Europe, Walther is the chef for the Danish ambassador in Tokyo. Before that, he cooked for the queen of Denmark. "When a new ambassador arrives, I always say that I have tattoos," Walther says. "But I always keep them covered at work."

It's not only at work—it's nearly every public place imaginable. "My bodysuit has certainly motivated me to stay in shape. I don't want a tiger to look like a hippo," Walther says with a smile. At the gym, however, he wears a tracksuit, and then showers at home. Forget swimming pools or public baths. There are strict rules about people with tattoos entering both kinds of establishments.

Then there are also basic, unwritten manners. "I know if I wear shorts in summertime, and then, for example, cross my legs on the subway, people will be able to see part of my bodysuit." Catching a glimpse of it, he explains, might make some uncomfortable, or lead to discrimination against him. In Japan, you typically don't see people with irezumi—although they certainly do exist! Unless you are in a trendy, youthful part of Tokyo or Osaka, tattoos typically stay covered and are not for daily display.

"In the West, people get tattoos to show them off," says Walther. "But in Japan, irezumi are often more personal and private." Even when he goes back to Europe and visits the beach, Walther says his tattoos can cause quite a stir.

Left The red tiger Walther wanted can be seen on the side of his body.
Right On his back is the sorcerer Unryu-Kuro, who is able to conjure and control dragons. Dragons, which rule the sky and the waters, are often paired with tigers, which rule the land.

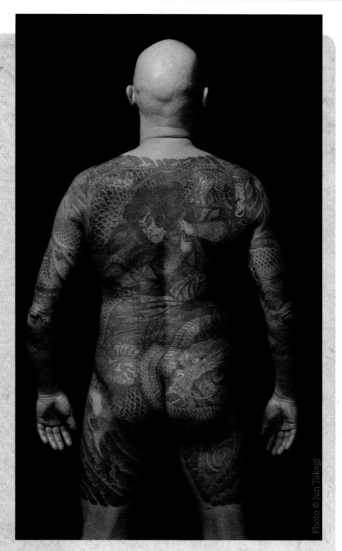

Photo © Jun Takagi

"I know some families probably cover their children's eyes," he jokes.

Walther got his first tattoo in 1984, while still living in Copenhagen. "It was a bat tattooed on my ass," he says with a laugh. "It was very outrageous at the time." While fun, the tattoo's meaning was just a bit, ahem, cheeky. Everything changed once he moved to Japan and discovered irezumi.

"It was the year 2000, and I can still remember this vividly. There was a man standing on some steps wearing a blue shirt." Walther just caught a glimpse of the man's irezumi peeking out from underneath his shirtsleeve. "I thought it looked so dangerous and so underground," says Walther, who struck up a conversation and befriended the man. "He eventually taught me so much about tattooing, and introduced me to Japan's best tattooists."

After Walther had met Horiyoshi III and gone through the customary getting-to-know-you and gift-giving rituals, the tattoo master started work on Walther's left sleeve. That eventually turned into a full bodysuit. "I wanted something with meaning," Walther said. "You know those people who get Chinese character tattoos and don't know what they mean? That's exactly what I didn't want." Continuing, he says, "I really think it's important, though, before you get a tattoo, to wait until you know what it means." Because for Walther, if you don't know what your own tattoos symbolize, they're nothing more than permanent lines and circles and colors that fade over time.

He wanted his bodysuit in irezumi's old color palette of black, red, and blue-green. The result was four dragons and two tigers. While he did want tigers, Walther didn't want yellow or orange ones, because the color wouldn't be harmonious with the reds, blues, greens, and blacks in his bodysuit. "Look, the tattoos are going on my body, and I wasn't interested in flashy colors," he says. "After much discussion with Horiyoshi, he finally agreed to do the

tigers in red." That was one of the few times Horiyoshi III has done red tigers.

In total, Walther reckons he's spent four or five million yen (around $40,000) on his bodysuit—as well as a lot of pain. "I'll tell you what, under the arm and near the crotch were some of the most intense pain I've ever had in my entire life," he says. "But the pain is part of the experience."

The world-class chef says he feels like the dragons on his bodysuit give him power, as does as knowing that he was able to withstand the physical pain necessary to get them. Yet it's more than that—there's a peace of mind that irezumi offer. "There are very few things in this world you can buy that nobody can ever take away from you as long as you live." A bodysuit is one of them.

CONTEMPORARY DESIGNS AND GEEK TATTOOS

From anime girls to abstract shapes, Japanese tattooing has changed. Or has it? Throughout this book, a wide variety of classic motifs are presented. Some of them are well over a thousand years old, while others are much newer. Japan's visual vocabulary is not static. *Irezumi* aren't, either. They're as alive as the skin on which they breathe.

Right Tattoos are no longer off-limits to *otaku*. Two tattooed cosplayers pose as Ryuko Matoi from the anime *Kill La Kill*.

EAST MEETS WEST

Call it tattoo diplomacy. Following World War II, more and more American tattooists started taking a keen interest in irezumi. Sailor Jerry, one of America's most influential tattooers, began corresponding with Horihide, a tattooist from Gifu, Japan. Sailor Jerry worked with a wide range of colors and pigments. He even made his own purple tattooing ink, a hue that tattooers at that time said was impossible to create. Sailor Jerry traded that color know-how for knowledge about Japanese motifs and shading techniques. This correspondence is all the more amazing considering that it happened only decades after the war, and Sailor Jerry was unabashedly patriotic. The desire to learn and improve tattooing was more important.

American tattooing has traditionally used strong, dark lines and flat colors, unlike the fine lines and shaded hues of irezumi. Sailor Jerry began using a more Japanese style of gradual shading. He also added dragons, tigers, and geisha to his repertoire of pinups, eagles, and ships, and did large Japanese-style backpieces with cloud and wave backgrounds. American tattoos had long been isolated "one-point" designs. You'd get, say, a panther on your arm, and that was it. Even early bodysuits done in the West looked like a series of one-point designs instead of elaborately shaded backgrounds with "trimmings" like maple leaves or cherry blossoms to underscore the central motif.

Above Japan and American flags flown together in a modern piece show how far the two countries' relations have progressed. **Left** A Japanese courtesan tattoo stencil done on acetate by Sailor Jerry. It dates from after World War II.

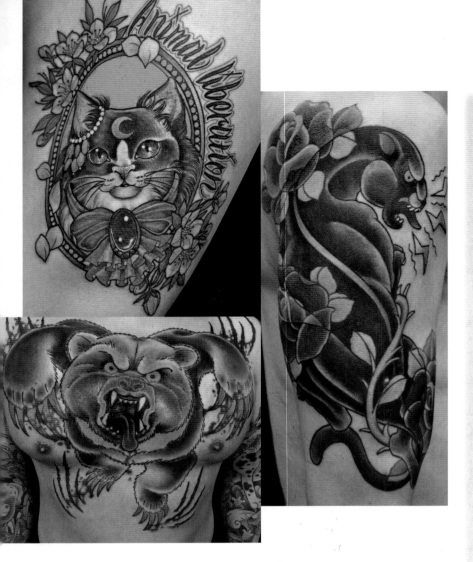

Top Cherry blossoms are worked into this fancy cat tattoo. **Above** Cartoonish and playful designs are more and more prevalent in the current Japanese tattoo scene. **Right, above** Modern Japanese tattooers freely embrace and build upon classic Western imagery, such as the iconic black panther design.

While Sailor Jerry was only able to correspond with Japanese tattooers, his protégé, Don Ed Hardy, actually went to Japan in 1973 to work at Horihide's studio. Like Sailor Jerry, Hardy always wanted to elevate tattooing to a higher art form. Hardy had long been interested in ukiyo-e prints and motifs, and his seriousness toward his work and extensive knowledge of Japanese art even rubbed off on Horiyoshi III, who began to take irezumi more seriously after befriending the American.

The influence of Sailor Jerry and other mid-20th century Western tattooers like Bert Grimm can be still felt in Japan. In the West, the style is called "Old School," but in Japan, it's referred to as "American Traditional," even if the designs aren't all entirely American. The style's common motifs, which include pinups, hearts, panthers, anchors, dancers, and roses, are given a decidedly local spin when combined with Japanese-language slogans or irezumi designs.

Machines vs Tebori

The buzz of the tattoo machine is heard more and more in Japanese tattoo shops. Even tattooists who use the hand-poked *tebori* method often use a machine to draw the *sujibori* (outline), as it achieves straighter lines.

Some, like Horiyoshi III and Horimasa, now use a machine more than tebori tools—often at the request of their Japanese clients—for a very simple reason: Machines are faster. They also provide a great deal of precise control, producing great results. Tattooists like Gakkin of Kyoto have shown that machines can produce truly stunning gradation and shading.

The notion that Japanese irezumi are defined by tebori is an oversimplification that discounts the rich pictorial motifs that tattooists have drawn upon for centuries. While tebori can offer incredible detail, since the number of needles can be changed and customized depending on what's required, modern tattooers often employ machines to create more precise work.

JAPAN'S CHANGING CULTURE

Part of what made irezumi intimidating in years past was that you couldn't walk off the street right into a tattoo parlor. They were hidden in houses, apartments, and unmarked buildings. That changed in the 1990s with the advent of the "street shop" in Japan. Complete with signs and listed phone numbers, these were walk-in tattoo parlors like those found throughout much of the Western world. Instead of the back-room studios closely associated with organized crime, these shops provided a far more inviting environment designed to break the intimidating stereotype.

Many of the new generation of tattoo artists eschewed the traditional apprenticeship, picking up their craft elsewhere or even teaching themselves. The self-taught Japanese tattooer known as Sabado opened Eccentric Tattoo Shop in Nagoya in 1993, among the first—if not the first—of Japan's street shops. "For the year before that, I tattooed out of an apartment, but I wanted to make a shop like I had seen during my travels in the United States and South America," Sabado explains.

It wasn't only studios that were emerging from the underground. Japanese pop princesses like Ayumi Hamasaki and Namie Amuro also played against type, flaunting their Western-style tattoos in public—something that would've been unthinkable for the previous generation of cute celebs. It was an era in which people did the unexpected, whether that was fashion or art, and the nation's youth once again started getting tattooed.

Left The friendly facade of Sabado's truly eccentric studio in Nagoya. **Right, top** Ozuma's breathtaking work shows irezumi's full potential and continues to inspire tattooers the world over.

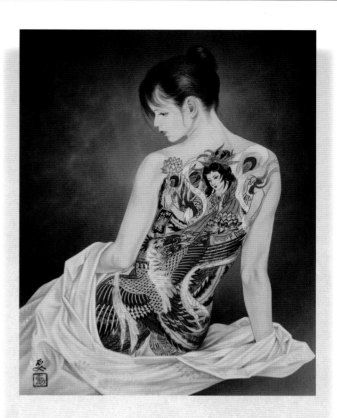

The Legacy of Ozuma
Irezumi's Master Tattoo Painter

Not all fine artists who have influenced irezumi lived in the 18th century. The irezumi nudes of Kaname Ozuma (1939–2011) continue to have an impact on tattooing today.

Whether in his portraits of Horiyoshi III's female clients or in paintings displaying irezumi designs of his own, Ozuma showed a deep understanding of how the body and tattoos converge into a singular expression.

Ozuma considered himself a great friend of Horiyoshi III as well as a rival: Both of them were constantly trying to outdo each other creatively, taking irezumi to higher forms of originality and expression. Ozuma also mentored younger artists, including Horiren, teaching them the finer points of Japanese painting.

Like the woodblock prints of Kuniyoshi Utagawa before him, Ozuma's paintings of deities, demons, and dragons continue to provide endless inspiration for tattooers and irezumi enthusiasts.

NEW TAKES ON OLD MOTIFS

One result of the apprenticeship system was that many young tattooers followed their master's style, just as that master had followed their own master's style. The aim was consistency. However, from the 1990s on, you started seeing more young Japanese tattooers who chose not to replicate the work of others but made an effort to create their own unique, trademark look. Even amid the quest for originality, these tattooers continued to use classic motifs and adhered to the rules of irezumi. Visually, however, they added their own spin.

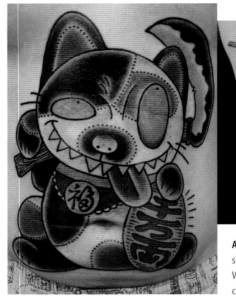

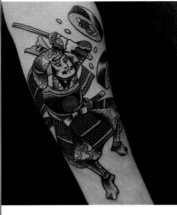

Above In this playful tattoo, a samurai slices a sushi roll with a blade. **Left** Watch out, because this *maneki neko* carries a scythe.

Avant-Garde Ink
The Vanguard of Japanese Tattoos

These tattoos might look modern and edgy, but they're often firmly grounded in patterns found on Japanese family crests (see page 26), fabrics, and ceramics. Some of the tattoos are in precise geometric shapes, while others are akin to the emotive lines seen in calligraphy. They don't have to be abstract or monochrome, and there is no set style. Instead, Japanese avant-garde tattoos reflect the country's centuries-old visual cues and respect basic irezumi grammar while pushing form and line forward in new ways on the human body.

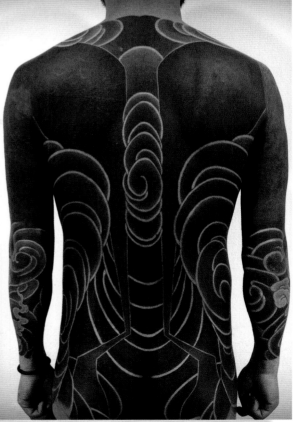

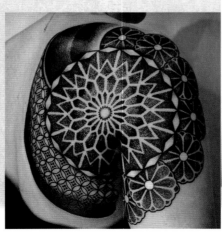

Right Nissaco fuses Japanese textile patterns with geometry, reminding us of their timeless beauty. **Far right** Long patches of solid black contrast with whorls of wind. Gakkin deftly shows that less is truly more.

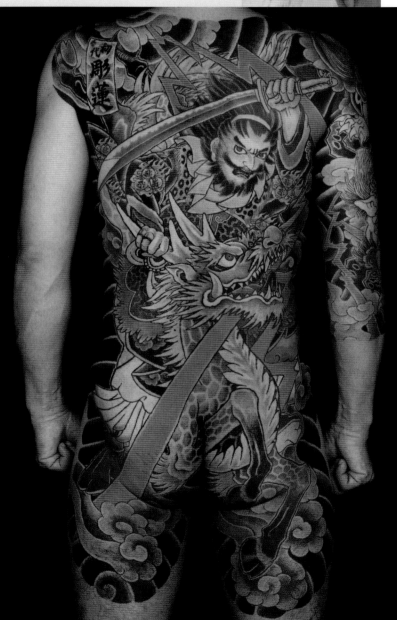

Right This *yokai*, the long-necked *rokurokubi*, incorporates contemporary color schemes and layouts. **Left** Modern takes on old designs result in exciting new tattoos. **Below left** Mixing it up, a topknot and katana sword for this samurai cat. **Below** Many artists gradually began to experiment with new colors such as bright orange as they became available in Japan. Even traditional designs like this backpiece were brought to life in new and interesting ways thanks to the expanded range of pigments.

GEEK TATTOOS

In Japan, they're now called *otatoo* (ヲタトゥーor "wotatou"), a word that combines "otaku," meaning geek or nerd, and "tattoos." (It's also a word that was coined by this book's coauthor, Hori Benny.) These tattoos, which feature characters and designs from manga, anime, and video games, are aimed at otaku and done by otaku.

For decades, characters like Mickey Mouse were prime tattoo fodder in the West. Japan, however, had firmly established ideas of how tattoos should look. It wasn't until the 1980s that American tattooist Mike Malone, who was a colleague of Don Ed Hardy and a protégé of Sailor Jerry, did an enormous irezumi backpiece, but instead of a deity or a *Suikoden* hero, he inked Godzilla as the subject. This fusion inspired other American tattooers like Dave Waugh to do large anime-themed backpieces. In Japan, the home of anime and manga, tattooers would later follow suit.

Around the turn of the century, Hori Hiderow, a tattooist in Hiro-shima, was unabashedly incorporating Japanese otaku influences into his work. At that time, Hori Hiderow's shop was unlike anything you'd see in Japan: Gundam models, Star Wars toys, and Ultraman figures dotted the studio. Posters of anime girls covered the walls. The place looked more like otaku heaven than a tattoo studio. His work also proudly displayed those geek motifs in a way others in Japan weren't yet doing. Hori Hiderow, who passed away in 2009, showed a generation of younger tattooers that it was okay to reference (heck, even wallow in) the manga, anime, and video games

they loved. In short, geeks could be themselves.

The rise of otaku tattoos hasn't happened in a vacuum. It mirrors the passions and interests of modern life. This generation's heroes are not from the *Suikoden*, but from *Neon Genesis Evangelion*, *One Piece*, and *Final Fantasy*. These are the modern Japanese myths that offer courage, inspiration, and ideals. And naturally, that makes them perfect for tattoos.

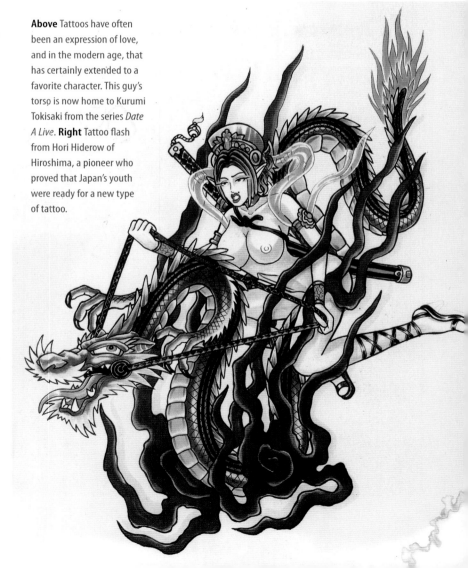

Above Tattoos have often been an expression of love, and in the modern age, that has certainly extended to a favorite character. This guy's torso is now home to Kurumi Tokisaki from the series *Date A Live*. **Right** Tattoo flash from Hori Hiderow of Hiroshima, a pioneer who proved that Japan's youth were ready for a new type of tattoo.

Above left Geometry and glitch lines surround the Eva Unit 01's hallmark greens and purples, demonstrating a range of technique and making for a striking *Neon Genesis Evangelion* tattoo. **Above** Joseph Joestar and Lisa Lisa from *JoJo's Bizarre Adventure*, arranged specifically for this custom tattoo. **Left** Testament, from the fighting game series *Guilty Gear*, is inked on an avid player. **Right** Ryuko Matoi from *Kill La Kill*, as a *kakushi-bori* inside the thigh of a traditional Japanese bodysuit.

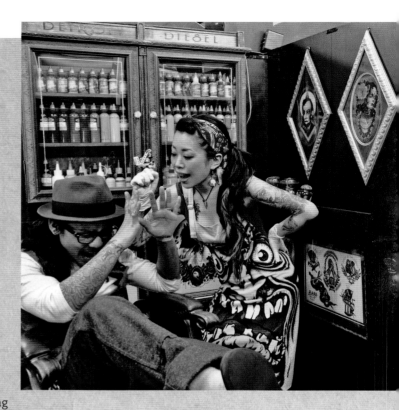

Above Mica and En are a fun-loving couple who share a mutual passion for their craft.

TATTOOIST PROFILE
MICA CAT
THE NEXT GENERATION OF JAPANESE TATTOOERS

"I feel like some things for tattooing are changing in Japan," says Mica. She's decked out in a *Neon Genesis Evangelion* shirt and a miniskirt. "But other things are not."

Customers come from all over Japan—and the world—to get tattoos from Mica and her husband En at the studio they share in Tokyo. Detroit Diesel Tattoo Works looks like something out of an Edward Gorey illustration. The plastered green walls are covered with humorously macabre art. There's a medicine cabinet filled with plastic bottles of tattoo ink and a bookshelf packed with Hokusai and Kuniyoshi art books. According to En, who is tattooing the Bodhisattva of Wisdom and Memory on the back of a young man, the shop's name has its roots in the Quentin Tarantino-penned film *True Romance*, which is partly set in Detroit.

Young, cool vibe aside, Mica is quick to point out that not all their customers are hip 20-something-year-olds. "Here we also get customers in their 40s and 50s," Mica says. "I don't know about other shops, but tattooing is not just a youth thing." Japanese people approaching middle age are actually freer to get tattoos, because if their children are grown, they don't have to worry about being refused entry into public pools or beaches. The shop sees all kinds of people—from young, artsy types to middle-aged doctors.

Mica is part of the younger generation of Japanese tattooists. Interested in fashion, art, and pop culture, her work still shows a passion for traditional irezumi. "My tattoos are original works, but I believe it's necessary to adhere to certain irezumi conventions," she says. "If you don't, then you lose everything that makes irezumi, well, irezumi."

Mica points out her geisha drawing tacked to the wall. The folds in the geisha's kimono, she explains, are done in a traditionalist style, as are the peony motifs. The way the geisha's face and body are executed, along with the general layout, shows an influence of Japanese manga, American pinups, graphic art, and, yes, irezumi. A multitude of styles come together in Mica's work in a fresh new way that still adheres to Japanese tattooing conventions.

Having grown up with a love for drawing, Mica used to be a graphic designer. "Most of the work I was doing, though, wasn't using my own original illustrations, and I felt like graphic design wasn't what it was cracked up to be," Mica says. "I had heard that tattooists got to do their own designs." With a friend, she went to check out a tattoo studio. "I didn't have a bad image of tattoos then," adds Mica, who didn't have any tattoos at the time. "But going to the tattoo studio was different than what I expected." She was surprised at how

Left One of Japan's best-known human-driven robots, *Mazinger Z*, done by En and effortlessly paired with a dragon and water *mikiri* background. **Below** Mica's beautiful ladies may be made in Japan, but they don't shy away from Western sensibilities!

happy the customers were. "I thought it was wonderful that customers could always appreciate and look at their tattoos," says Mica. "I was thankful a job like this existed."

Now Mica and her husband are the teachers. Two fashionably dressed young women named Miyuki and Manami stand with notepads, watching En as he continues to work on the Buddhist backpiece.

"We didn't set out to attract women apprentices, but it just worked out that way," says Mica. "More women are starting to get interested in becoming tattooers."

One of the apprentices, Miyuki, concentrates as she quickly scribbles notes. "This is so I can remember the

work flow for a piece like this," she says. She says she wants to be a tattooist because she's into Japanese heavy metal. Her fellow apprentice, Manami, has a different reason entirely. "If you become a tattooist, you can work anywhere in the world," she says. "It's truly an international profession." Manami sees irezumi as a ticket to a jet-setting job.

"I wish tattooing was more accepted in Japan like in North America or Europe," says Mica, lighting a cigarette. "But I can't ever seeing this country becoming that open to tattooing." En isn't optimistic, either, adding, "Compared to 20 years ago, more people have tattoos. Perhaps Japan will never become open about tattooing."

For Japanese people, however, things have changed, Mica explains. "It's easier to walk into an irezumi studio now than it was in the past," she says. Many studios are like Mica and En's: welcoming and comfortable. "Plus, tattoos aren't seen as scary

anymore to many folks. Their image has softened."

Yet some things have not changed, especially among those in power. "There are still some stubborn people who aren't open to tattoos. I mean, even doing basic things like renting an apartment can be difficult, if not impossible, for those who have visible tattoos." Then there are increasingly vocal politicians who rail against tattoos, and members of the country's media who continually equate them with organized crime. "Still, I think there are more talented tattooists in Japan now than ever, doing amazing and brilliant work," says Mica. "Stuff like that gives me hope."

AYANE
EXPRESSING YOURSELF IN A MODERN WAY

"I've always loved anime," says 26-year-old Ayane. "I thought, if I'm going to get tattoos, I'd like to get anime characters." Ayane is a regular on the Osaka otaku scene, hanging out in the city's anime, manga, and gaming district of Nippon-bashi and often participating in comic conventions. Tattoo enthusiasts like Ayane are helping to redefine what irezumi means and what it can be.

With all her otaku cred, it's no wonder that both of Ayane's thighs are covered with stylized versions of the characters Asuka Langley and Rei Ayanami from the sci-fi anime *Neon Genesis Evangelion*—the handiwork of Osaka tattooist Hori Benny, the coauthor of this book. "The layout was arranged so they complement each other—like the Shinto gods Raijin and

Fujin," Ayane explains. "It wasn't really decided who was who, but maybe Asuka on the right is Raijin and Rei on the left is Fujin."

While Raijin and Fujin (see page 100) are traditional irezumi designs, Asuka and Rei are more contemporary motifs. Tattoo enthusiasts in Japan have always gotten images that speak directly to them. During the Edo period, that was the *Suikoden* heroes or religious deities. Today, it could be a character from anime, manga, or a video game.

For Ayane, her tattoos are more than a show of geek fandom. They've offered her new perspective on life. "I used to be bad at articulating my thoughts," she says.

Right Ayane's first tattoo of her favorite character, Asuka Langley from the landmark sci-fi anime, *Neon Genesis Evangelion*.

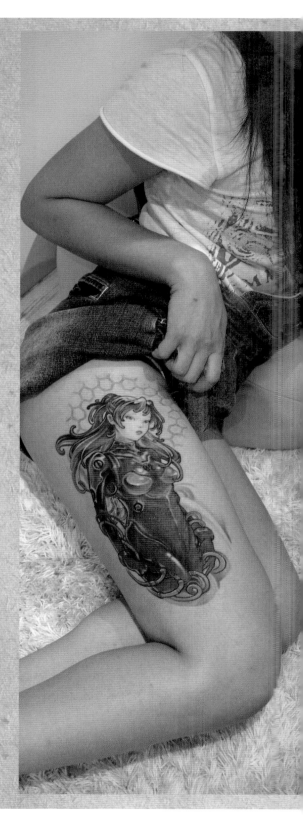

Right The series' other female lead, Rei Ayanami, adorns Ayane's opposite thigh. Just like classic Japanese irezumi, these modern anime characters complement each other, creating two parts that form a whole. And just as in eras past, the tattoos reflect an aspect of the wearer.

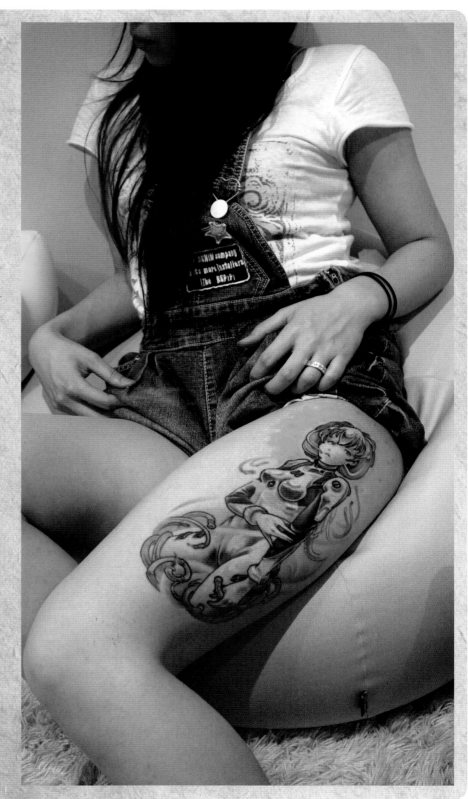

"And I wasn't very proactive, but I started thinking that there are things I wanted to do and ways I could express myself."

Among them, she says, were tattoos. In Japan, where they are still somewhat taboo, getting inked requires a strong sense of commitment because of the way tattoos can affect one's daily life, whether it has to do with choosing whether to go to the beach or deciding which clothes to wear to work.

With all the negativity mainstream Japanese society often casts upon tattoos, Ayane is another example of how, seemingly against all odds, they can make people's lives better. These strong anime characters have given her more confidence. For Ayane, getting tattooed helped her take charge and change herself for the better. She's an anime geek and a tattoo enthusiast, and she proudly wears both identities as a badge of honor—as she should.

Questions to Ask
If You're Planning to Get Inked

Not all countries, Japan included, regulate tattooing. It's essential for clients to pick a studio that works in a hygienic and safe environment. Most well-established tattoo studios do, but here are things to keep in mind:

Does the tattooist wear gloves? Are disposable needles used? If the tattooist does tebori, are the needles new and was the tebori tool made especially for you?
If you're not sure, ask.
Are the tools taken apart, wiped down with sterilizer, and put in an autoclave machine (aka steam and pressure sterilizer)?
If the machine itself isn't clean, it could harbor harmful diseases.
While tattooing, is the ink that will be used dispensed into disposable cups?
If the same container of ink is used between clients, diseases can breed in said ink and then spread.
Is there some kind of covering between you and the tattoo chair or bed? Or, if this is a really traditional studio, is there a covering between you and the tatami mats?
Many studios wrap the area where the customers sit or lie in a disposable plastic sheet or cover it in sterile paper. In Japan, however, clients also bring their own towels. Be aware that, due to health and safety regulations, this practice does not typically exist in the West.

These questions are not unique to getting a tattoo in Japan; they can be asked anywhere. In Japan, this kind of information is typically placed on tattooists' official sites. Since the onus is ultimately on the client, though, you should not feel reluctant to ask.

Above Modern studios in Japan value cleanliness as well as quality.

PHOTO CREDITS

Page 4, 19, 78, 104, 110, 111, 119, 120 Wikipedia Commons
www.wikipedia.org/

Page 27 Irwin Wong
www.irwinwong.com

Page 32
LACMA, Herbert R. Cole Collection

Page 36 Mrhayata
www.flickr.com/photos/mrhayata

Page 38 Tony Alter
www.flickr.com/photos/78428166@N00

Page 40 Robert Lyle Bolton
www.flickr.com/photos/robertlylebolton

Page 41, 95 Jean-Pierre Dalbéra
www.flickr.com/photos/dalbera

Page 41 Nullumayulife
www.flickr.com/photos/41265963

Page 44, 63, 96 Juuyoh Tanaka
www.flickr.com/photos/tanaka_juuyoh

Page 45 ThisParticularGreg
www.flickr.com/photos/thisparticulargreg

Page 59 Durán
www.flickr.com/photos/63930773@N06

Page 72 Coniferconifer
www.flickr.com/photos/conifer

Page 73 Sébastien Bertrand
www.flickr.com/photos/tiseb

Page 77 Ryan Poplin
www.flickr.com/photos/poplinre

Page 106
Library of Congress, Fine Prints: Japanese, pre-1915.

Page 112 Vince42
www.flickr.com/photos/84609865@N00

Page 120 IAMJOHNYOO
www.iamjohnyoo.com/

Page 124 The Fostinum
www.fostinum.org

Page 126 Hori Benny

Page 144, 145 Jun Takagi
juntakagi.com

CONTRIBUTORS

Akatsuki www.red-bunny.com: **pp 41, 56, 64, 70, 93, 103, 133, 135**
Aki www.diabloart.jp: **p 152**
Bunshin Horitoshi bunshin-horitoshi.jp: **pp 37, 38, 42, 44, 58, 60, 61, 67, 70, 79, 98, 118, 125, 136**
Dan Sinnes www.electricavenuetattoo.com: **pp 7, 42–43, 73, 83, 101, 115**
En detroitdiesel-tattooworks.com: **pp 2, 39, 58, 148, 153, 156**
Gakkin www.gakkin-tattoo.com: **pp 26, 52–53, 76, 78, 83, 114, 125, 150**
Hiro swallownest-design.com: **pp 67, 50, 75, 96, 105, 147,**
Hori Benny www.horibenny.com: **pp 8, 10, 42, 43, 77, 79, 82, 83, 89, 91, 97, 108, 116, 117, 118, 119, 151, 153, 154, 157–158**
Hori Ei ameblo.jp/7thheavenart: **pp 5, 41, 48, 57, 60, 70, 74, 112, 119**
Hori Fuki www.red-bunny.com: **pp 15, 37, 44, 130, 134**
Hori Kyo www.horikyo.com: **pp 110, 127, 128, 132**
Hori Magoshi www.magoshibori.com: **pp 6, 15, 27, 39, 48, 60, 65, 66, 81, 97, 98, 99, 103, 105, 107, 128, 140**
Hori Taka www.radicalskintattoo.com: **pp 2, 17, 47, 50, 59, 65, 69, 75, 79, 96, 113, 118, 128**
Hori Taro www.horitaro.jp: **p 72**
Hori Toku 8ball.tattoo.jp: **pp 80, 99, 101**
Hori Zaru www.horizaru.com: **pp 10, 69, 76, 96, 103, 114, 150**
Horimasa www.horimasa.jp: **pp 2, 41, 49, 57, 62, 64, 69, 75, 81, 84, 85, 90, 99, 100, 106, 107, 110, 115, 128, 132, 137, 140**
Horiren www.horiren.com, with photos by hiro hara (hirohara@hotmail.com): **pp 3, 16, 63, 79, 88, 91, 93, 94, 99, 100, 106, 107, 109, 122–123, 129, 139, 140, 141, 151**
Horiyoshi III www.ne.jp/asahi/tattoo/horiyoshi3: **pp 54, 144–145**
Mica detroitdiesel-tattooworks.com: **pp 35, 46, 58, 82, 148, 153, 156**
Miyazo www.miyazo.com: **pp 48, 49, 50, 51, 61, 63, 66, 75, 76, 115, 116, 130, 133**
Naoki www.tattooing.jp: **pp 3, 6, 36, 37, 69, 86, 87, 118, 151**
Nissaco www.facebook.com/nissacotattoo: **p 150**
Owen Williams tamatattoostudio.com: **p 68**
Sabado www.lovesabado.com: **pp 67, 74, 116, 148, 150**
Shigehara yktattoo.jp: **pp 3, 45, 68, 69, 70, 72, 73, 74, 92, 101, 102, 105, 109, 113, 141**
Shodai Hori Shige: **pp 95, 97**
Stace Forand waterstreetphantom.tumblr.com: **pp 38, 74, 114, 121**
Yasshin 8ball.tattoo.jp: **pp 39, 80, 92, 98, 104, 105, 107, 117**
Yebis yebisink.com: **pp 60, 67, 70, 75, 139**
Yutaro theskullandsword.com: **p 29**

ACKNOWLEDGMENTS

Thanks to: Eric Oey for all his input. Our editors Cathy Layne and June Chong for shepherding this project through, our designer Sow Yun, and everyone else at Tuttle.

Further thanks to all contributors and interviewees for their thoughtful insight and enthusiasm.

A special thanks to the Yokohama Tattoo Museum, Horiyoshi III, Don Ed Hardy, Doug Hardy, Horiren, Hori Magoshi (aka Hori Shige V), and Crystal Morey for all their advice and assistance. Fostin Cotchen, Jun Takagi and Hiro Hara for their wonderful photos.

A big thanks to the work of Merrily C. Baird, Ian Buruma, Basil Hall Chamberlain, Thomas W. Cutler, Margo DeMello, John Dower, Sandi Fellman, Christine M. E. Guth, Wolfgang Herbert, Tadasu Iizawa, Marisa Kakoulas, Noburo Koyama, Donald McCallum, Saburo Mizoguchi, Cecilia Segawa Seigle, Haruo Shirane, Tattoo Burst, D. M. Thomas, W. R. Van Gulik, and Hiroko Yoda, as well as aisf.or.jp/~jaanus/, hanzismatter.blogspot.jp, onmarkproductions.com, and web-japan.org, among others.

Brian would like to thank his wife and three kids, his parents, his in-laws, everyone at Kotaku and Gawker Media (especially Nick Denton, Stephen Totilo, and Luke Plunkett), Jerry Martinez, and finally, Rolling Thunder Pictures.

Hori Benny would like to thank his family for their unconditional love. He would also like to thank his adopted country, Japan, whose rich irezumi traditions continue to inspire.

Published by Tuttle Publishing, an imprint of
Periplus Editions (HK) Ltd

www.tuttlepublishing.com

Library of Congress Cataloging-in-Publication Data

Names: Ashcraft, Brian, author. | Benny, Hori, author.
Title: Japanese tattoos : history, culture, design / by Brian
Ashcraft with Hori Benny.
Description: Tokyo ; Rutland, Vermont : Tuttle Publishing,
2016. | Includes bibliographical references.
Identifiers: LCCN 2016003189 | ISBN 9784805313510
(paperback)
Subjects: LCSH: Tattooing--Japan--History. | Japan--Social
life and customs.
 | BISAC: SOCIAL SCIENCE / Popular Culture. | ART / Body
Art & Tattooing. | ART / Asian.
Classification: LCC GT2346.J3 A75 2016 | DDC 391.6/50952--
dc23 LC record available at http://lccn.loc.gov/2016003189

ISBN: 978-4-8053-1351-0
ISBN: 978-4-8053-1860-7 (for sale in Japan only)

Distributed by
North America, Latin America & Europe
Tuttle Publishing
364 Innovation Drive, North Clarendon, VT 05759-9436 U.S.A.
Tel: 1 (802) 773-8930; Fax: 1 (802) 773-6993
info@tuttlepublishing.com; www.tuttlepublishing.com

Japan
Tuttle Publishing
Yaekari Building, 3rd Floor, 5-4-12 Osaki
Shinagawa-ku, Tokyo 141-0032
Tel: (81) 3 5437-0171; Fax: (81) 3 5437-0755
sales@tuttle.co.jp; www.tuttle.co.jp

Asia Pacific
Berkeley Books Pte. Ltd.
3 Kallang Sector #04-01, Singapore 349278
Tel: (65) 67412178; Fax: (65) 67412179
inquiries@periplus.com.sg; www.tuttlepublishing.com

26 25 24 10 9 8

Printed in China 2402EP

"BOOKS TO SPAN THE EAST AND WEST"

Tuttle Publishing was founded in 1832 in the small New England town
of Rutland, Vermont [USA]. Our core values remain as strong today
as they were then—to publish best-in-class books which bring
people together one page at a time. In 1948, we established a
publishing outpost in Japan—and Tuttle is now a leader in publishing
English-language books about the arts, languages and cultures of
Asia. The world has become a much smaller place today and Asia's
economic and cultural influence has grown. Yet the need for
meaningful dialogue and information about this diverse region has
never been greater. Over the past seven decades, Tuttle has
published thousands of books on subjects ranging from martial arts
and paper crafts to language learning and literature—and our
talented authors, illustrators, designers and photographers have
won many prestigious awards. We welcome you to explore the
wealth of information available on Asia at **www.tuttlepublishing.com**.

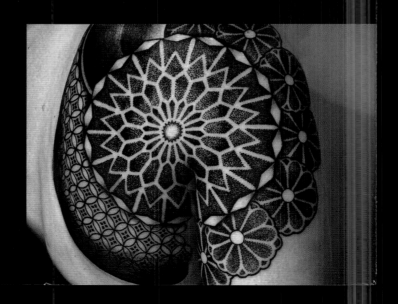